WASSILY KANDINSKY

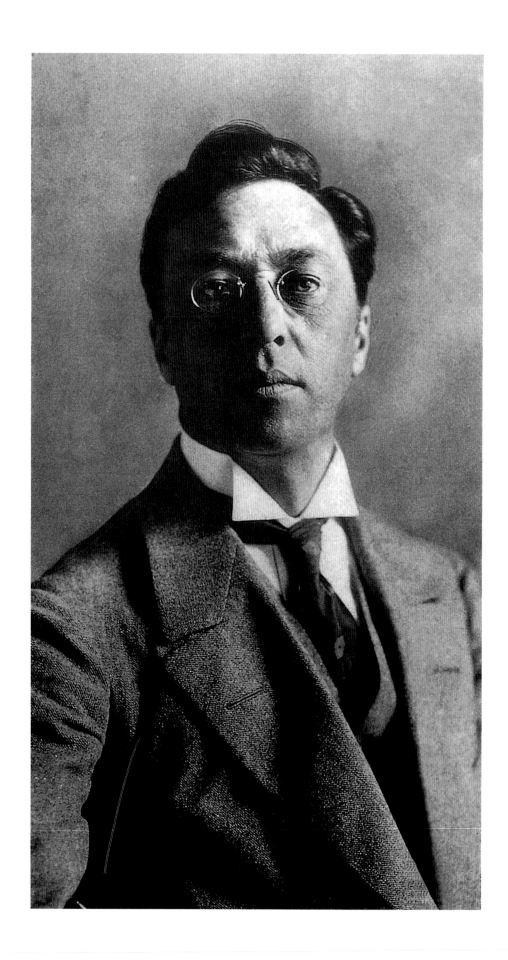

Portrait of Kandinsky, c. 1913
Photograph
accompanying his autobiographical *Reminiscences*, 1913

Ulrike Becks-Malorny

WASSILY KANDINSKY

1866–1944

The journey to abstraction

TASCHEN

HONG KONG KÖLN LONDON LOS ANGELES MADRID PARIS TOKYO

To stay informed about upcoming TASCHEN titles, please request our magazine at
www.taschen.com/magazine or write to TASCHEN America, 6671 Sunset Boulevard,
Suite 1508, USA–Los Angeles, CA 90028, contact-us@taschen.com, Fax: +1-323-463 4442.
We will be happy to send you a free copy of our magazine which is filled with information
about all of our books.

Original edition: © 1994 Benedikt Taschen Verlag GmbH
© VG Bild-Kunst, Bonn 2007 for the illustrations
English translation: Karen Williams, Low Barns
Cover design: Sense/Net, Andy Disl and Birgit Reber, Cologne

Printed in South Korea
ISBN 978-3-8228-3564-7

Contents

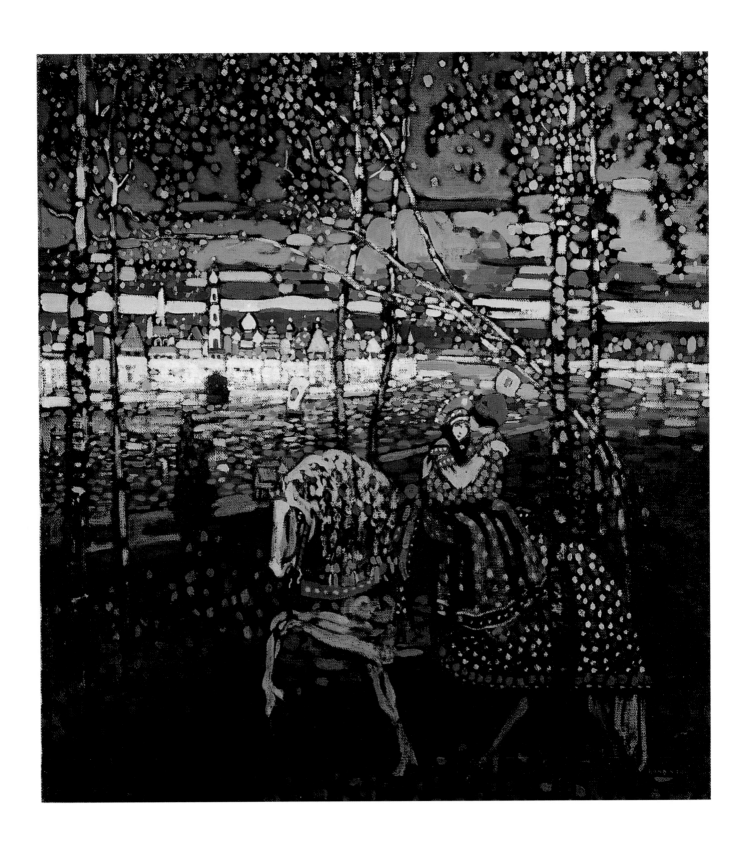

Beginnings in Munich

"A man who can move mountains." Thus Franz Marc described his friend and colleague Wassily Kandinsky, who revolutionized the art of our century with his ideas of a new pictorial language.

For as the founder of abstract painting Kandinsky released art from its traditional duty – namely, to provide a copy of the visible world. Although, in the early years of the twentieth century, there were other artists similarly experimenting with the dissolution of the object and the promotion of colour and form to means of expression in their own right, Kandinsky was the most logical and consistent in his pursuit of abstract means of expression. He made it his life's work to carry painting up to and over the threshhold of abstraction, whereby his artistic activities were always accompanied by theoretical reflections and insights.

Music, as a form of art free from all obligation to the outside world, thereby provided him with both a point of orientation and a yardstick in his observations on the "sounds" of colours. Kandinsky envied music its independence and the freedom of its means of expression, and he attempted to establish what he called a "theory of harmony for painting" comparable to that of music – an internal discipline which colours and forms were to obey.

All his life Kandinsky was a traveller between worlds. Born in Moscow in 1866, he spent the majority of his years in Germany and Paris. Yet he was Russian through and through. He viewed his beloved Moscow as the quintessence of everything Russian and the inspiration for all his artistic endeavours. The powerful emotions and intense impression of colour which swept over him at the sight of the roofs and onion domes of Moscow bathed in the evening light awoke in him the desire to capture the experience on canvas. The colour harmonies of the magical cityscape struck him like the sounds of different instruments and shook him to the depths of his soul:

"The sun dissolves the whole of Moscow into a single spot, which, like a wild tuba, set all one's soul vibrating... Pink, lilac, yellow, white, blue, pistachio green, flame red houses, churches, each an independent song – the garish green of the grass, the deeper tremolo of the trees, the singing snow with its thousand voices, or the *allegretto* of the bare branches, the red, stiff, silent ring of the Kremlin walls, and above, towering over everything, like a shout of triumph, like a self-oblivious hallelujah, the long, white, graceful, serious line of the Bell Tower of Ivan the Great...

Russian Beauty in a Landscape, c. 1904
Russische Schöne in Landschaft
Tempera, card, lined in dark grey,
41.5 x 28.8 cm
Munich, Städtische Galerie im Lenbachhaus

PAGE 6:
Couple Riding, 1906/07
Reitendes Paar
Oil on canvas, 55 x 50.5 cm
Munich, Städtische Galerie im Lenbachhaus

In the "romantic" pictures of his early Munich years Kandinsky returns to the magical Moscow of his childhood memories. His subjects are taken from the world of chivalrous knights and ancient legend. *Couple Riding* is a scene from an old Russian fairytale: the Knight bears home the beautiful Helena, whom he has just rescued from the clutches of the firebird. Kandinsky's costly, shimmering palette and impressionistic application of paint lend these pictures a poetic, symbolic character.

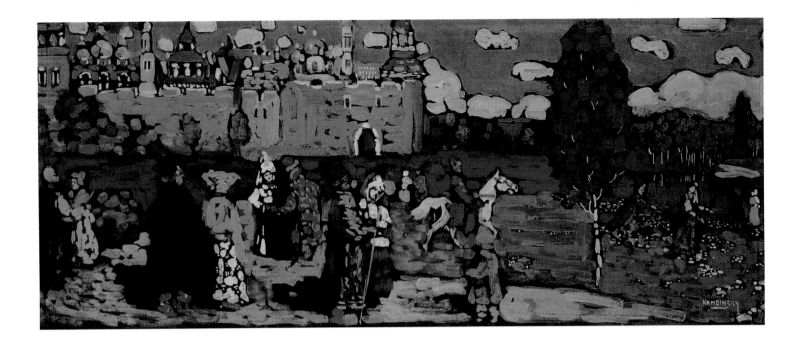

Russian Scene, 1904
Russische Szene
Tempera on card, 23 x 55 cm
Paris, Musée National d'Art Moderne,
Centre Georges Pompidou

This is not a picture of Russian life at the begin-
ning of the century, but an atmospheric folkloric
scene in which the originality and the magic of
Russian legends come to the fore. Kandinsky
produced a number of tempera paintings with
motifs of "Old Russia" while staying in Sèvres,
near Paris, where Russian art and music were
currently in great vogue.

PAGE 9 ABOVE:
Volga Song, 1906
Wolgalied
Tempera on card, 49 x 66 cm
Paris, Musée National d'Art Moderne,
Centre Georges Pompidou

PAGE 9 BELOW:
Colourful Life, 1907
Das bunte Leben
Tempera on canvas, 130 x 162.5 cm
Munich, Städtische Galerie im Lenbachhaus

To paint this hour, I thought, must be for an artist the most impossible,
the greatest joy."

The young Kandinsky lacked the confidence to embark upon an art-
istic career straight away, however. He saw art as something exalted and
unattainable, and considered his own abilities still too inadequate to be
able to express his feelings in pictures. Instead he did a degree in law,
combined with courses in economics, graduating at the age of 26. Yet
art, whether in the form of painting or music, continued to prove itself a
source of new and surprising insights. Visiting the Hermitage in St. Pe-
tersburg, he was fascinated by the division of Rembrandt's paintings into
areas of light and dark and discovered a "mighty chord" in the contrasts
between their colours. Wagner's music provided him with his first experi-
ence of a total work of art. At a performance of *Lohengrin,* the sounds of
the orchestra conjured up before his eyes the colours of a Moscow eve-
ning; he saw and heard the sunset hour he so longed to paint and real-
ized that painting could develop just such powers as music possesses.
Kandinsky had a particular capacity for synaesthetic experience. He did
not perceive colours solely in terms of objects, but associated them with
sounds which ranged in varying intensities from high to low and shrill to
muted.

Another profound experience occurred in Kandinsky's final year as a
law student in Moscow, when he saw a painting from Monet's *Haystacks*
series and – disconcertingly – failed to recognize the subject. This gave
him a first inkling that the power of colour could render the presence of
the object superfluous. Long before Kandinsky addressed himself syste-
matically to painting and focused his attention upon the problem of non-
objectivity in the picture, he unconsciously realized from this Impressio-
nist work that the force of the palette alone can determine the impact of a
picture. When he eventually came to renounce the object in his own art,
he would remember that fateful encounter with Monet.

In the light of these formative experiences, Kandinsky's decision to

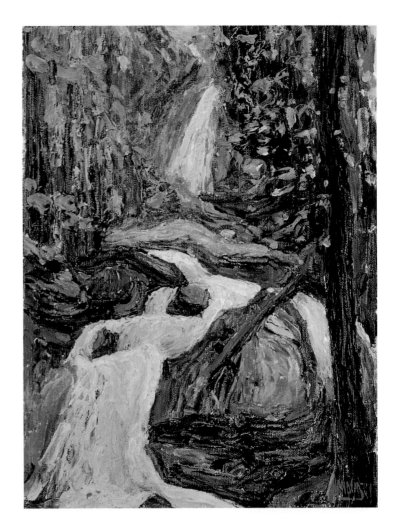

ABOVE LEFT:
Odessa – Port I, c. 1898
Odessa – Hafen I
Oil on canvas, 65 x 45 cm
Moscow, State Tretyakov Gallery

ABOVE RIGHT:
Kochel – Waterfall I, c. 1900
Kochel – Wasserfall I
Oil on canvas, 32.4 x 23.5 cm
Munich, Städtische Galerie im Lenbachhaus

RIGHT:
The Isar near Grosshesselohe, 1901
Die Isar bei Großhesselohe
Oil on canvas, 32.5 x 23.6 cm
Munich, Städtische Galerie im Lenbachhaus

Half realist, half Impressionist – Kandinsky's first oil paintings are tentative attempts to find a personal form of expression. Colour already plays a dominant role, forcing the object into second place. Kandinsky uses the palette knife to apply his paints in impastoed strips, making them "sing out" as powerfully as he can.

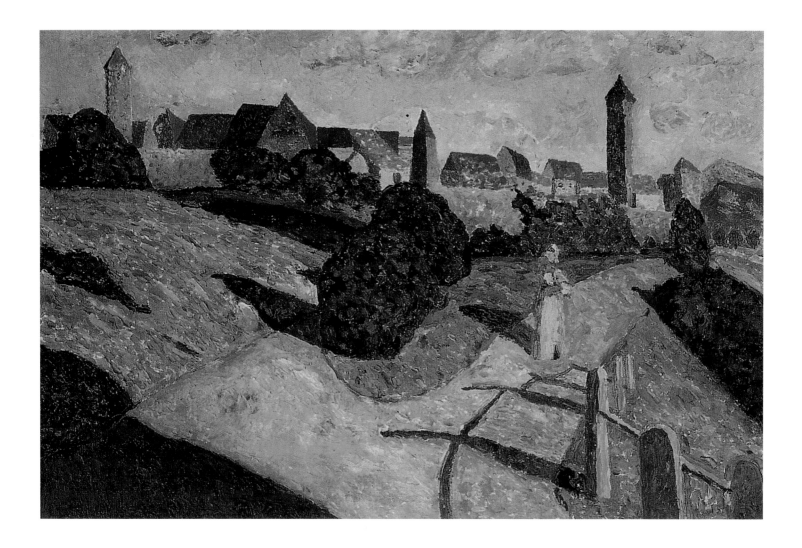

become a painter is not altogether surprising. By the time he left Moscow for Munich in 1896, he was no longer working as a lawyer, but as the director of a printing works specializing in art reproductions. It seems he had already abandoned the academic legal path for good.

Kandinsky was 30 when he went to Munich. Since the days of Ludwig I, the city on the Isar had enjoyed a reputation as a flourishing centre of the arts. It was there that Arnold Böcklin and Franz von Stuck celebrated their greatest triumphs, and there that the Munich Secession was founded in 1892, giving a platform to a group of progressive artists. The Secession embraced a wide spectrum of stylistic trends, ranging from academic historicism and naturalism to Impressionism and Symbolism. The artists of the Secession may have lacked a common programme, but they nevertheless managed to break away from the encrusted traditions of Academy exhibitions and brought a breath of fresh air into the Munich art scene.

Another contemporary movement rising to prominence in Munich was Jugendstil. Originating from the Arts and Crafts Movement in England, and the German counterpart to Art Nouveau in France and Belgium, Jugendstil took its name from the journal *Jugend (Youth)* founded in Munich in 1896. Jugendstil aimed to create a new consciousness of form which would replace the pomposity and obsessive detail of 19th-century historicism. Typical features of this new style included the use of power-

Old Town II, 1902
Alte Stadt II
Oil on canvas, 52 x 78.5 cm
Paris, Musée National d'Art Moderne,
Centre Georges Pompidou

"On good advice, I visited Rothenburg ob der Tauber… Only one picture has survived from this trip, *The Old Town*, which I painted from memory only after my return to Munich. It is sunny, and I made the roofs just as bright a red as I then knew how."
(Kandinsky in *Reminiscences*, 1913)

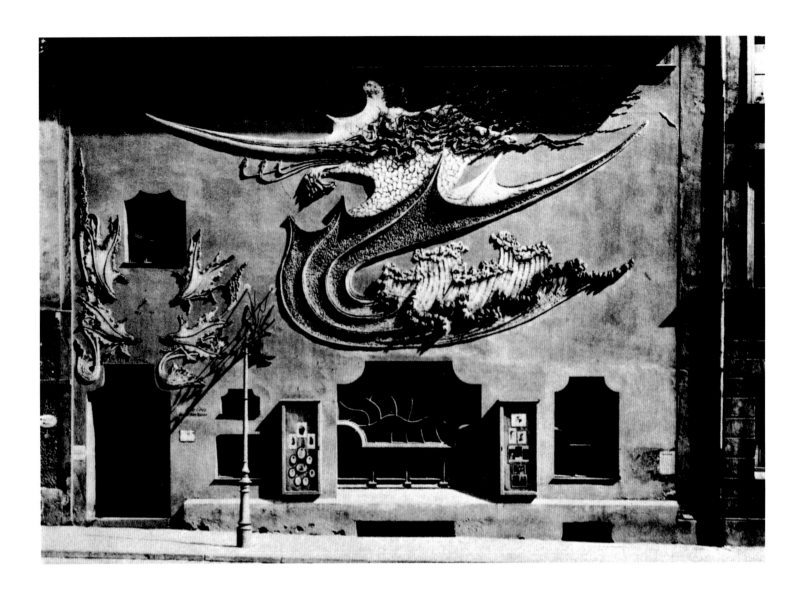

August Endell:
Façade, Elvira Hofatelier, Munich, 1896/97
Photograph

Jugendstil in Munich around 1900
Jugendstil brought a breath of fresh air into the
Munich art scene, which was still largely domin-
ated by 19th-century historicism. The new, or-
namental style, with its floreated and abstractive
motifs, rejected the representation of real objects
and promoted line to the chief element of design.

Hermann Obrist and Richard Riemerschmid:
Décor of a room in the villa of the Jugendstil ar-
tist Hermann Obrist, c. 1900/10
Elm and walnut furniture by Obrist, Riemer-
schmid and Bernhard Pankok
Munich, Münchner Stadtmuseum

Franz von Stuck:
The Villa Stuck with poplars
Photograph
Berlin, Ullstein Bilderdienst

Franz von Stuck, who worked in a symbolist
vein of Jugendstil, was Kandinsky's teacher in
1900. Stuck's ideal of an aesthetically designed
environment was not without influence upon his
pupil. Stuck's villa on the banks of the Isar
(above) was built entirely to his own designs,
from the ground plan right down to the details of
the interior decoration. Inside, Stuck's own paint-
ings formed the crowning glory of this total
work of art.

Paul Klee:
Sketch of the Villa Stuck in Munich
in a letter of 20 April 1900
Chinese ink on paper
Berlin, private collection

Although Paul Klee was a student under Stuck at
the same time as Kandinsky, the two did not ac-
tually become friends until later. Klee's carica-
ture shows a pupil respectfully approaching the
Villa Stuck in order to submit his work to the
famous master for comment.

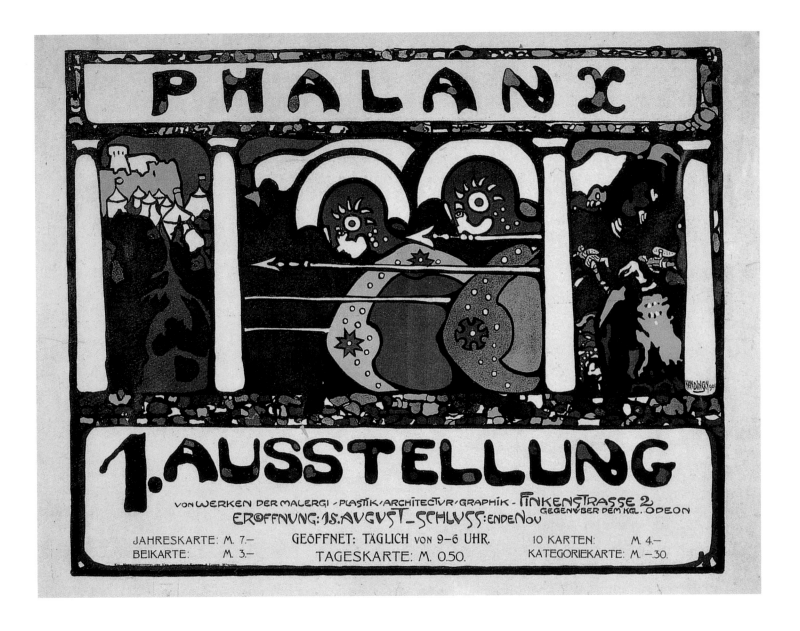

Poster for the 1. Phalanx Exhibition, 1901
Colour lithograph on paper, 47.3 x 60.3 cm
Munich, Städtische Galerie im Lenbachhaus

Phalanx was an association of artists founded by
Kandinsky in 1901. Its aim was to provide an ex-
hibition platform for artists who were underrep-
resented in the official Munich art-dealing world.
There were eleven Phalanx exhibitions alto-
gether. Kandinsky was interested above all in
publicizing works by the French Impressionists
and Neo-Impressionists. He particularly admired
Claude Monet, one of whose *Haystacks* series he
had earlier seen in Moscow.

ful undulating lines and decorative ornament entirely abstracted from the
representational world. The spokesmen for the reformist movement were
the young architect August Endell and the sculptor Hermann Obrist. En-
dell's designs for the Elvira Hofatelier of 1896/97 (p. 12) caused a scan-
dal in Munich, and his provocative thesis that "The greatest mistake one
can make is to believe that Art is the reproduction of Nature" was per-
ceived as an affront to the Munich art establishment.

Kandinsky arrived in Munich in 1896 accompanied by his young wife,
his cousin Anya Chimikian whom he had married in 1892. He began his
studies at the well-known art school run by the Yugoslav Anton Ažbè,
where his initial enthusiasm was rapidly dampened by the life classes;
drawing "smelly, apathetic, expressionless, characterless" models was
something he found thoroughly repellent. He took the life class for two
years nevertheless, but used every spare opportunity to paint vibrantly col-
oured landscape studies from nature. Such works led his fellow students to
classify him as a "colourist" and a "landscape painter", labels which
pained him, even though he admitted himself that he was much more at
home with colour than with drawing. "I was intoxicated with nature," he
later wrote, "again and again I tried to make colour carry first the chief

weight and subsequently the entire weight." Seeking to improve his drawing skills, he applied to join the class run by Academy professor Franz von Stuck, co-founder of the Munich Secession, who was at that time considered to be Germany's foremost draughtsman. This first application was rejected, but after a year of working on his own Kandinsky applied again, and this time was accepted into Stuck's painting class. Stuck praised Kandinsky's expressive drawings, but opposed his "extravagant use of colour" and advised him to spend a while working exclusively in black and white "so as to study form by itself". A lingering echo of Stuck's recommendations can perhaps be found in Kandinsky's later woodcuts and his colour drawings on a black ground. Kandinsky attended Stuck's classes for a year and benefitted in several ways from his teacher. "He cured my pernicious inability to finish a picture with one single utterance. He told me I worked too nervously, that I singled out the interesting bit straight away." Stuck taught him how to integrate his spontaneous creative ideas into the more routine aspects of the overall composition.

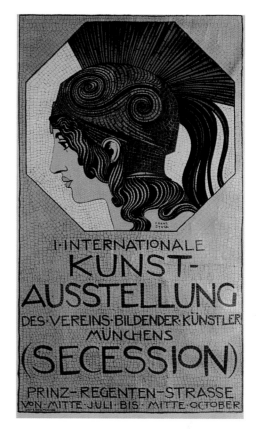

When Kandinsky left Stuck's atelier in the late autumn of 1900 he had been living in Munich for four years. We have almost no tangible evidence of his artistic activities during this period, however: apart from a few furniture designs in sketchbooks, no works have survived. Kandinsky had nevertheless learned much about the mechanics of exhibiting in the Bavarian capital, and had no doubt recognized how difficult it was to make a name for oneself as an artist within such a talented field of competition.

The founding of the artists' association Phalanx in May 1901 offered Kandinsky the opportunity not only to take part in exhibitions himself, but – even more importantly – to introduce the public to trends in art which were still underrepresented in Munich, namely Impressionism and Jugendstil. The members of Phalanx had met through Stuck's atelier and included, alongside Kandinsky, Stuck's studio assistant Ernst Stern, the puppeteer Waldemar Hecker and the sculptor Wilhelm Hüsgen. These last three were members of "Die Elf Scharfrichter" (The Eleven Executioners), a literary and artistic cabaret which, like Phalanx, rejected traditional artistic conventions and championed the ideals of the avant-garde. Kandinsky was particularly fascinated by one of the numbers performed in the cabaret, in which the artist Stern produced "musical drawings" by moving his pencil across a piece of paper to the rhythm of a piece of music.

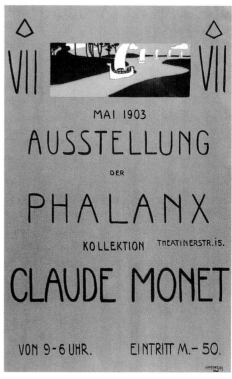

Kandinsky designed the poster for the first Phalanx Exhibition (p. 14). Although clearly inspired by an earlier poster by Franz von Stuck advertising the Munich Secession exhibition of 1893 (p. 15 above), it goes much further in its use of flat areas of colour and its degree of abstraction. Its forms are also more dynamic, as Kandinsky presents the phalanx of the avant-garde attacking the fortress of tradition.

The first Phalanx exhibition included unidentified works by Kandinsky, puppets and masks from the "Scharfrichter" cabaret, and a selection of decorative pieces. It was the first time that Kandinsky had stepped into the public arena, and it was clear from the start that he was eager to draw upon many different artistic trends in support of his aims. Phalanx also gave him his first opportunity to act as leader of a group of kindred spirits. In the Phalanx School of Painting founded soon afterwards he was also to reveal his talents as a teacher. Indeed, organization and teach-

ABOVE:
Franz von Stuck:
Poster for the International Art Exhibition held by the Munich Secession in 1893
Lithograph on paper, 61.5 x 36.5 cm
Munich, Münchner Stadtmuseum

BELOW:
Poster for the 7. Phalanx Exhibition, 1903
Colour lithograph on paper, 83.5 x 61.2 cm
Munich, Städtische Galerie im Lenbachhaus

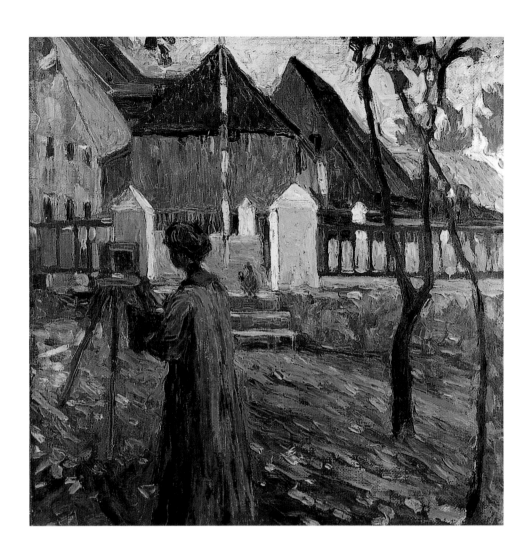

Gabriele Münter Painting in Kallmünz, 1903
Gabriele Münter beim Malen in Kallmünz
Oil on canvas, 58.5 x 58.5 cm
Munich, Städtische Galerie im Lenbachhaus

Kandinsky and Gabriele Münter in Kochel, 1902
Photograph
Munich, Gabriele Münter and Johannes Eichner
Foundation

ing were to become the main strands which would run alongside Kandinsky's artistic activities throughout his life. He was never solely a painter, but a theoretician, intermediary and organizer at the same time.

The Phalanx School of Painting was forced to close after just a year due to lack of students, but by then it had introduced Kandinsky to Gabriele Münter, who had registered as a pupil. Gabriele Münter became the intimate companion of Kandinsky's Munich years. As his confidante and critic, she partnered him through the crucial years of his artistic development, although she was ultimately unable to follow his path to abstraction in her own painting.

In 1903 Kandinsky began a series of extensive trips abroad, frequently in the company of his new companion. He had separated from his wife Anya and given up the apartment they had shared in Munich. His travels took him to Venice, Odessa, Tunis, Rapallo, Paris, Berlin and the South Tyrol. Some of these destinations probably coincided with exhibitions in which he was taking part; he regularly submitted works to the Berlin Secession and the Salon d'Automne in Paris, for example. This was also a period of exploration and experimentation with new means of artistic expression. The works which he produced between 1900 and 1908 are correspondingly unhomogeneous in nature, and as yet give no hint of the transformations that Murnau would bring.

A generous share of this early œuvre is made up of works in tempera in

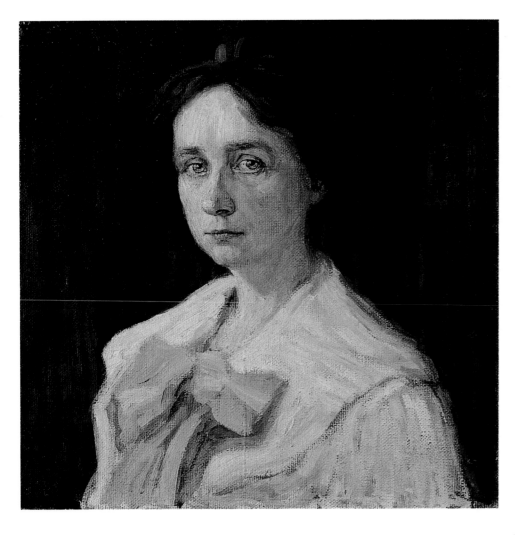

Gabriele Münter was one of the first women students at the Phalanx school, at which Kandinsky taught painting and life drawing. State art academies were still closed to women at that time. The pupil-teacher relationship developed into an intimate bond, and Gabriele Münter remained Kandinsky's companion until 1914.

"You are hopeless as a pupil," Kandinsky told Gabriele Münter. "One can't teach you anything. You can only do what is inside you. You have everything naturally. What I can do for you is protect and nurture your talent so that nothing comes to spoil it."

Portrait of Gabriele Münter, 1905
Bildnis von Gabriele Münter
Oil on canvas, 45 x 45 cm
Munich, Städtische Galerie im Lenbachhaus

which Kandinsky takes up themes from Russian folksong and legend. *Russian Beauty in a Landscape* (p. 7), painted around 1904, is a creation of Kandinsky's rhapsodic imagination. Against a dark background, a fairytale figure is seated within a fairytale landscape shimmering in a kaleidoscope of colours. Small dabs of paint build a mosaic-like surface and suggest a dream world lost in time and space. *Russian Scene* (p. 8) and *Volga Song* (p. 9 above) also appear to be taken from Russian folklore. For Kandinsky, these pictures were an expression of his homesickness for Russia: "In my use of line and distribution of coloured dots, I was trying to express the musical side of Russia. Other pictures from that period reflect the contradictory, later the eccentric aspects of Russia."

The large-format tempera *Colourful Life* (p. 9 below) equally belongs to the mythically transfigured world of fairytale. Here, however, the figures of romantic folklore have given way to a crowded wealth of characters and activities from secular and sacred Russian life. More than in other works from the same period, human figures have here become abstract colour ornaments. Kandinsky is perhaps recalling his impressions of a research trip to the province of Vologda, where the peasants in their colourful local costumes "ran around like brightly coloured, living pictures on two legs", and where he was profoundly struck by the "great wooden houses covered with carvings" and the "brightly coloured, elaborate ornaments" decorating every item of furniture and every object.

Gabriele Münter:
Portrait of Kandinsky, 1906
Porträt Kandinsky
Colour woodcut, 25.9 x 19 cm
Munich, Städtische Galerie im Lenbachhaus

17

Farewell (Large Version), 1903
Abschied (Große Fassung)
Colour woodcut, two blocks, 31.2 x 31.2 cm
Moscow, State Tretyakov Gallery

Woodcuts make up another significant proportion of Kandinsky's early œuvre. *The Singer* (p. 19), a colour woodcut of 1903, demonstrates the skill with which Kandinsky had already mastered this difficult medium. More than any other artistic technique, the woodcut demands a high degree of abstraction from nature and compels the artist to reduce his means of expression to condensed, flat forms and a few clear colour contrasts. *The Singer* combines the flowing lines of ornamental Jugendstil with a subdued, lyrical colouring. Kandinsky saw the woodcut as offering a direct parallel to a lyric poem. Like the Symbolist poets grouped around Stefan George and Karl Wolfskehl, he was convinced that all forms of art perceived via the sensory organs mutually overlap. *The*

ABOVE RIGHT:
Night (Large Version), 1903
Die Nacht (Große Fassung)
Colour woodcut, 29.4 x 12.5 cm
Munich, Städtische Galerie im Lenbachhaus

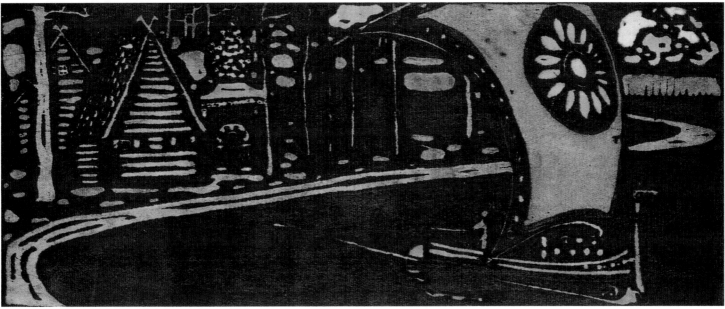

The Blue Rider, 1903
Der blaue Reiter
Oil on canvas, 55 x 65 cm
Zurich, private collection

The rider is a romantic fairytale figure from Kandinsky's Russian childhood. As Saint George, he combats evil and symbolizes battle and setting forth upon new adventures.

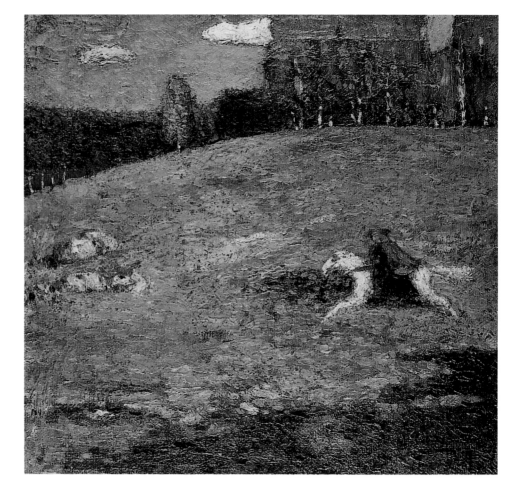

BELOW:
Untitled (Knight and Dragon), c. 1903/04
Ohne Titel (Ritter und Drache)
Pencil on paper
Munich, Städtische Galerie im Lenbachhaus

PAGE 19, ABOVE LEFT:
The Singer, 1903
Die Sängerin
Colour woodcut, three blocks, second state, 19.5 x 14.5 cm
Munich, Städtische Galerie im Lenbachhaus
PAGE 19, BELOW:
The Golden Sail, 1903
Das goldene Segel
Colour woodcut, two blocks, gold and stencil, third state, 12.7 x 29.7 cm
Munich, Städtische Galerie im Lenbachhaus

PAGE 21:
In the Forest, 1904
Im Walde
Mixed media on panel, 26 x 19.8 cm
Munich, Städtische Galerie im Lenbachhaus

Singer is thus intended as a synthesis of sound, image and word. We are shown the precise moment at which the pianist plays the first notes and the singer starts to sing – the moment of the first chord and the first sound. According to Kandinsky, the "inner sound" of a work of art must produce a corresponding resonance in the soul of the viewer. "In general, colour is a means of exerting a direct influence upon the soul. Colour is the keyboard. The eye is the hammer. The soul is the piano, with its many strings. The artist is the hand that purposefully sets the soul vibrating by means of this or that key."

This notion of a synthesis of the arts combining and concentrating all spiritual forces was widespread amongst the intellectual élite of the day. It went hand in hand with the idea that art alone could vanquish materialistic thinking. The role of conqueror of the material and non-spiritual fell to the "Blue Rider", a key figure in Kandinsky's iconography. The rider motif accompanies his work from its earliest beginnings right up to its dissolution into abstract forms. The rider thereby appears in many different guises: as a romantic fairytale figure, as a medieval knight embodying the virtues, as a secret messenger, as a trumpet-blowing herald, and as Saint George, saving humankind from evil. The rider is always a symbol of search and encounter, battle and embarkation upon new challenges. The motif appears in numerous woodcuts, drawings and paintings behind glass, and in 1912 inspired the title and cover design for the *Blaue Reiter Almanac (Blue Rider Almanac)*, one of the most important compilations of programmatic writings by artists to appear this century.

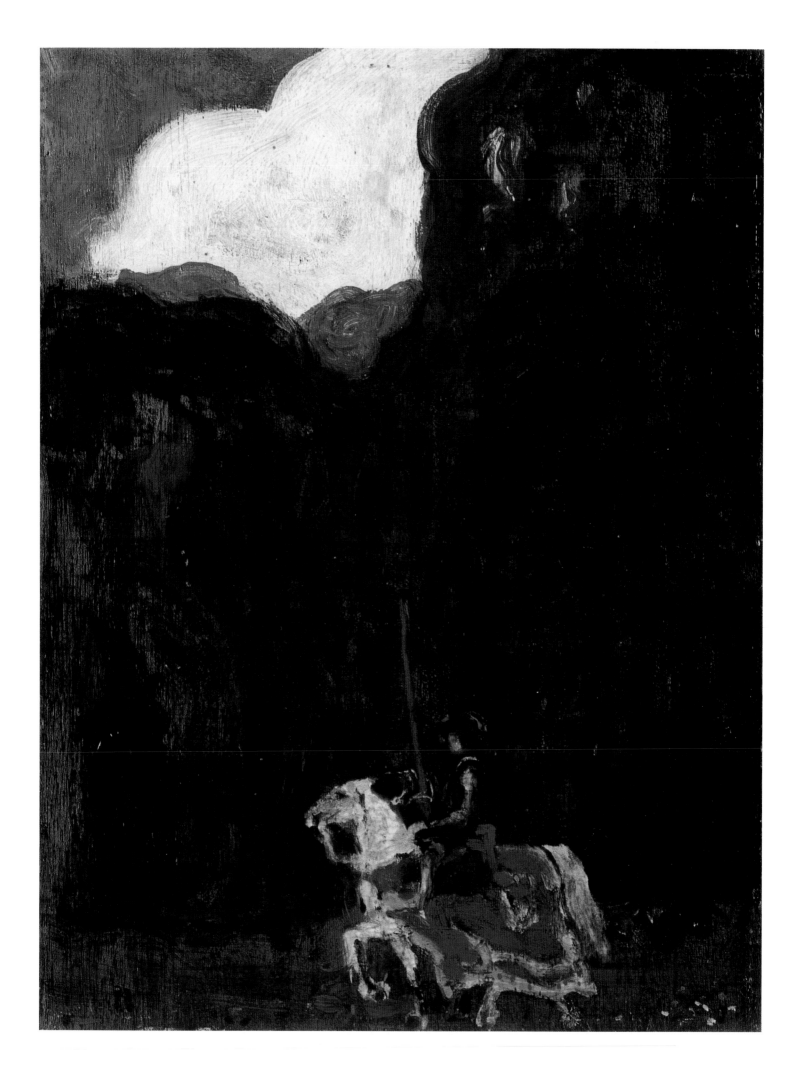

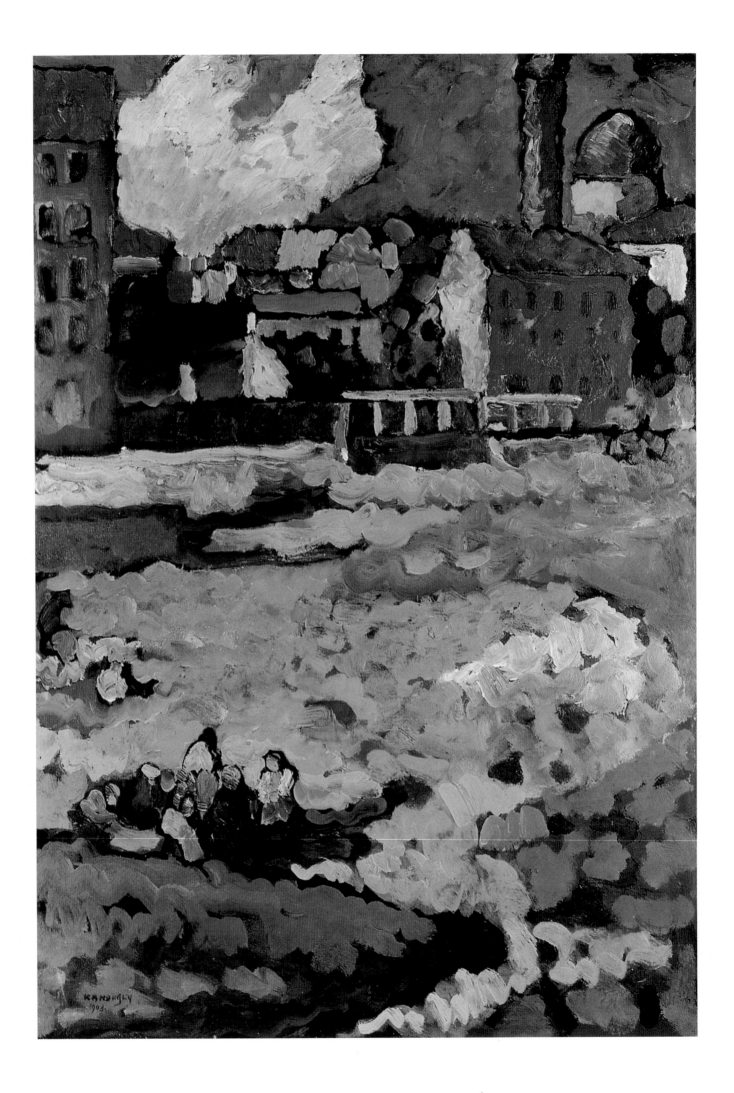

Embarking upon the journey to abstraction

After five years of extensive travelling throughout Europe, Kandinsky finally settled back in Munich in 1908. Behind him lay a period of artistic difficulties, personal problems, and even bouts of depression. His marriage to Anya Chimikian oppressed him, and his search for new pictorial means was proving painful and laborious. All these factors exacerbated his turbulent mental state, and during his last trip to Paris he almost had a nervous breakdown. Upon his return to Munich, he went first to a sanatorium to recuperate. In October 1908 Kandinsky and Gabriele Münter moved into a spacious apartment at 36 Ainmillerstraße, almost next door to Paul Klee, who was living at number 32. The two men would not properly become friends, however, until they reached the Bauhaus in the 1920s. For the next few years Kandinsky lived in Munich for all but the summer months; these he spent painting in the foothills of the Bavarian Alps, in the market town of Murnau where in 1909 Gabriele Münter bought a house.

For Kandinsky, Munich and Murnau marked the beginning of a phase of undisturbed creative activity. Apart from regular visits to his relatives in Odessa and Moscow, he was to make few other trips abroad until 1914. Instead he embarked upon an intensive exchange of ideas with artist colleagues, and in particular with his fellow Russians Alexei von Jawlensky and Marianne von Werefkin, who frequently came to paint in Murnau. Jawlensky, two years Kandinsky's senior, had also arrived in Munich from Russia in 1896 and had studied with Anton Ažbè, but had not made contact with Kandinsky until later. Jawlensky was undoubtedly the most "modern" of the Murnau group at that time. He had worked in Brittany and Provence in 1905 and knew Matisse personally. Kandinsky welcomed the stimulation offered by Jawlensky's views on art, although without adopting the latter's Synthetist style of painting, influenced by Paul Gauguin and the Pont-Aven School and characterized by powerful planes of colour heavily outlined in black.

Life in Murnau and Munich represented a new start for Kandinsky, both in artistic and in personal terms. He felt at home in the Murnau farmhouse and rediscovered the inner peace that had been missing for so long. He became an enthusiastic gardener and went for long walks in the nearby mountains. He designed elements of the décor and furnishings for the house in Murnau, including furniture decorated with folkloric ornaments and a frieze of stylized flowers and riders for the banisters, which

Gabriele Münter:
Kandinsky in a suburb of Munich
Photograph
Paris, Musée National d'Art Moderne,
Centre Georges Pompidou

PAGE 22:
Munich – Schwabing with St. Ursula's Church,
1908
München – Schwabing mit Ursulakirche
Oil on card, 68.8 x 49 cm
Munich, Städtische Galerie im Lenbachhaus

St. Ursula's church lay only two blocks from the Ainmillerstrasse, and this picture may therefore capture a view from Kandinsky's apartment. The loose brushwork and powerful palette point to French influences. Kandinsky uses the large patch of empty ground in the centre of the composition as the starting-point for a free and subjective exploration of form and colour.

he painted himself using a stencil. He also began writing prose-poems, composing 38 altogether between 1908 and 1912. In 1913 these were published by the Piper Verlag under the title *Sounds* (*Klänge*), accompanied by colour and black-and-white woodcuts (cf. p. 110). In these Dadaistic poems, Kandinsky employs a method borrowed from young children's early attempts at speech: through constant repetition and babbling words are emptied of their meaning, so that only the pure sound remains. It is Kandinsky's aim to uncover this "pure sound" of language, the sound which "sets the soul vibrating".

His painting from this era displays clear parallels with Paul Cézanne. It was Cézanne's belief that, rather than remaining at the level of superficial reality and capturing the fleeting atmosphere of the moment, the artist should look beyond the surface to where "perhaps nothing, perhaps everything is". Cézanne's recommendation that the artist should sit in front of nature and view it "like a dog", without aim or prejudice but simply registering, is comparable to Kandinsky's notion of childish sounds ungoverned by the mind. But whereas Cézanne was thinking solely in terms of our experience of colour ("Colour is the place where our mind and the universe meet"), Kandinsky extended the principle to all forms of sensory perception, in the spirit of a synthesis of the arts. Thus colour, word and sound were to interact in a manner unfiltered by the mind, and thereby raise the mind to a higher sphere of perception.

Just as his *Sounds* were artistic formulations far removed from traditional poetry, Kandinsky also devised abstract stage productions during these Murnau years which were similarly distinct from conventional forms of theatre. He gave these scenic compositions titles such as *The Yellow Sound*, *Black Figure*, *Black and White*, and *Green Sound*. These compositions employed a variety of expressive means, including the sound of the human voice and of instruments, "physical-psychological sound" (movement, wild dancing), and colour sound. Colour sound – in the form of coloured light – played the largest role, reinforced and intensified by the two other types of sound, which were performed simultaneously. What was unusual about these works, which contemporaries described as the boldest and most adventurous happenings in the field of the theatrical arts, was that they employed their expressive means free of all "practical" purpose: the voices carried no message, but simply created an atmosphere which Kandinsky hoped would make the soul receptive to new and intense experiences.

Measured against his theories and the avant-garde, inter-disciplinary nature of *Sounds* and his abstract theatre pieces, Kandinsky's painting from the early Murnau years appears almost conventional. A number of works from 1908, including *Houses in Munich* (p. 26), *Munich–Schwabing with St. Ursula's Church* (p. 22) and *Autumn Study near Oberau* (p. 32) recall earlier, impressionistic studies which still deferred to the rules of perspective. Others, such as *Winter I* (p. 33), employ the romantic, fairytale palette and dappled brushwork reminiscent of the tempera works of around 1906. The influence of the Fauves is also clearly visible in Kandinsky's pictures. The Fauves had exhibited for the first time as a group in 1905, at the Salon d'Automne in Paris in which Kandinsky and

Kandinsky in Bavarian costume, Murnau, c. 1908/09
Photograph
Munich, Gabriele Münter and Johannes Eichner Foundation

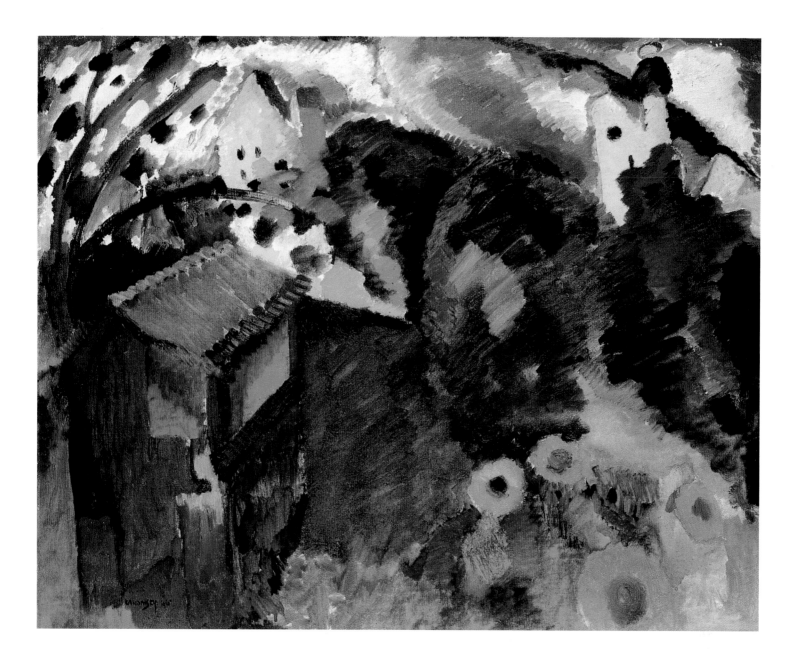

Jawlensky had also taken part. The expressive colouring of Matisse, Dufy and de Vlaminck now became a means, in Kandinsky's hands, to render the object increasingly insignificant.

Kandinsky drew closer to his ultimate goal, abstraction, by a variety of paths. In some pictures, for example, he allows a spatial impression of foreground, middle distance and background to remain (*Murnau – Landscape with Tower*, p. 31), but dissolves the individual elements of nature into a composition of luminous colour zones. Although the overall picture is still read as a landscape, its relationship to reality is weakened by its unnatural palette and the pronounced structuring of its paint. The expressive brushwork of *Riegsee – Village Church* (p. 30), which also dates from 1908, produces a similar effect: the centre of the composition disintegrates into a confusion of bold colour planes bearing no direct reference to the representational world. "I had little thought for houses and trees, drawing coloured lines and blobs on the canvas with my palette knife, making them sing just as powerfully as I knew how." Forms and colours tended increasingly to sound independent chords. Kandinsky drew inspiration from the performance of *Lohengrin* he had heard as a student in

Murnau – Garden I, 1910
Murnau – Garten I
Oil on canvas, 66 x 82 cm
Munich, Städtische Galerie im Lenbachhaus

After several unsettled years of travelling and the distractions of city life, the Bavarian market town of Murnau offered the artist a haven of peace and seclusion. Here Kandinsky's style embarked upon a profound transformation, increasingly freeing itself from the conventions of perspective and absolving colour from all fidelity to the object. *Murnau – Garden I* is a characteristic example of this transitional phase. Kandinsky shows us the view from his garden, looking across to a wooden barn and the houses of Murnau. Conventional perspective has here given way to a two-dimensional manner of representation.

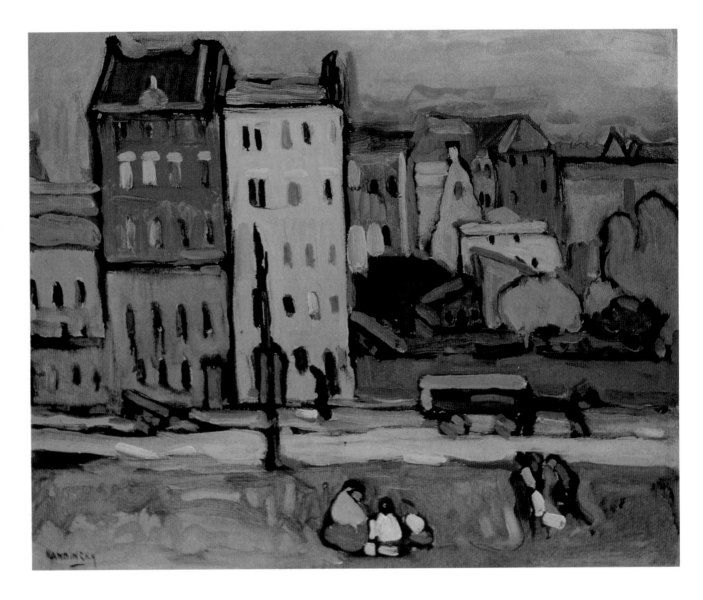

Houses in Munich, 1908
Häuser in München
Oil on card, 33 x 41 cm
Wuppertal, Von der Heydt-Museum

This is probably a view of the Hohenzollern-
straße as seen from Kandinsky's window.
Perspective and object have not yet started to
dissolve.

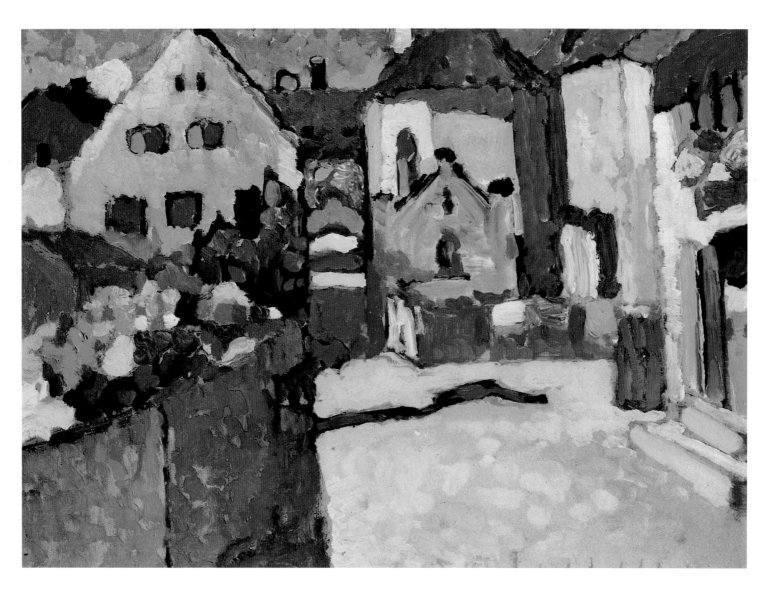

Grüngasse in Murnau, 1909
Oil on card, 33 x 44.6 cm
Munich, Städtische Galerie im Lenbachhaus

Although here, too, perspective is still intact,
Kandinsky now employs a striking palette whose
powerful, impastoed colours serve more than the
simple description of objects.

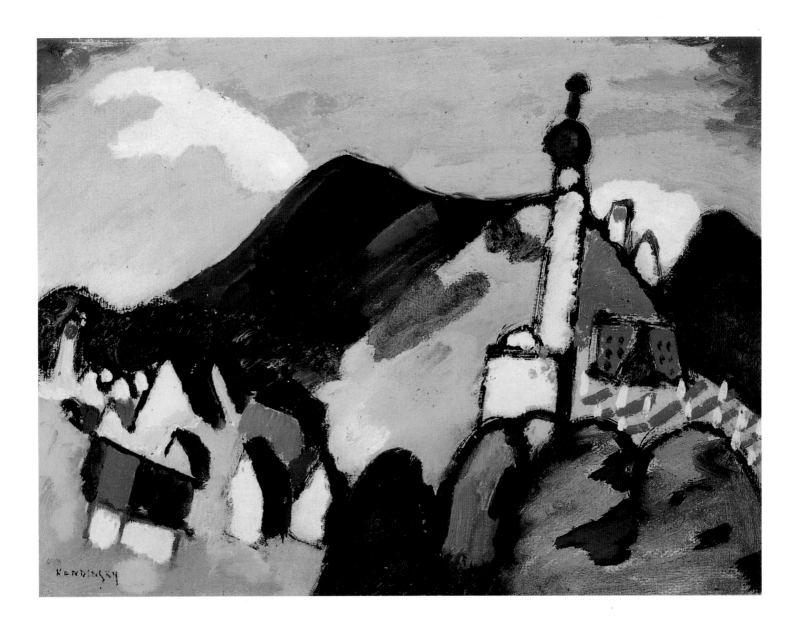

Study for **Murnau with Church II**, 1910
Murnau mit Kirche II
Oil on card, 32 x 44 cm
Private collection, on loan to the Franz-Marc-
Museum, Kochel am See

Kandinsky explored the motif of the town of
Murnau, nestled in the foothills of the Bavarian
Alps, in numerous sketches, studies and oil paint-
ings. Here, the elements of the landscape appear
as clearly-outlined planes which are stacked one
behind the other. In the portrait-format painting
opposite, however, outline and stacking are
gone; the landscape dissolves into a billowing
cloud of colour, from which the church tower
rises as the only visible remnant of the figurative
world.

PAGE 29:
Murnau with Church I, 1910
Murnau mit Kirche I
Oil on cardboard, 64.7 x 50.2 cm
Munich, Städtische Galerie im Lenbachhaus

Moscow, during which it became clear to him that "painting could de-
velop just such powers as music possesses".

The experience that Kandinsky had previously acquired in various art-
istic techniques now proved its worth. His intensive handling of the wood-
cut was particularly helpful in freeing his style. He transferred the ele-
ments of the woodcut – its planarity, linearity, saturated colouring and
"non-colours" of black and white – to oil painting. Thus *Murnau – View
with Railway and Castle* (p. 36) of 1909 reveals a strikingly flattened per-
spective. Although the picture still contains a few narrative elements,
such as the girl waving, the telegraph poles and the steam from the en-
gine, the composition is nevertheless increasingly freer and its im-
pressions of nature increasingly more subjective. The right half of the pic-
ture in particular seems to dissolve into patches of colour which can no
longer be attached to an object or fixed in space. The contrast between
the planes of saturated, impastoed colour and the black of the train lend
the painting an inner dynamism and make it sing out.

The motif of the train was not new: as a symbol of speed and progress,
it had already fascinated the Impressionists. For Kandinsky, the trains
which thundered past his Murnau garden inspired in him the desire to

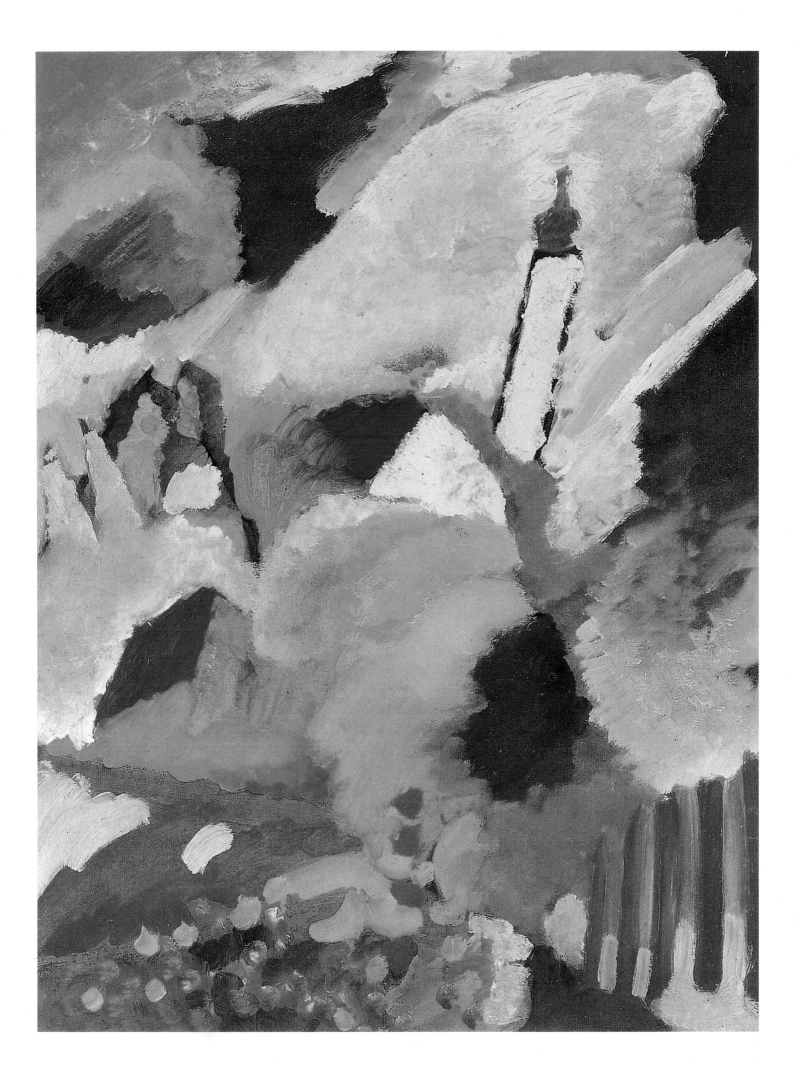

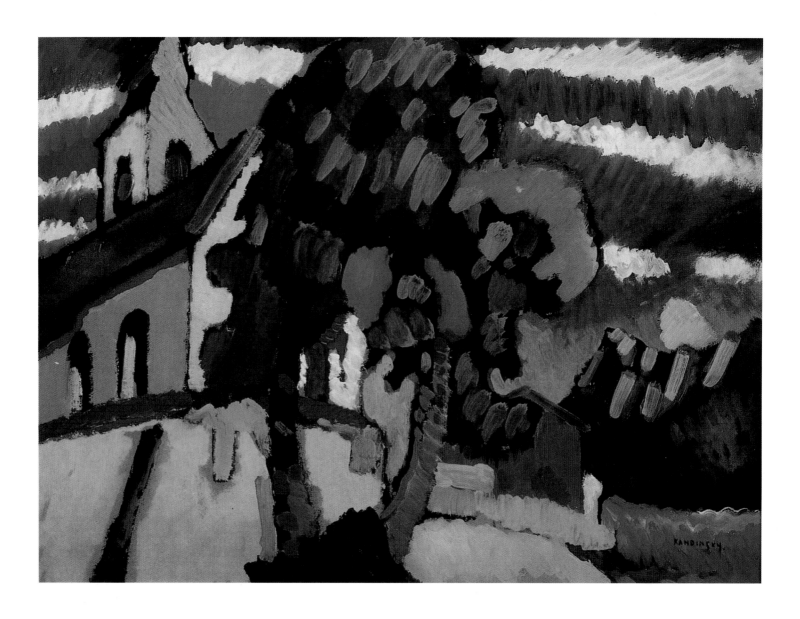

Riegsee – Village Church, 1908
Riegsee – Dorfkirche
Oil on card, 33 x 45 cm
Wuppertal, Von der Heydt-Museum

capture this multisensory experience of noise, light and shadow, dynamism and personal impressions in a vehement statement of colour.

Kandinsky was not the only artist attempting to break through the façade of the representational world in his pictures. Back in the 1880s, Vincent van Gogh had sought to bring objects of nature to life on his canvas by employing colours of maximum intensity, and thus to find truth in subjective and immediate expression. Cézanne, on the other hand, wanted to overcome the chance element in appearances and to fathom the laws of perception ("I proceed by studying Nature, in that I logically develop what we see and feel.") Cézanne's aspiration towards objective truth made him the forerunner of Cubism, whereas van Gogh prepared the ground for Expressionism. Kandinsky followed the path of neither, however. He admired both Picasso and Matisse and the daring colours of the Fauves, and must also have sympathized with the painter and theoretician Maurice Denis, one of the precursors of the Symbolist movement, who made the famous statement: "A picture – before being a horse, a nude or an anecdotal subject – is essentially a flat surface covered with colours arranged in a certain order." Kandinsky's attention was probably drawn to such theories by his compatriot Jawlensky, who was in close contact with the French art scene.

The concept of a non-objective style of painting in which colours and forms produced a comparable effect to music had long been on Kandinsky's mind. His encounter with Monet's *Haystacks* in an exhibition in Russia was later followed by a similar experience with one of his own pictures in Munich, providing him with fresh confirmation that the object represented a disturbing element in his pictures:

"Much later, after my arrival in Munich, I was enchanted on one occasion by an unexpected spectacle that confronted me in my studio. It was the hour when dusk draws in. I returned home with my painting box… and suddenly saw an indescribably beautiful picture, pervaded by an inner glow. At first, I stopped short and then quickly approached this mysterious picture, on which I could discern only forms and colours and whose content was incomprehensible. At once, I discovered the key to the puzzle: it was a picture I had painted, standing on its side against the wall. The next day, I tried to recreate my impression of the picture from the previous evening by daylight. I only half succeeded, however; even on its side, I constantly recognized objects, and the fine bloom of dusk was missing. Now I could see clearly that objects harmed my pictures."

Kandinsky, as is clear from his theoretical writings, viewed painting as something "spiritual", something which went beyond that which can be

Kandinsky applies his powerful, suggestive colours in broad brushstrokes placed at conflicting angles. Blue-violet finds its complementary in warm yellow, red in saturated green. The landscape has become merely the starting-point for an exercise in colour. The true subject of the painting is now the power of the individual colours, their mutual interplay and their impact upon the viewer.

Murnau – Landscape with Tower, 1908
Murnau – Landschaft mit Turm
Oil on card, 75.5 x 99.5 cm
Paris, Musée National d'Art Moderne,
Centre Georges Pompidou

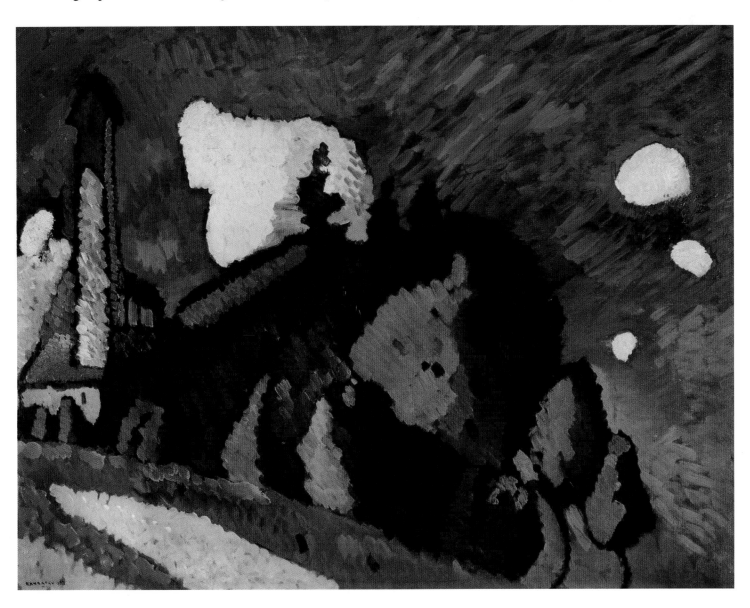

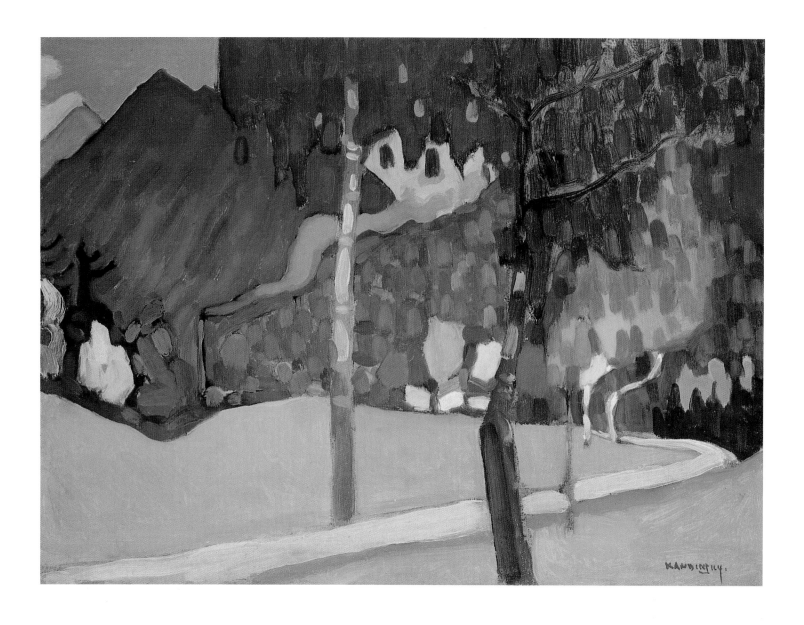

Autumn Study near Oberau, 1908
Herbststudie bei Oberau
Oil on card, 32.8 x 44.5 cm
Munich, Städtische Galerie im Lenbachhaus

established by logic and perceived with the senses. He attempted to probe "what holds the world together at its innermost core" and sought to uncover the relationships between the individual branches of art. Freeing painting from the world of recognizable objects offered him a means of drawing closer to the secret of "the spiritual in art".

Even though Kandinsky's goal seemed to lie directly before his eyes, with the road to abstraction clearly signposted, the works which he produced between 1908 and 1910 form an unhomogeneous group and draw upon a number of different sources. Alongside French influences, reflected in Kandinsky's use of a freer, flatter pictorial structure and luminous colours, Bavarian glass painting provided a new source of inspiration for both Kandinsky and Gabriele Münter. The traditional art of painting behind glass was widespread in the Lake Staffel region, and it was probably there that Gabriele Münter discovered it. It reminded Kandinsky of his first encounter with folk art in Vologda province. Writing of the ornaments he saw decorating every object, he wrote: "They were never petty and so strongly painted that the object within them became dissolved." Votive Bavarian folk art struck the Murnau painters as authentic and still unaffected by fashionable trends or commercial considerations.

Kandinsky adopted the two-dimensionality and, in particular, the linear elements of glass painting – the fine, frequently black outlines of its forms and figures – into his own art. Indeed, line as a pictorial element would play a major role in his later works, and in 1925 he made a special study of the line and its function in the picture in *Point and Line to Plane,* one of the Bauhaus book series.

In 1909, alongside studies from nature, Kandinsky began to produce pictures in which, for the first time, motifs and objects appear mysterious and cryptic. This tendency towards concealment, towards hiding his true self, is something which emerges in his letters: "I hate it when people see what I'm really feeling," he had written to Gabriele Münter as far back as 1904. A year later his sentiments were equally strong: "Sometimes I'd like to be utterly alone in the world, estranged from the whole world, perhaps enemies with it…. Out of society with me! Absolute solitude!… No one understands me… I feel, think, dream, always want to be different from the others."

His graphic works, the woodcuts which he published under the title *Poems without Words* and *Xylographs*, were similarly full of fantastical flourishes and encoded feelings, imbued with memories of Russia and difficult to interpret. *Picture with Archer* (p. 45) is one such heavily encrypted work featuring a number of motifs from earlier compositions – a rider, human figures, a city skyline and a mountain. The symbolism of the mounted archer, turning to aim at something behind him, is unmistakable: freedom from encrusted tradition and the ballast of the past. The dappled roofs and domes of the buildings clustered against a black ground just left of centre recall the romantic tempera paintings of Russian scenes dating from Kandinsky's early Munich period. However, these identifiable objects are forced into the background by the suggestive power of the surrounding colours and forms. The expressiveness and in-

Winter I, 1909
Oil on card, 75.5 x 97.5 cm
St. Petersburg, Hermitage

Pink, light violet, deep blue and green make up the unnatural palette of this wintery Murnau scene. Although the composition remains conventional, the colours infuse the landscape with a mysterious, dreamlike atmosphere.

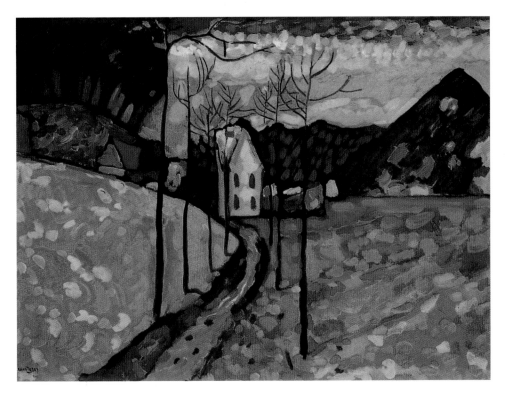

The rider holds a key position in Kandinsky's pictorial language of the Munich years. The rider represents the seeker and the herald; he is the symbol of embarkment upon a new era – an era in which the task of art is to open up new "spiritual" worlds, and to guide humankind to experiences and sensory perceptions of even greater intensity.

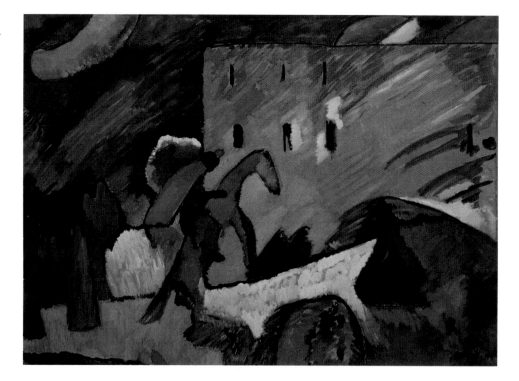

Improvisation 3, 1909
Oil on canvas, 94 x 130 cm
Paris, Musée National d'Art Moderne,
Centre Georges Pompidou

Landscape with Trumpet-blowing Rider,
1908/09
Landschaft mit Trompete blasendem Reiter
Ink brush and blue pencil on paper,
16.5 x 20.9 cm
Munich, Städtische Galerie im Lenbachhaus

PAGE 35:
The Blue Mountain, 1908/09
Der blaue Berg
Oil on canvas, 106 x 96.6 cm
New York, The Solomon R. Guggenheim Museum, Gift of Solomon R. Guggenheim, 1941

ternal tension of the composition are underlined by the diagonal hatching of the paint and the black contours outlining the planes, and are further heightened by the contrasting palette of bright, almost harsh colours and dark gradations of greenish-black.

1909 can be seen as a transitional year in Kandinsky's œuvre, producing both naturalistic landscapes such as *Murnau – View with Railway and Castle* (p. 36) and compositions in which the representational world is presented in an increasing state of disintegration.

Another series of pictures painted in 1909 may perhaps be traced back to the trip to Tunis which Kandinsky had made four years previously. Bearing titles such as *Oriental* (p. 46) and *Improvisation 6 (African)* (p. 41), these pictures are characterized by a very bright, garish palette which is dominated by the primaries red, yellow and blue in very slight modulations. The use of white as a contrasting element heightens the overall colour intensity. The figures are presented purely schematically; they are no longer based on observed reality but on formal relationships. There is a striking similarity between Kandinsky's *Improvisation 6* of 1909 and a picture by the painter Adolf Hoelzel entitled *Composition in Red I* (p. 40), dating from 1905. Hoelzel, spokesman of the New Dachau School, had already developed a stylized form of landscape painting by the start of the century. Even more significantly, however, he had also investigated the geometrical principles employed in artistic compositions and proposed theories on the creation of internal pictorial tensions. Hoelzel and Kandinsky did not know each other personally in the early 1900s, but since Hoelzel regularly exhibited at the Munich Secession and had published numerous theoretical writings, Kandinsky would undoubtedly have known of his work. In *Composition in Red I*, Hoelzel attains a degree of abstraction which Kandinsky would not reach for some years to come.

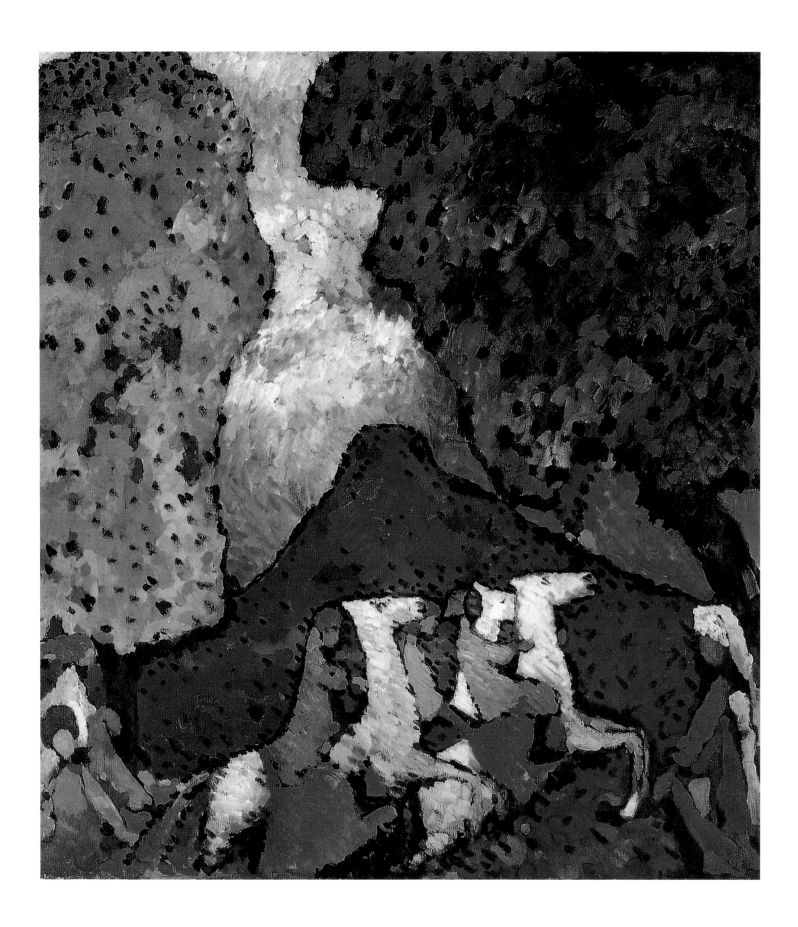

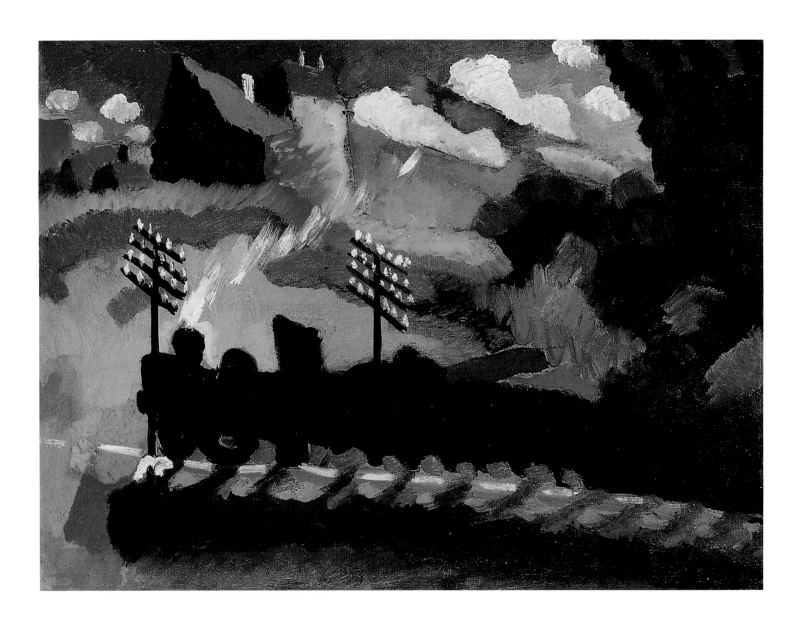

Murnau – View with Railway and Castle, 1909
Murnau – Ansicht mit Eisenbahn und Schloß
Oil on card, 36 x 49 cm
Munich, Städtische Galerie im Lenbachhaus

Kandinsky, perhaps more than other artists, gave written accounts of his artistic development throughout his life. In 1914, for example, he was invited to speak at the opening of an exhibition of his work in Cologne; he declined to appear in person, but sent instead the typescript of a lecture to be delivered on his behalf:

"My process of development," Kandinsky wrote, "consists of three periods:

1. The period of dilletantism, my childhood and youth, with its uncertain, for the most part painful emotions and, to me, incomprehensible longing." This period in Kandinsky's life was dominated by two simultaneous but fundamentally different impulses, namely a love of nature, and the indefinite stirrings of the urge to create. "This love of nature consisted principally of pure joy in and enthusiasm for the element of colour. I was often so strongly possessed by a strongly sounding, perfumed patch of blue in the shadow of a bush that I would paint a whole landscape merely in order to fix this patch... At the same time I felt within myself incomprehensible stirrings, the urge to paint a *picture*. And I felt dimly that a picture can be something other than a beautiful landscape, an interesting and picturesque scene, or the portrayal of a person. Because I loved

colours more than anything else, I thought even then, however confusedly, of colour composition, and sought that objective element which could justify the [choice of] colours.

2. The period after leaving school.

It soon appeared to me that past ages, having no longer any real existence, could provide me with freer pretexts for that use of colour which I felt within myself. Thus, I chose first medieval Germany, with which I felt a spiritual affinity... I also created many things from within myselfy... freely from memory and according to my mental picture. I was far less free in my treatment of the 'laws of drawing'... I saw with displeasure in other people's pictures elongations that contradicted the structure of the body, or anatomical distortions, and knew well that this would not and could not be for me the solution to the question of representation. Thus, objects began gradually to dissolve more and more in my pictures. This can be seen in nearly all the pictures of 1910.

3. The period of conscious application of the materials of painting, the recognition of the superfluousness, *for me*, of real forms, and my painfully slow development of the capability to conjure from within myself not only content, but also its appropriate form – thus the period of transition to pure painting, which is also called absolute painting, and the attainment of the abstract form necessary for me."

Here Kandinsky is referring to the period around 1912. A little further on in the same paper, he explains the significance of the object in his pictures of around 1910 in greater depth:

"As yet, objects did not want to, and were not to, disappear altogether from my pictures...[since] objects, in themselves, have a particular spiritual sound, which can and does serve as the material for all realms of art.

Landscape near Murnau with Locomotive, 1909
Landschaft bei Murnau mit Lokomotive
Oil on card, 50.4 x 65 cm
New York, The Solomon R. Guggenheim Museum

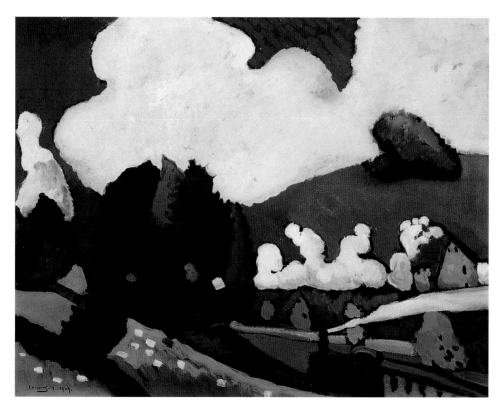

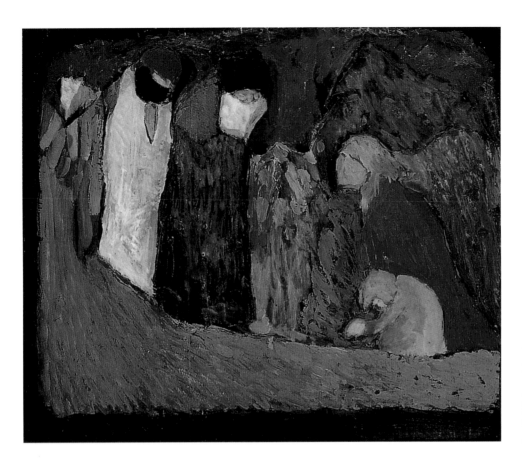

Encounter, c. 1908/09
Begegnung
Woodblock, carved, painted in oils,
36.5 x 42.5 x 3.5 cm
Munich, Städtische Galerie im Lenbachhaus
On permanent loan from the Gabriele Münter
and Johannes Eichner Foundation

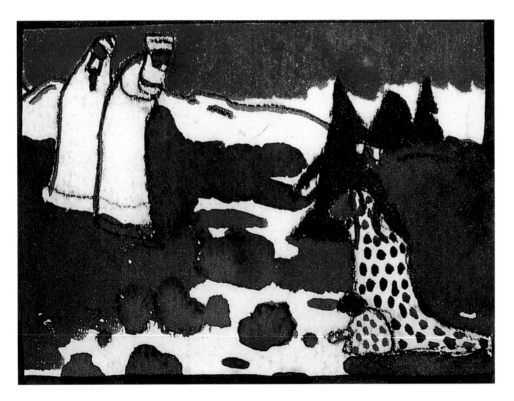

The motif of the meeting or encounter was one
that Kandinsky took up on several occasions dur-
ing this period, using a variety of artistic media
and techniques. He deliberately suppresses the
originally strongly religious connotations of the
motif, and concentrates instead in these composi-
tions upon the disposition of colour and line,
which he uses to convey the situation of the
figures in an informal manner.

Figures and Child in a Landscape, 1908/09
*Landschaft mit sich begegnenden Gestalten und
Kind*
Watercolour over charcoal and pencil on paper,
12 x 15.5 cm
Munich, Städtische Galerie im Lenbachhaus

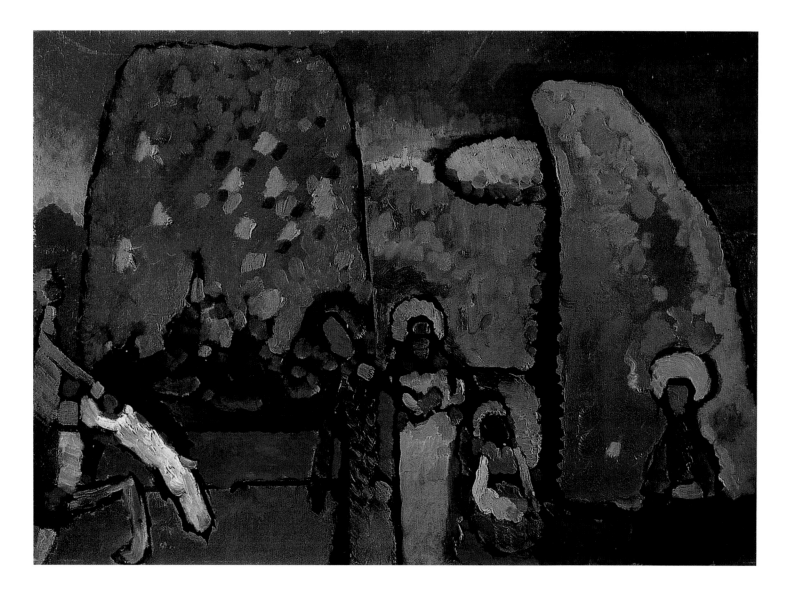

Study for *Improvisation 2 (Funeral March)*,
1909
Improvisation 2 (Trauermarsch)
Oil on card, 50 x 69.5 cm
Munich, Städtische Galerie im Lenbachhaus

And I was still too strongly bound up with the wish to seek purely pictorial forms having *this* spiritual sound. Thus, I dissolved objects to a greater or lesser extent within the same picture, so that they might not all be recognized at once and so that these emotional overtones might thus be experienced gradually by the spectator, one after another. Here and there, purely abstract forms entered of their own accord, which therefore had to produce a purely pictorial effect without the above-mentioned coloration. In other words, I myself was not yet sufficiently mature to experience purely abstract form without bridging the gap by means of objects. If I had possessed this ability, I would already have created absolute pictures at that time."

The need to raise public awareness at a time of dramatic artistic change, to play an active role in the spread of new ideas and to demonstrate them in art, led in early 1909 to the foundation of a new exhibiting society in Munich. The Neue Künstlervereinigung München (New Artists' Association of Munich) included the Murnau friends Kandinsky, Münter, Jawlensky and Werefkin, as well as Alfred Kubin, Adolf Erbslöh and Alexander Kanoldt. Paul Baum and Karl Hofer also joined during the course of the year, together with Vladimir Bekhteev, Erna Bossi, Moshe Kogan and the dancer Alexander Sakharov. A relatively large association with an international membership, the Neue Künstlervereinigung staged

Adolf Hoelzel:
Composition in Red I, 1905
Komposition in Rot I
Oil on canvas, 68 x 85 cm
Hanover, Sprengel Museum

its first exhibition in December of that year in the Thannhauser gallery in Munich. Kandinsky designed the poster, logo and membership card for the association (pp. 50 and 51) as well as composing an opening statement of its aims:

"Our point of departure is the belief that the artist, apart from the impressions that he receives from the world of external appearances, continually accumulates experiences within his own inner world. We seek artistic forms that should express the reciprocal permeation of all these experiences – forms that must be freed from everything incidental, in order powerfully to pronounce only that which is necessary – in short, artistic synthesis. This seems to us a solution that once more today unites in spirit increasing numbers of artists."

The purpose of the Neue Künstlervereinigung, according to its constitution, was "to hold art exhibitions in Germany and abroad and to accompany these with lectures, publications and similar means". The Neue Künstlervereinigung held three exhibitions altogether, all of which opened in Munich and subsequently toured to other German cities. At the first exhibition Kandinsky showed *Picture with Rowing Boat* and other works, while Jawlensky submitted his portrait of Sakharov entitled *The White Feather* (p.52). A number of foreign guests were invited to the second exhibition in the autumn of 1910, including Mogilevsky and the Burliuk brothers from Russia, and Braque, Derain, van Dongen, Rouault, Picasso and de Vlaminck from France. This was the first time that the international character of the new movement had been properly demonstrated in Germany.

The critics reacted with violent and dismissive derision to both exhibitions, condemning them as "carnival clowning" and an "artist's joke". There were references to "shameless bluffers" and a "horde of dabblers".

These two pictures, painted four years apart, reveal an astonishing similarity in their degree of abstraction. Neither artist has here fully taken the step from naturalism to pure abstraction, however. Adolf Hoelzel's interest in the formal relations within pictures began very early, and in 1901 he published the essay "On Form and the Distribution of Mass in the Picture" in the Jugendstil magazine *Ver Sacrum*. There he set out his theories on formal pictorial composition – ideas which would only be explored much later by Kandinsky in his Bauhaus book *Point and Line to Plane*.

PAGE 41:
Improvisation 6 (African), 1909
Improvisation 6 (Afrikanisches)
Oil on canvas, 107 x 95.5 cm
Munich, Städtische Galerie im Lenbachhaus

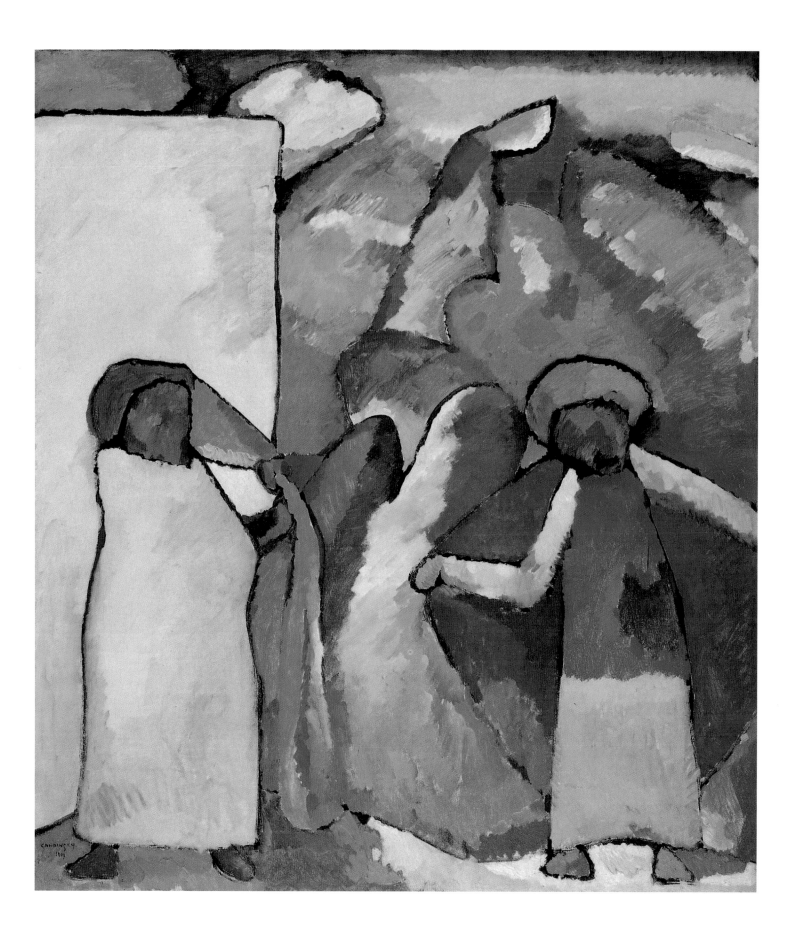

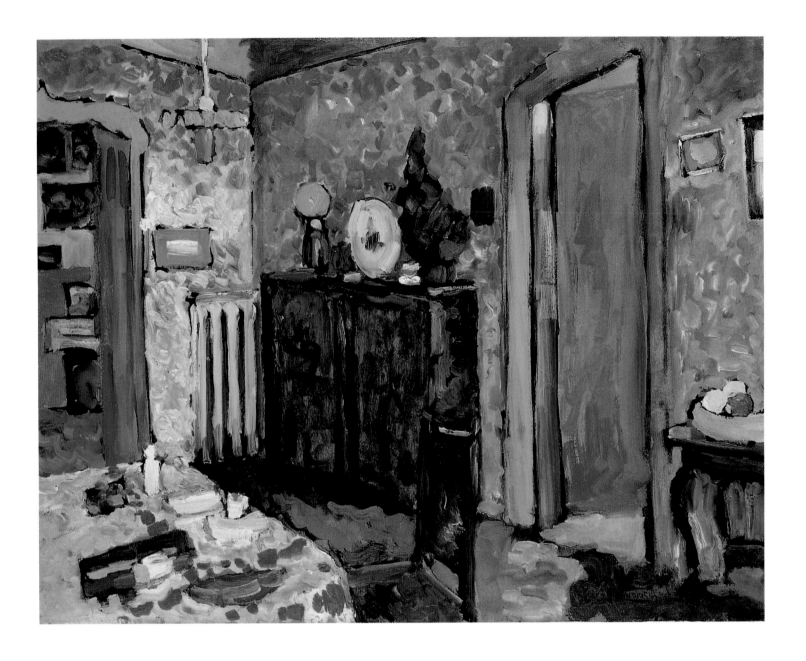

Interior (My Dining Room), 1909
Interieur (Mein Eßzimmer)
Oil on card, 50 x 65 cm
Munich, Städtische Galerie im Lenbachhaus

"They not only paint the most impenetrable mysteries," wrote one reviewer, "but they also write enigmatic things about their art... They fantasize with their brushes and pens like someone sick with fever or under the effects of morphium or hashish."

In the city of Munich, which had grown even more conservative since Phalanx had disbanded, the avant-garde art of the group around Kandinsky thus met with unanimous disapproval. "There is almost something amusing about the way in which the Munich public dismisses the exhibitors. People behave as if these were the isolated excesses of sick minds, when in fact they are modest and austere beginnings on territory which has yet to be developed. Don't people know that the same new creative spirit is at work, ardently and defiantly, in every corner of Europe today?" wrote Franz Marc, an ardent supporter of the new art, after visiting the exhibition at Thannhauser's gallery. He subsequently established close contacts with the Neue Künstlervereinigung, and in January 1911 was simultaneously elected a new member and third member of the board. Marc and Kandinsky went on to develop a close personal friendship.

Kandinsky exhibited six woodcuts in the 1910 Neue Künstlervereinigung exhibition, an indication of the importance which he attached to this medium. Of the four oil paintings which he also showed, just one was a Murnau landscape. The other three – *Composition II*, *Improvisation 10* and *Boat Trip* – belonged to the lyrical, free improvisations that he had started producing in increasing numbers around 1910. *Composition II*, measuring 2 x 2.75 metres, was the largest painting that Kandinsky had produced to date. The canvas itself was lost in the Second World War, but a number of sketches and a detailed study in oil survived and are today housed in the Guggenheim Museum in New York. The oil sketch for *Composition II* (p.56) differs little from the final version other than in its smaller format. While the preparatory ink drawing (p.57) still shows the individual distribution of the main formal accents in the picture, in the study these are woven into an integrated texture of forms and colours. What at first sight appears to be a pattern of small colour forms distributed more or less evenly across the surface plane, reveals itself upon closer inspection to be a highly dynamic composition. The two riders in the centre provide the starting-point for the two, divergent lines of direction governing the composition. These lines are taken up by the white elongated forms and carried deep into the picture. To use Kandinsky's own language, the two riders sound the main chord, which is modulated by smaller, accompanying colour planes. But despite the presence of these directional indicators in the middle of the composition, the study does not have an explicit centre. In his review of the exhibition, Franz Marc compared *Composition II* with Persian carpets, the artistry of whose colours and composition he prized highly. Kandinsky's picture, Marc believed, was similarly full of rhythm and ornamental colour. For Kandinsky, *Composition II* represented his first successful attempt to free himself from perspective and one which took him a major step further along the road to abstraction.

Kandinsky in his apartment in Ainmillerstraße, Munich 1913
Photograph
Munich, Gabriele Münter and Johannes Eichner Foundation

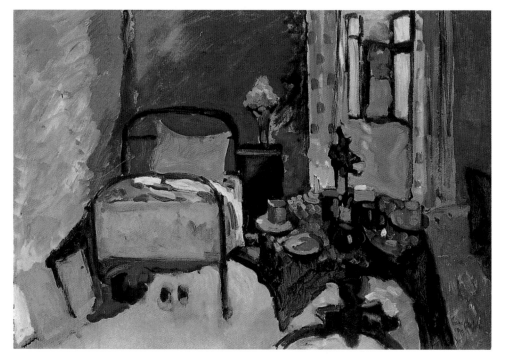

Bedroom in Ainmillerstraße, 1909
Schlafzimmer in der Ainmillerstraße
Oil on card, 48.5 x 69.5 cm
Munich, Städtische Galerie im Lenbachhaus

Pictures of the artist's domestic surroundings, whether the flat in Munich or the house in Murnau, are extremely rare in Kandinsky's œuvre. The confined space of an interior and the many objects contained within it did not allow his imagination the freedom that he found in painting outdoors. Added to this was the fact that Kandinsky never liked to publicize his private life. He was reticent, even withdrawn by nature, and always refrained from personal comment. In photographs, too, he invariably appears stiff and aloof.

Archer, 1909
Bogenschütze
Colour woodcut on paper, 31.4 x 24.2 cm
Munich, Städtische Galerie im Lenbachhaus

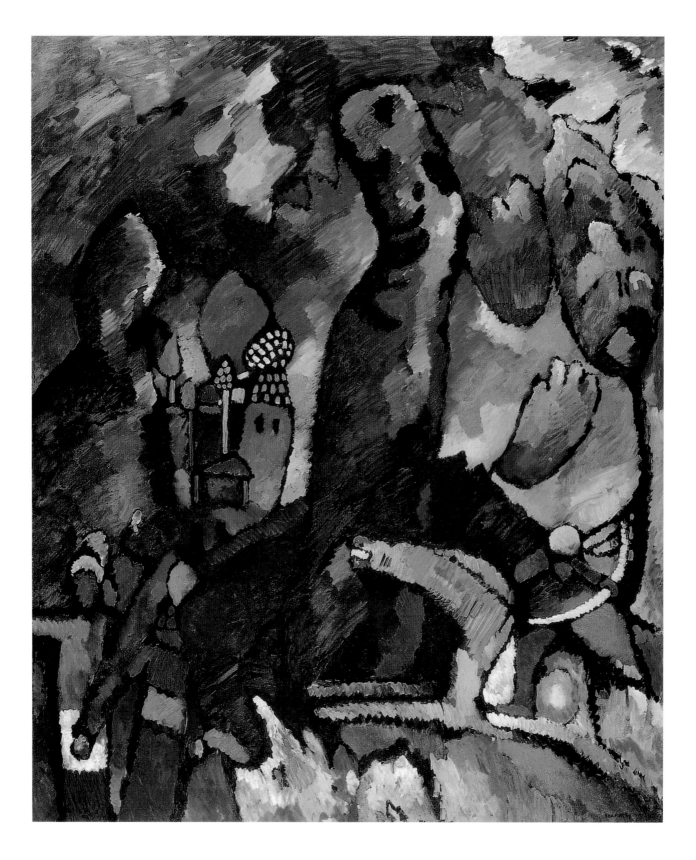

Picture with Archer, 1909
Bild mit Bogenschütze
Oil on canvas, 175.2 x 144.7 cm
New York, The Museum of Modern Art,
Fractional gift of Mrs. Bertram Smith

Alongside colour and form, line also plays an important role in Kandinsky's non-objective compositions. It is employed as a pictorial element in its own right in the top right-hand corner of *Composition II*, while in the rest of the picture, as in numerous earlier works, it serves primarily to outline planes. In *Improvisation 10* (p. 61), which was also on view at the 1910 exhibition, line assumes the same compositional status as the colour zones.

The fourth and last of the oil paintings which Kandinsky showed at the second Neue Künstlervereinigung exhibition was *Boat Trip* (p. 63), also dating from 1910. Here Kandinsky explores the use of what he called the "graphic colours" of black and white. The composition suggests a lake set within a mountainous landscape. The dark colour of the water, the light catching the building and the rowing boats gleaming white could be evocative of sunset over the lake.

Despite such narrative elements, however, Kandinsky is not in fact concerned with depicting a real situation. The boats are primarily white forms; the diagonal direction of their movement is emphasized by their oars. The lake is a black plane whose edge cuts a sharp diagonal in the centre of the picture. Two powerful horizontal lines, one yellow and one red, add further structure and correspond to the red-and-yellow stripe across the top of the picture. Kandinsky has not yet succeeded in achieving "purely abstract form without bridging the gap by means of objects"; he is still in a phase of search and experimentation. More and more, however, objects are becoming the mere vehicles of colour, and references to reality pure elements of tension.

During this period Kandinsky also eagerly absorbed influences and stimuli from non-European art. In a series of reviews written for the Russian magazine *Apollon*, he reported enthusiastically on the Eastern – and in particular Japanese and Persian – art to be seen in exhibitions in Mun-

Oriental, 1909
Orientalisches
Oil on card, 69.5 x 96.5 cm
Munich, Städtische Galerie im Lenbachhaus

In 1905 Kandinsky and Gabriele Münter spent four months in Tunisia. They lived chiefly in and around Tunis, where Kandinsky made sketches which would later form the basis for paintings. Here Kandinsky recaptures the brilliant Tunisian light and the animated bustle of an oriental market.

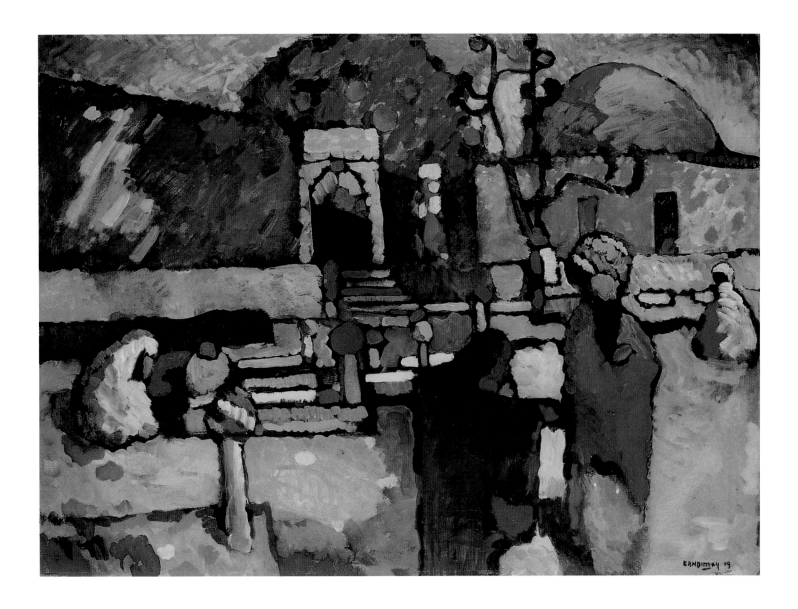

ich. In the case of Japanese art, he was especially excited by a series of woodcuts in which he sensed an "inner sound". In the Persian miniatures featured in an exhibition of Muhammadan art he recognized everything that he himself was attempting to achieve: complete detachment from reality, "primitive use of colour", and "perspective... calmly set at naught" with simple compositional means.

Amongst all the members of the Neue Künstlervereinigung, it was Kandinsky who pursued the dissolving of the object the most consistently and the furthest. This gave rise, in the spring of 1911, to disagreements with Erbslöh and Kanoldt, who were unwilling to follow Kandinsky's lead. Kanoldt, himself searching for solidity of form in his Cubist-style pictures, must have found Kandinsky's lonely path particularly unsettling, and his "disintegrating figures...profoundly repellent", as a friend of the association was later to write. Jawlensky, occupying the middle ground, attempted to play the mediator, but a split within the Neue Künstlervereinigung grew increasingly inevitable. Things came to a head when the hanging committee for the association's third exhibition rejected Kandinsky's *Composition V* (p. 81) on the grounds that it exceeded the permitted dimensions. It was Kandinsky himself who had introduced

Sketch for *Improvisation 4*, 1909
Improvisation 4
Oil on card, 65 x 100 cm
Munich, Collection Ernst Schneider

the clause into the constitution stating that the maximum size of a picture was to be four square metres, as a way of excluding the excessive numbers of oversized works submitted by Palmié, a former member of the association. In this instance, however, the large size of *Composition V*, which measured 1.9 x 2.75 metres, simply provided the jury with an excuse; what they were really voting against was the character of the painting. Kandinsky, Marc and Münter immediately resigned from the Neue Künstlervereinigung and, under the name of "Der Blaue Reiter" (The Blue Rider), organized their own exhibition. It opened two weeks later.

Mountain, 1908
Berg
Oil on canvas, 109 x 109 cm
Munich, Städtische Galerie im Lenbachhaus

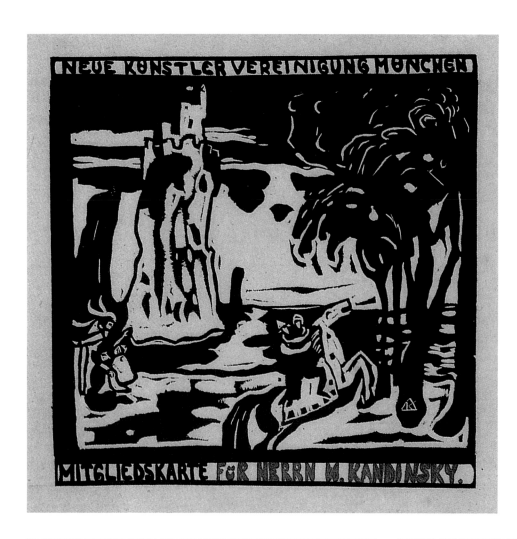

Neue Künstlervereinigung München membership card, 1908/09
Colour woodcut on handmade paper, sole state, 14.1 x 14.4 cm
Munich, Städtische Galerie im Lenbachhaus
Circular printed by the Neue Künstlervereinigung (logo by Kandinsky), 1909
Private collection

YOUR HONOURS!

We beg to draw your attention to an association of artists which was established in January 1909 and which cherishes the hope that, through exhibitions of serious works of art, it may do everything in its power to contribute to the advancement of artistic culture. We start out from the belief that, apart from those impressions which he receives from the outer world, from Nature, the artist is constantly amassing experiences in an inner world; and that the search for artistic forms by which to express the mutual permeation of all these experiences – forms which must be freed from everything inessential in order to give powerful expression only to the essential –, in short, the striving towards artistic synthesis, appears to us to be a solution which is currently spiritually uniting more and more artists. Through the foundation of our association, we hope to give a material form to these spiritual links between artists which will enable us to address the public with combined forces.
Most respectfully,

NEUE KÜNSTLERVEREINIGUNG
MÜNCHEN

MÜNCHEN, DEN

NEUE KÜNSTLER-
VEREINIGUNG
MÜNCHEN. □□□

EW. HOCHWOHLGEBOREN!

Wir erlauben uns, Ihre Aufmerksamkeit auf eine Künstlervereinigung zu lenken, die im Januar 1909 ins Leben getreten ist und die Hoffnung hegt, durch Ausstellung ernster Kunstwerke nach ihren Kräften an der Förderung künstlerischer Kultur mitzuarbeiten. Wir gehen aus von dem Gedanken, dass der Künstler ausser den Eindrücken, die er von der äusseren Welt, der Natur, erhält, fortwährend in einer inneren Welt Erlebnisse sammelt; und das Suchen nach künstlerischen Formen, welche die gegenseitige Durchdringung dieser sämtlichen Erlebnisse zum Ausdruck bringen sollen — nach Formen, die von

allem Nebensächlichen befreit sein müssen, um nur das Notwendige stark zum Ausdruck zu bringen, — kurz, das Streben nach künstlerischer Synthese, dies scheint uns eine Lösung, die gegenwärtig wieder immer mehr Künstler geistig vereinigt. Durch die Gründung unserer Vereinigung hoffen wir diesen geistigen Beziehungen unter Künstlern eine materielle Form zu geben, die Gelegenheit schaffen wird, mit vereinten Kräften zur Oeffentlichkeit zu sprechen.

Hochachtungsvollst

NEUE KÜNSTLERVEREINIGUNG
MÜNCHEN.

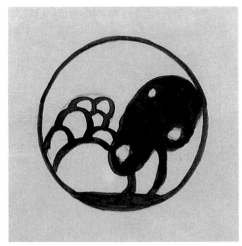

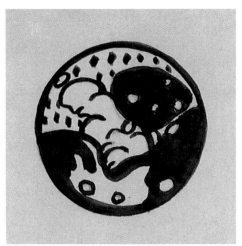

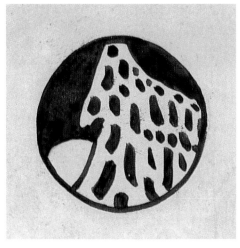

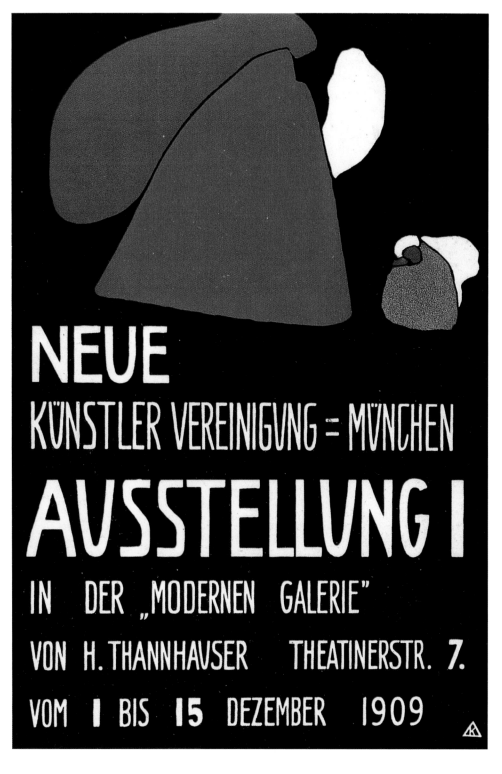

Designs for the logo of the Neue Künstlervereinigung, 1909
Brush in blue over pencil
Munich, Städtische Galerie im Lenbachhaus

Poster advertising the first exhibition by the Neue Künstlervereinigung, 1909
Munich, Städtische Galerie im Lenbachhaus

With the foundation of the Neue Künstlervereinigung München (New Artists' Association of Munich), Kandinsky and his artist friends (Jawlensky, Münter, Erbslöh, Werefkin, Kanoldt, Kubin, Schnabel and Wittenstein) took up from where Kandinsky's earlier group, Phalanx, had left off. Here, too, the aim was to introduce the conservative Munich art world to the latest trends in painting, especially those from France. Between 1909 and 1911 the Neue Künstlervereinigung mounted three large exhibitions, featuring not only

works by its members, but also pictures by Picasso, Braque, Vlaminck and the Russians David and Vladimir Burliuk. The third exhibition took place without the participation of Kandinsky, Marc, Münter and Kubin however, who had resigned in protest at the hanging committee's rejection of a painting by Kandinsky. They went on to form their own group, Der Blaue Reiter (The Blue Rider). Following the departure soon afterwards of Werefkin, Jawlensky and Bekhteev, the Neue Künstlervereinigung was dissolved in 1912.

51

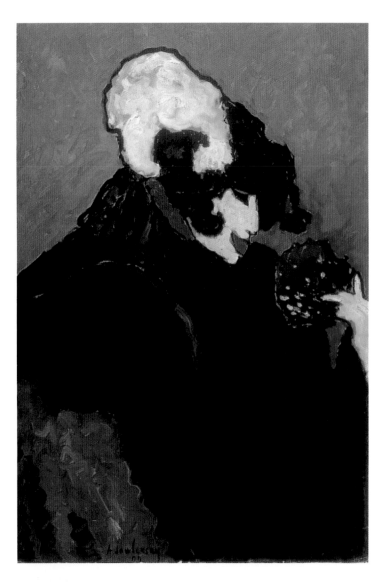

Pictures from the first exhibition by the Neue Künstlervereinigung München, which was held from 1 to 15 December 1909 in Thannhauser's Moderne Galerie in Munich.

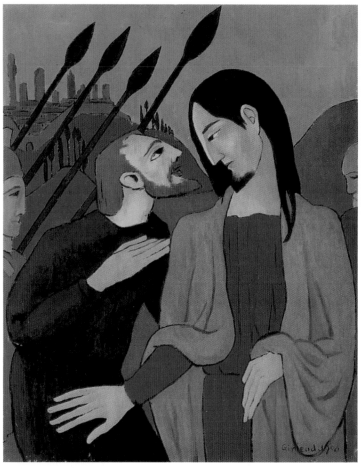

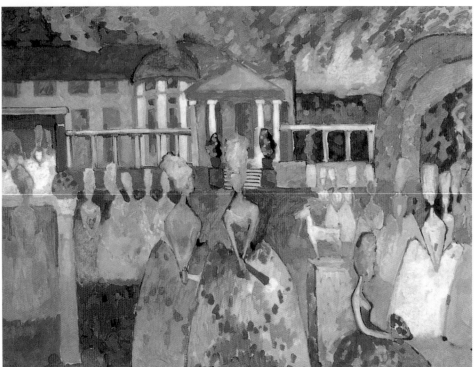

ABOVE LEFT:
Alexei von Jawlensky:
The White Feather, 1909
Die weiße Feder
Oil on card, 101 x 69 cm
Stuttgart, Staatsgalerie Stuttgart

ABOVE RIGHT:
Pierre Paul Girieud:
Judas, 1908
Oil on canvas, 92.3 x 73 cm
Munich, Städtische Galerie im Lenbachhaus
On permanent loan from the Gabriele Münter and Johannes Eichner Foundation

LEFT:
Crinolines, 1909
Reifröcke
Oil on canvas, 96.3 x 128.5 cm
Moscow, State Tretyakov Gallery

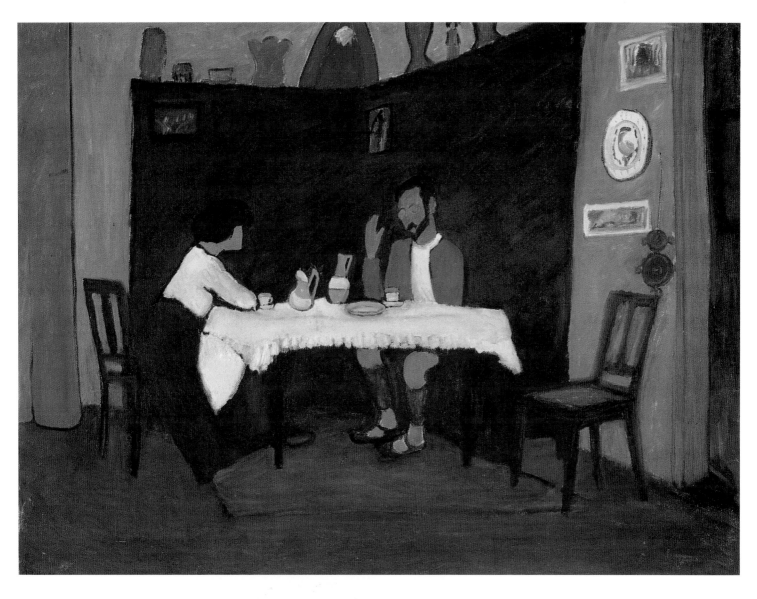

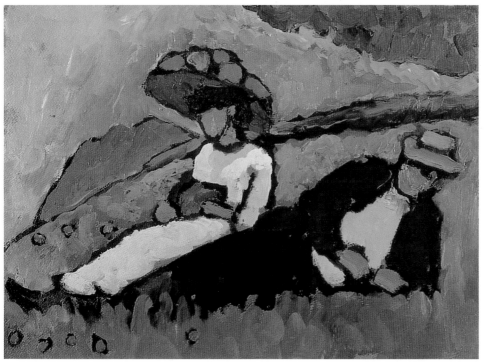

Gabriele Münter:
Kandinsky and Erma Bossi at the Table, 1912
Kandinsky und Erma Bossi am Tisch
Oil on canvas, 95.5 x 125.5 cm
Munich, Städtische Galerie im Lenbachhaus

Gabriele Münter:
Jawlensky and Werefkin, 1908/09
Jawlensky und Werefkin
Oil on card, 32.7 x 44.5 cm
Munich, Städtische Galerie im Lenbachhaus

Unlike Kandinsky, Gabriele Münter frequently took her friends as subjects for her paintings. More muted in the expressiveness of her palette, she portrays Kandinsky and the painter Erma Bossi sitting somewhat stiffly over coffee in the Murnau farmhouse. With the exception of Marc, none of Kandinsky's artist colleagues followed him down the road to abstraction.

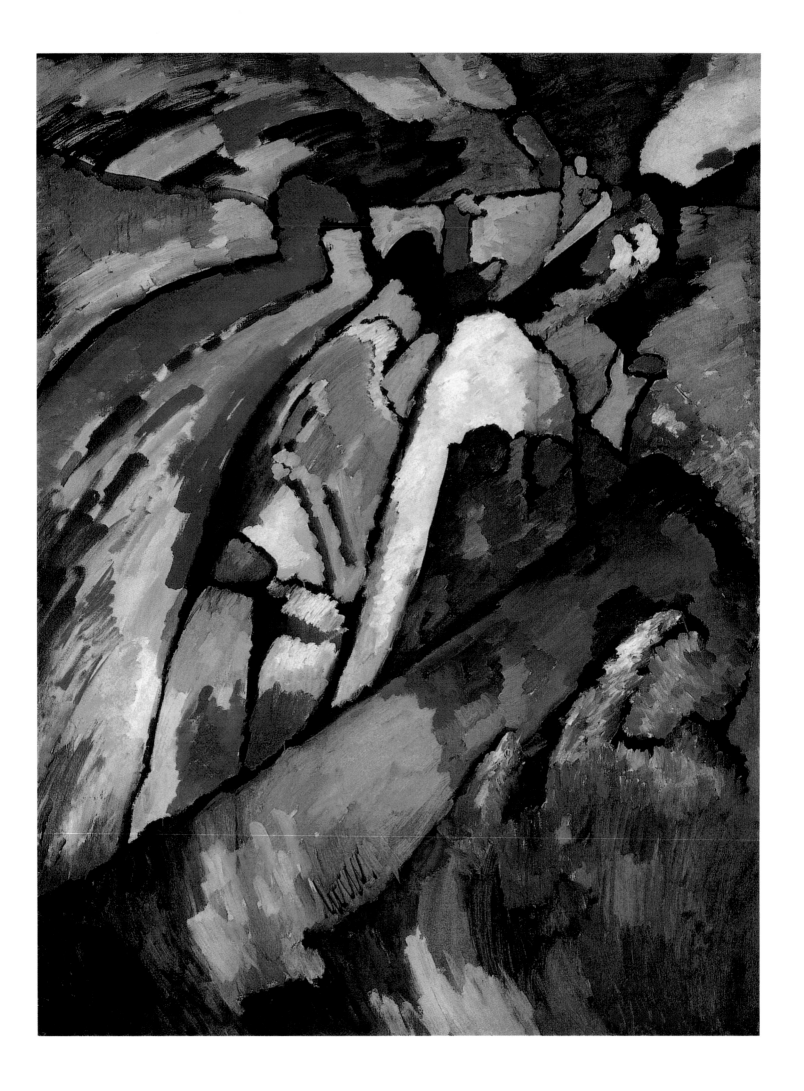

"On the Spiritual in Art"

"However interesting and informed your essay on the spiritual in art, I regret that I must decline to publish the same. – The readership of this type of theoretical treatise is unfortunately insufficiently large to guarantee the commercial success of the work, and I fear that reviewers would not be altogether favourably inclined towards the book in its present form, since the style, which suffers from numerous un-German turns of phrase, still betrays too much of a foreign hand."

Thus the response of the Munich publisher Georg Müller, to whom Kandinsky submitted a typed copy of his essay *On the Spiritual in Art* in autumn 1909. Piper Verlag also initially turned down the manuscript for stylistic reasons, but in September 1911 – probably thanks to the intervention of Franz Marc – agreed to print a first edition of 1000 copies. The author, it was stipulated in the contract, would bear half the printing costs of 1000 Marks.

By autumn 1912 the book was already into its third impression, a reflection of the enthusiasm with which it was received by the minds of the day, and in particular by young artists seeking new avenues in art.

Kandinsky's book is not easy to read: his language is full of analogy and – as the publishers had already complained – his German is flawed. German was not, after all, his mother tongue, and in places his use of the language gave rise to misunderstandings. *On the Spiritual in Art* nevertheless ranks alongside the *Blaue Reiter Almanac* as one of the documents most influential upon twentieth-century art. Kandinsky himself called it his most important theoretical work. The content of the essay was much discussed amongst his contemporaries, and it is interesting to note that, at around this same time, artists in other parts of Europe – such as Kasimir Malevich in Moscow and Piet Mondrian and František Kupka in Paris – were severing their ties with external nature in a process similar to that proposed by Kandinsky in his book and realized in his art.

Kandinsky considered it essential that a painting should grow out of what he termed an "internal necessity". This was a key concept in his theoretical writings and one which he regularly professed to be the guiding principle of all his artistic activities. A work of art, he believed, should no long depend upon an external model such as nature. Instead, the decisive factor in the genesis of a picture should be the inner voice of the artist. Thus the uncontrollable subjectivity of outer appearances would be countered by a conception based on inner impressions.

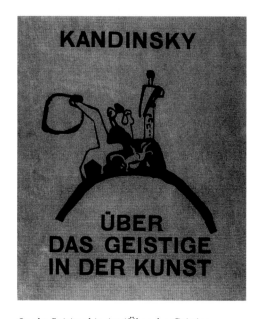

On the Spiritual in Art (Über das Geistige in der Kunst)
Cover design for the 1. edition, 1911
Paris, Musée National d'Art Moderne,
Centre Georges Pompidou

"In 1910 I had the finished text lying in my drawer, since not a single publisher had the courage to wager the (as it turned out, quite low) cost of publication. Even the warm sympathy evinced by the great Hugo von Tschudi went for nothing." (Kandinsky to Paul Westheim concerning *On the Spiritual in Art*, 1930)

"Years had to elapse before I arrived, by intuition and reflection, at the simple solution that the aims (and hence the resources too) of nature and art were fundamentally, organically, and by the very nature of the world different – and equally great, which also means equally powerful." (Kandinsky in *Reminiscences*, 1913)

PAGE 54:
Improvisation 7, 1910
Oil on canvas, 131 x 97 cm
Moscow, State Tretyakov Gallery

Kandinsky viewed the power of the "spiritual", the inner voice, as the
ultimate authority. From childhood on he had possessed a highly-pro-
nounced capacity to absorb impressions "so intensively and continuously
that I felt as if my chest would burst, and breathing became difficult." His
sensibility was so strongly developed that at times he felt crammed to ex-
cess with feelings and emotions, and looked with envy upon civil ser-
vants "who, after work, may and can relax completely". "I *had*, however,
to see continuously." This capacity for profound inner experience formed
the inspirational source of Kandinsky's work.

It would be wrong, and contrary to Kandinsky's own way of thinking,
to interpret this emphasis upon the "inner" as a complete rejection of the
representational world. Kandinsky himself regularly acknowledged that
he was unable to fully renounce the object in his pictures before 1914. As
he explained, however, the objects he depicted arose in him out of pure
emotion; they formed themselves in his imagination out of colour and
line and should therefore be understood by the viewer as abstract. Retain-
ing a figurative element in a picture was of only secondary importance; it
was simply a reverberation. What mattered was that colour and form
should grow out of an internal necessity.

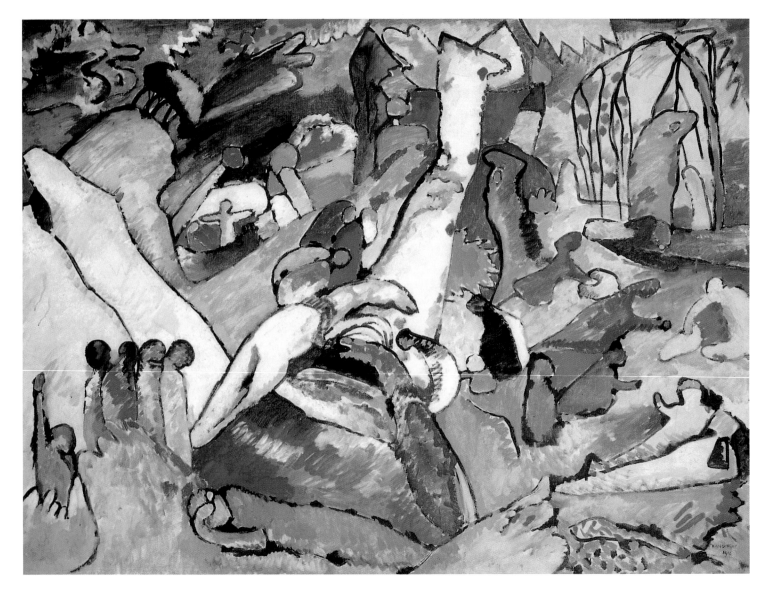

Study for *Composition II*, 1909/10
Komposition II
Chinese ink, 23.8 x 30.15
Paris, Musée National d'Art Moderne,
Centre Georges Pompidou

In 1912 an abridged version of *On the Spiritual in Art* was read – to great acclaim – at an artists' conference in St. Petersburg. In 1914 it was published in English in a first translation by Michael Sadler. (Astonishingly, however, it was not to appear in France until 1949. Although Kandinsky had shown Herwarth Walden a translation by Guillaume Apollinaire as early as 1913, the outbreak of the First World War and Kandinsky's return to Moscow delayed publication, and the final version did not appear until after Kandinsky's death.)

On the Spiritual in Art is divided into two sections. The first comprises a series of philosophical reflections on art, which, in Kandinsky's opinion, should never be an end in itself and should never be subordinated to materialistic considerations. The second section is a treatise on colour, which Kandinsky believed housed secret powers – powers which the artist made visible in his pictures.

Kandinsky opens his essay with the observation that the imitation of the artistic principles of past eras can only lead at best to soulless works devoid of inner meaning. Outward similarity between the artistic forms of different epochs is nevertheless possible, however, where this is rooted in a deeper necessity and reflects an inner kinship in the pursuit of the same goals. Kandinsky suggests that our sympathy for primitive art arises partly in this way.

In Kandinsky's eyes, humankind is overly dominated by materialistic thinking, and our feelings are under threat of growing coarse. "Our souls, when one succeeds in touching them, give out a hollow ring, like a beautiful vase discovered cracked in the depths of the earth." The work of art,

especially if it portrays states of minds and moods, can protect the soul from such coarsening and maintain it at a certain pitch, "as do tuning-pegs the strings of an instrument".

An art which contains no future potentialities, and which is therefore only a child of the present, is a "castrated art" in Kandinsky's opinion and will be of short duration. True art has "an awakening prophetic power". It is part of the spiritual life, which is the progress towards knowledge. The artist possesses the secret, inborn power of "vision", with which he drags "the heavy cartload of struggling humanity, getting stuck amidst the stones, ever onward and upward".

In the second chapter, entitled "Movement", Kandinsky suggests that the spiritual life can be symbolized by a triangle, divided into unequal parts, whose most acute segment is at the top. This triangle is moving slowly upwards: where the highest point is today, the next division will be tomorrow. "At the apex of the topmost division there stands sometimes only a single man. His joyful vision is like an inner, immeasurable sorrow. Those who are closest to him do not understand him and in their indignation, call him deranged: a phoney or a candidate for the mad-house. Thus, Beethoven in his own lifetime stood alone and discredited upon the peak."

Artists are to be found in every division of the triangle, each the prophet of his environment. The upward movement of the triangle is not

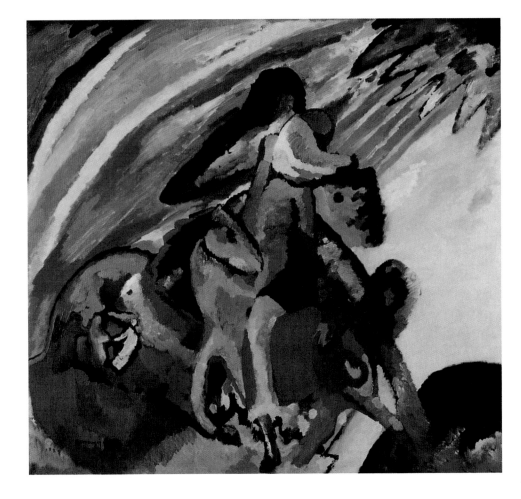

Improvisation 12 (Rider), 1910
Oil on canvas, 97 x 106.5 cm
Munich, Staatsgalerie moderner Kunst

Kandinsky's definition of an "Improvisation": "Chiefly unconscious, for the most part suddenly arising expressions of events of an inner character, hence impressions of 'internal nature'." (Kandinsky in *On the Spiritual in Art*, 1912)

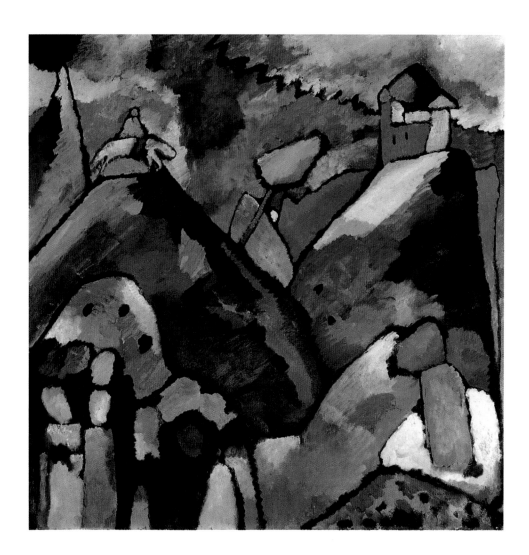

Improvisation 9, 1910
Oil on canvas, 110 x 110 cm
Stuttgart, Staatsgalerie Stuttgart

always sustained, however; at times when humankind places excessive value upon outward success and material goods, it may come to a halt or even slip downward. In such periods, art is "without a soul". "And yet, in spite of being thus continually dazzled, in spite of this chaos, this wild chase, in reality the spiritual triangle moves forward and upward, slowly but surely and with irresistible force" towards a new goal stamped by the emotion of the artist's soul.

In the third chapter, "Spiritual Turning-Point", Kandinsky polemicizes against the inhabitants of the various divisions of the spiritual triangle. He characterizes those dwelling in the large lower divisions as ignorant and lacking in initiative; they "have never managed to solve a problem for themselves." The higher one ascends the spiritual triangle, the greater the sense of scepticism towards established facts. These compartments include art historians "who write books full of praise and deep sentiments – about an art that was yesterday described as senseless." In such books, art historians merely reposition the "barriers" around art, "which this time are supposed to stay permanently and firmly in place," but which are outdated even before they are defined. These art historians fail to recognize that they are concentrating solely on the external principles of art, which are only valid for the past and not for the future. "One cannot crystallize in material form what does not yet exist in material form. The spirit that will lead us into the

Improvisation 14, 1910
Oil on canvas, 73 x 125 cm
Paris, Musée National d'Art Moderne,
Centre Georges Pompidou

Kandinsky painted 35 "Improvisations" up to
1914. Arising from the unconscious, they never-
theless feature elements of the Murnau landscape
(trees, mountain tops) and shadowy figures
(riders?). In the above *Improvisation*, however,
the most important component is colour, reson-
ating in contrasts and cool dissonances.

realms of tomorrow can only be recognized through feeling." For this, the talent of the artist is necessary.

Climbing still higher towards the apex of the triangle, we find profes-
sional intellectuals "who examine matter over and over again and finally
cast doubt upon matter itself, which yesterday was the basis of every-
thing, and upon which the whole universe was supported." At the same
time, however, Kandinsky oberves an increase in the number of people
who, having failed to find the answers to their questions in materialistic
science, are turning for help to the methods of the past. This has given
birth to theosophy, a spiritual movement seeking to approach the prob-
lems of the spirit by the path of inner consciousness.

In such a situation where man's gaze turns inwards upon himself, lit-
erature, music and art "are the first and most sensitive realms where this
spiritual change becomes noticeable in real form." By way of example
Kandinsky cites the Belgian poet Maurice Maeterlinck, whom he de-
scribes as a clairvoyant and prophet of decline. Maeterlinck's works
clearly reflect "the darkening of the spiritual atmosphere." The poet
builds up this atmosphere by means of words, drawing both upon their
literal meaning and their inner, pure, abstract sound. One way of bringing
out this inner sound, according to Kandinsky, is to repeat a word several
times over. This causes the word to lose its external sense as a name,
whereby only the pure sound of the word remains. Kandinsky would sub-
sequently translate these ideas into his prose-poems *Sounds*.

Richard Wagner, Kandinsky continues, achieved something similar in
music in his use of *leitmotif*: a motif as a sort of spiritual atmosphere, ex-

pressed in music, which accompanies the hero. Of all the composers, however, Arnold Schoenberg in Vienna was undoubtedly the most advanced along the path to a new beauty. Unlike the old beauty, dominated by external considerations and conventions, this new beauty is occasioned by the demands of internal necessity. "Schoenberg's music leads us into a new realm, where musical experiences are no longer acoustic, but purely spiritual. Here begins the 'music of the future'."

Kandinsky sees a number of very different trends in painting. On the one hand, he identifies those artists "who seek the internal in the world of the external." These include the English painter and poet Dante Gabriel Rossetti, Arnold Böcklin and Giovanni Segantini. Paul Cézanne, on the other hand, was using purely pictorial means to make externally "dead" objects (the still life, or *nature morte*) come internally alive. "It is not a man, nor an apple, nor a tree that is represented; they are all used by Cézanne to create an object with an internal, painterly quality: a picture."

By contrast, Henri Matisse was unable to free himself from conventional beauty, despite his gifts as a colourist. Pablo Picasso adopted an entirely different approach: "he arrives at the destruction of the material object by a logical path, not by dissolving it, but by breaking it up into its individual parts and scattering these parts in a constructive fashion over the canvas. In this process he seems, strangely enough, to wish to retain a semblance of the material object." Colour was not Picasso's primary concern; he subordinated it to the necessities of form. Kandinsky concludes this chapter with the words: "Matisse – colour. Picasso – form. Two great pointers toward one great goal."

In the last chapter of the first section, entitled "The Pyramid", Kandinsky broaches a subject particularly close to his heart, namely the re-

Improvisation 10, 1910
Oil on canvas, 120 x 140 cm
Basle, Collection Ernst Beyeler

Improvisation 11, 1910
Oil on canvas, 97.5 x 106.5 cm
St. Petersburg, State Russian Museum

According to Nina Kandinsky, this work hung in the dining room of their Moscow
apartment. The painting contains numerous allusions to the representational world: the
dog in the foreground, apparently uninterested in events around it and preoccupied
with itself; a boat full of people being rowed across a stormy lake; two cannons; a
rigid group of figures armed with lances; two galloping armed riders; and suggestions
of buildings. Spontaneous impressions are woven into an animated composition
which almost appears narrative in the detailed execution of certain of its components.

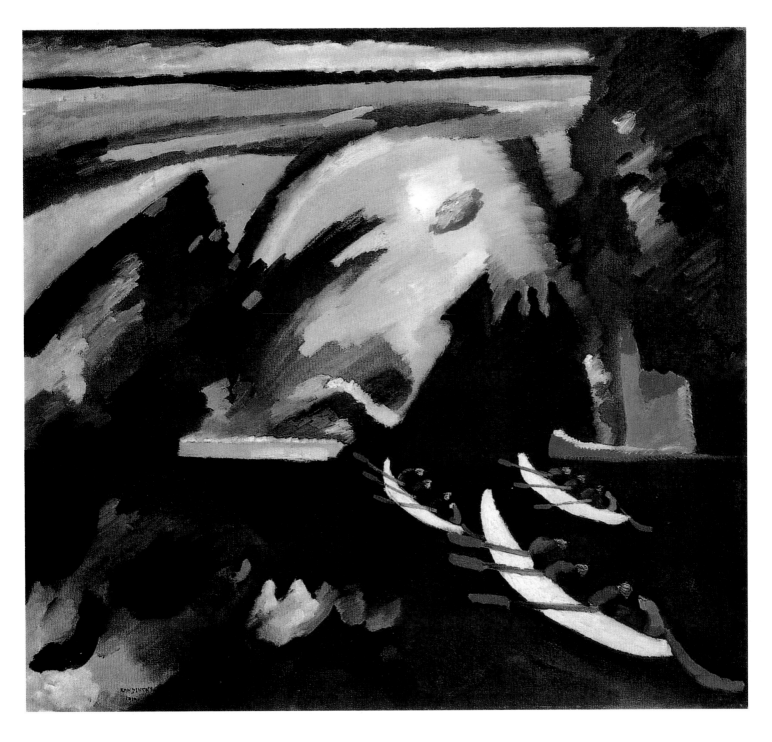

Boat Trip, 1910
Kahnfahrt
Oil on canvas, 98 x 105 cm
Moscow, State Tretyakov Gallery

Kandinsky uses black and white to add dramatic emphasis to this picture, which
numbers amongst his lyrical improvisations. Objects and features of the landscape are
now increasingly serving merely as symbols and vehicles of colour, while references
to reality are becoming pure elements of tension.

Composition IV, 1911
Komposition IV
Oil on canvas, 159.5 x 250.5 cm
Düsseldorf, Kunstsammlung Nordrhein-
Westfalen

Between 1910 and 1939 Kandinsky painted ten
large "Compositions". *Composition IV*, which
still features partially identifiable objects, repre-
sents a transitional stage along the road to ab-
straction.

"The whole composition is intended to produce a
very bright effect, with many sweet colours,
which often run into one another (dissolution),
while the yellow, too, is cold. The juxtaposition
of this bright-sweet-cold tone with angular move-
ment (battle) is the principal contrast in the pic-
ture. It seems to me that this contrast is here, by
comparison with *Composition II*, more powerful,
but at the same time harder (inwardly), clearer,
the advantage of which is that it produces a more
precise effect, the disadvantage being that this
precision has too great a clarity."
(Kandinsky in *Reminiscences*, 1913)

ciprocal relationship between the arts. "One art has to learn from an-
other how it tackles its own materials and, having learned this, use in
principle the materials peculiar to itself in a similar way, i.e., according
to the principle that belongs to itself alone." In this way it will be
possible to identify the particular forces of the different arts. By com-
bining these forces we will arrive at the top of the spiritual pyramid,
and at a truly monumental art.

The first part of *On the Spiritual in Art* is thus dedicated to Kandin-
sky's general observations and thoughts on art and on the possibilities of
artistic reorientation. It lays the intellectual and spiritual foundations for
Section B, "Painting", which discusses the formal preconditions and the
specific effects of painterly means.

The first chapter of this second section is devoted to the effects of
colour. Kandinsky distinguishes here between the purely physical effect
of colour, which is superficial and leaves no lasting impression, and its
psychological effect, which calls forth "a vibration from the soul". Kan-
dinsky believes that colour can influence the entire human body as a
physical organism: certain colours conjure up very specific associations
which set off a chain of emotional responses in the body. In addition to
these associative powers, colour also provides a means of exerting a di-
rect influence upon the soul. "Colour is the keyboard. The eye is the ham-
mer. The soul is the piano, with its many strings." The artist is the hand
which sets the soul vibrating by touching this or that key, according to
the principle of internal necessity.

The following chapter, "The Language of Forms and Colours", is the longest and most important of the book. According to Kandinsky, colour, unlike form, cannot exist independently. Although it may be possible to imagine an infinite red in our mind, such a red cannot be realized. If colour is to be rendered in material form, as in painting, it must be limited in its extension upon the surface of the canvas. Form itself, even if completely abstract and geometrical, has its own inner sound; it is a spiritual being possessing qualities that are identical with that form. The value of certain colours is reinforced by certain forms, as in the case of sharp yellow in a sharp triangle, or deep blue in a rounded form. In combination with other forms, however, these same colours may find their effect weakened, as in the case of sharp yellow in a circle. The incompatibility of certain forms and colours should be regarded not as something "disharmonious", but as offering new possibilities, i.e., new harmonies. "Since the number of forms and colours is infinite, the number of possible combinations is likewise infinite as well as their effects. This material is inexhaustible."

A form can either delineate a real material object or can be a totally abstract entity, such as a square, a circle or a triangle. Between these boundaries of the material and the abstract lie an infinite number of forms upon which the artist can draw. Whether abstract, representational or somewhere in between, however, forms must always be composed according to the "principle of internal necessity".

At this point, Kandinsky adds: "Today, the artist cannot manage exclusively with purely abstract forms. These forms are too imprecise for him. To limit oneself exclusively to the imprecise is to deprive oneself of possibilities, to exclude the purely human and thus impoverish one's means of expression." This is surprising coming from Kandinsky's pen – after all, the woodcuts illustrating his essay are composed of purely abstract, ornamental forms. In later editions of the work, Kandinsky

Section for *Composition IV*, 1910
Komposition IV
Oil study, 94.5 x 130 cm
London, Tate Gallery

Three drawings, the above oil study and a water-colour survive as preparatory studies for *Composition IV*. In this oil study, which concentrates upon the left half of the composition, the complex of linear elements is even more intricate than in the final version.

modifies this rather crass formulation: "Today, only a few artists can manage with purely abstract forms… At the same time, however, abstract forms are already being perceived as purely precise and are being used as the exclusive material in pictorial works. Outer 'impoverishment' is transforming itself into inner enrichment."

In Kandinsky's view, inner necessity arises out of three elements (which he terms the three "mystical necessities"): the personality of the artist, the style of the epoch, and the pure and eternally artistic which, as the principle element of art, knows neither time nor space. The first two elements are of a subjective nature. The pure and eternally artistic, on the other hand, is the objective element, which becomes comprehensible with the help of the subjective. The development of art, according to Kandinsky, is thus nothing other than the struggle of the objective against the subjective. The artist should not bow to the demands and precepts of his time, but should listen only to the voice of internal necessity, uninfluenced by accepted or unaccepted form. "All means are moral if they are internally necessary," Kandinsky writes. "All means are sinful if they did not spring from the source of internal necessity".

Kandinsky now develops a schema of isolated simple colours, with their modalities of warmth and coldness, lightness and darkness. Yellow is the typically warm colour, blue the typically cold colour. Both move in the horizontal plane, whereby yellow strives towards the spectator and blue away from him. In addition, yellow streams outward (eccentric motion) whereas blue withdraws from the spectator (concentric motion). Adding white to yellow increases its effect, just as the effect of blue is intensified by adding black.

Alongside these physical effects, colours also possess spiritual qualities. Thus yellow is disquieting and stimulating, with a shrill sound. It is the typical earthly colour. Blue, on the other hand, is the typically heavenly colour. It calls man towards the infinite and awakens in him a desire for the pure and the supernatural. In musical terms, dark blue can be compared to the deep notes of the organ.

Green, as the mixture of yellow and blue, cancels out within itself the opposite directions of movement displayed by its constituents. It is a peaceful, passive colour which has a beneficial effect upon tired people, but which can become tedious after a while. "Thus, pure green is to the realm of colour what the so-called bourgeoisie is to human society: it is an immobile, complacent element, limited in every respect. This green is like a fat, extremely healthy cow, lying motionless, fit only for chewing the cud, regarding the world with stupid, lacklustre eyes."

Gray, like green, is also described as immobile, but as a disconsolate lack of motion, since it is the product of the two soundless colours of black and white. Kandinsky characterizes red as a highly lively, turbulent and powerful colour, offering a wealth of permutations and variations and possessing many different psychological and symbolic effects. In musical terms, bright red is like the sound of a fanfare, vermilion like a tuba, and madder lake like the high notes of a violin.

Concluding this long chapter on the language of forms and colours, Kandinsky notes that all the descriptions he has employed for colours are "extremely provisional and clumsy". It is impossible to express the sub-

ABOVE:
With Riders, c. 1911
Mit Reitern
Ink brush over pencil, 29.6 x 23.2 cm
Munich, Städtische Galerie im Lenbachhaus

BELOW:
With Three Riders, 1911
Mit drei Reitern
Ink brush and watercolour, 25 x 32 cm
Munich, Städtische Galerie im Lenbachhaus

tleties of colour in words. "For this reason, words are and remain mere indications, somewhat external labels for colours."

Kandinsky has one final, important point to make: harmonization on the basis of individual colours is no longer suitable in an age such as ours full of questions and contradictions. For example, although the works of Mozart may create a welcome pause amidst the storms of our inner life, we hear them like the sounds of another, essentially unfamiliar era. Our own times demand something different: "Opposites and contradictions – this is our harmony. Composition on the basis of this harmony is the juxtaposition of colouristic and linear forms that have an independent existence as such, derived from internal necessity, which create within the common life arising from this source a whole that is called a picture." Thus, for example, the juxtaposition of red and blue – colours previously considered disharmonious – today forms one of the most strongly effective harmonies, because it rests upon the principle of contrast, the most important principle in art at all times.

In chapter VII, "Theory", Kandinsky writes that painting is still only in the very early stages of emancipating itself from nature. The artist is therefore still bound to the outward appearance of nature and must draw his forms from it. As regards his freedom to alter these forms and their

Lyrical, 1911
Lyrisches
Colour woodcut, 4 blocks, 14.9 x 21.8 cm
Munich, Städtische Galerie im Lenbachhaus

Just a few lines, reminiscent of Chinese calligraphy, suffice to invoke this galloping rider in jockey position. The white aureole ground creates a transcendental, spiritualized atmosphere in which the rider must be interpreted as the vanquisher of the material and the unspiritual.

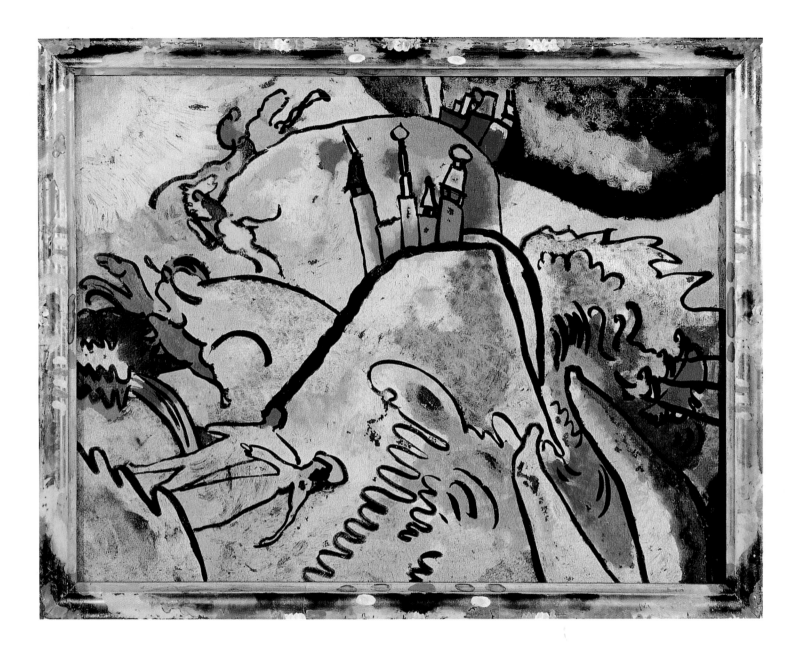

Glass Painting with Sun (Small Pleasures),
1911
Glasbild mit Sonne (Kleine Freuden)
Glass painting, 30.6 x 40.3 cm
Munich, Städtische Galerie im Lenbachhaus

Design for the glass painting **With Sun**, 1911
Mit Sonne
Coloured crayon on cardboard, 32.2 x 44.6 cm
Munich, Städtische Galerie im Lenbachhaus

colours, the artist may go as far as his sensibility permits. He must thereby avoid the external and the superficial, however. He must find a form "that first excludes the fairytale effect, and secondly, in no way inhibits the pure effect of colour". His guide along this path is, as ever, the principle of internal necessity.

In chapter VIII, entitled "Art and Artist", Kandinsky once again stresses the "complete unlimited freedom of the artist in his choice of means." The work of art must serve the development and refinement of the human soul; indeed, art is the "daily bread" of the soul. The artist, Kandinsky continues, is no Sunday's Child of life. "He has a difficult task to fulfil, which often becomes a cross to bear. He must know that every one of his actions and thoughts and feelings constitutes the subtle, intangible, and yet firm material out of which his works are created, and that hence he cannot be free in life – only in art."

Kandinsky concludes his essay with a confident look at the future. He sees the era of hasty, unconscious composition as past. The artist will soon be proud to be able to explain his works in "constructional" terms (as opposed to the Impressionists, who were proud of the fact that they were un-

able to explain anything). "The spirit in painting stands in a direct, organic relationship to the creation of a new spiritual realm that is already beginning, for this spirit is the soul of the epoch of the great spiritual."

This idea of a coming new spiritual epoch, a major theme throughout the book, grew out of the widespread scepticism felt in Kandinsky's day towards political and technological developments. The sense that science had failed ("The collapse of the atom was equated, in my soul, with the collapse of the whole world... Science seemed destroyed: its most important basis was only an illusion, an error of the learned, who...were groping at random for truth in the darkness and blindly mistaking one object for another."), with a mistrust of traditional knowledge and a sense that "there were no gods in the world any more" (as Peter Anselm Riedl has put it), were together prompting a search for new values and a new meaning to life.

Improvisation 21a, 1911
Oil on canvas, 96 x 105 cm
Munich, Städtische Galerie im Lenbachhaus

The central, tower-topped mountain is a motif which appears over and over again in Kandinsky's work. In 1913 it served as the starting-point for the oil painting *Small Pleasures*.

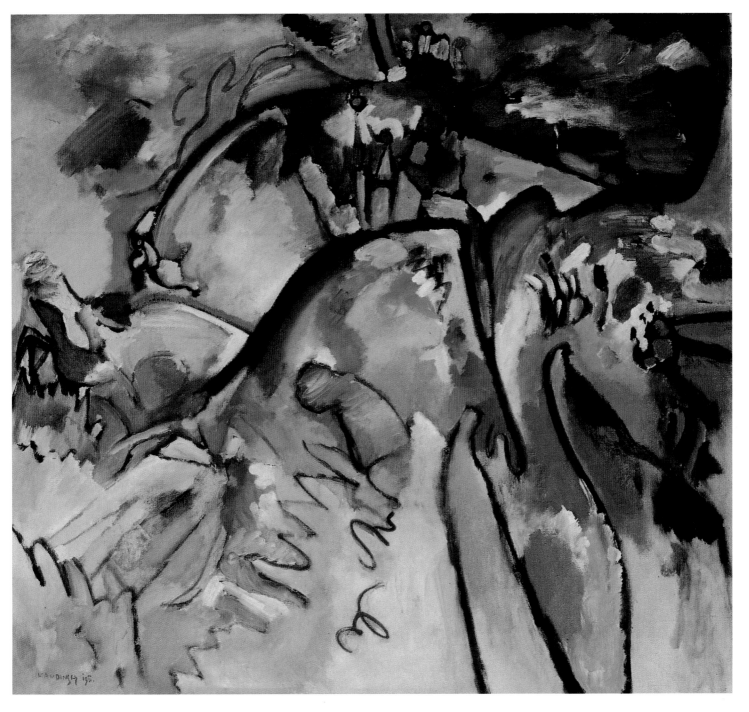

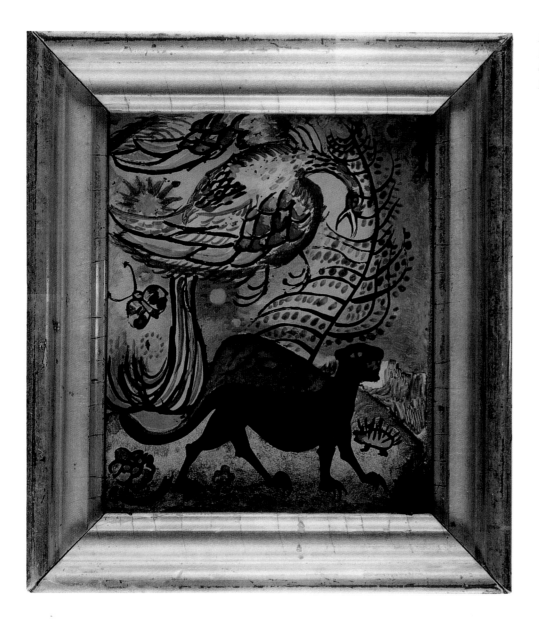

Hound of Hell and Bird of Paradise, 1911
Höllenhund und Paradiesvogel
Glass painting, 10.8 x 9.2 cm
Munich, Städtische Galerie im Lenbachhaus

As in the design of a print, painting behind glass requires the artist to visualize his composition in mirror image, since the finished picture is viewed from the unpainted side. One side of the pane of glass thus provides the ground on which the picture is painted, while the other serves to protect it, like the final coat of varnish given to an oil painting.

Kandinsky's glass paintings take up traditional, well-known themes of comfort and salvation from the Bible and popular legend: St. Vladimir, who intercedes between the needy and the Almighty; the Rider of the Apocalypse, who punishes the unjust but protects the just at the Last Judgement; and Good and Evil, symbolized in al-most ornamental fashion in the bird of paradise and the hellhound. These pictures thereby combine the traditions of Russian icon painting with borrowings from Bavarian folk art, which also provided a source of inspiration for Gabriele Münter.

A striking feature of the series is that their frames, too, are often painted. Kandinsky decorates the wooden surrounds with dabs of colour and undulating lines, heightening the naïve, folk-art character of their subjects. Since most of these glass paintings are small in size, they may also be seen to represent a modern-day version of the domestic icon.

PAGE 71, ABOVE LEFT:
Angel of the Last Judgement, 1911
Engel des Jüngsten Gerichts
Glass painting, 26 x 17 cm
Munich, Städtische Galerie im Lenbachhaus

PAGE 71, ABOVE RIGHT:
Rider of the Apocalypse, 1911
Apokalyptischer Reiter
Tempera on glass, 29.5 x 20 cm
Munich, Städtische Galerie im Lenbachhaus

PAGE 71, BELOW LEFT:
St. Vladimir, 1911
St. Wladimir
Glass painting, 29 x 25.6 cm
Munich, Städtische Galerie im Lenbachhaus

PAGE 71, BELOW RIGHT:
With Rider, 1912
Mit Reiter
Watercolour on textured glass, 27.5 x 28 cm
Paris, Musée National d'Art Moderne,
Centre Georges Pompidou

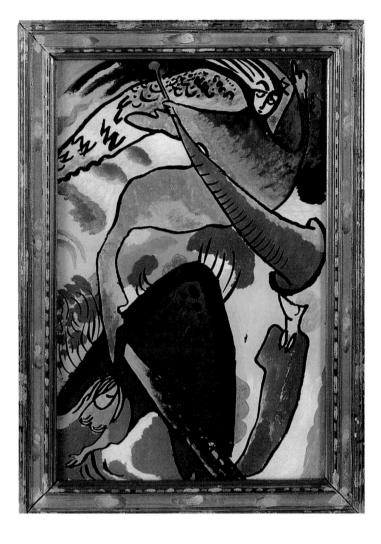

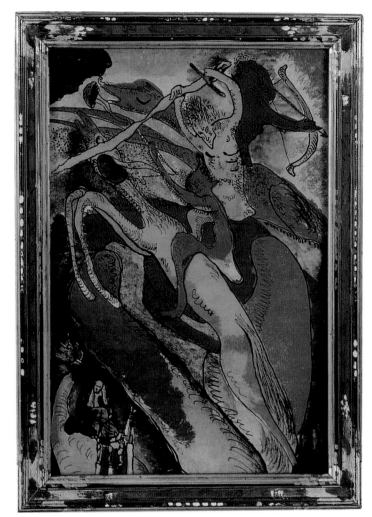

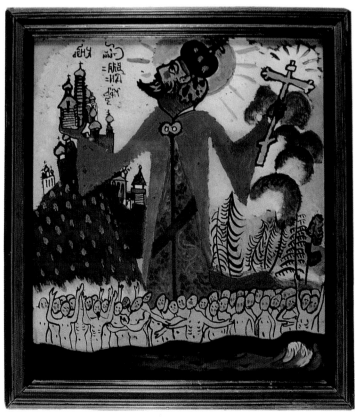

Vanity cabinet, c. 1910
Photograph
Munich, Gabriele Münter and Johannes Eichner
Foundation

Banisters with stencilled riders, c. 1910
Photograph
Munich, Gabriele Münter and Johannes Eichner
Foundation

The house which Gabriele Münter bought in
Murnau in 1909 was also intended as the home
to which the artist couple would retire in their
old age. Kandinsky had simple furniture made
for the interior, some of which he decorated him-
self with stylized flowers and riders on galloping
horses, painted with the aid of a stencil.

Stencil with rider, 1911
Pencil, card, cut out in places, traces of paint
from use, 24.2 x 33 cm
Munich, Städtische Galerie im Lenbachhaus

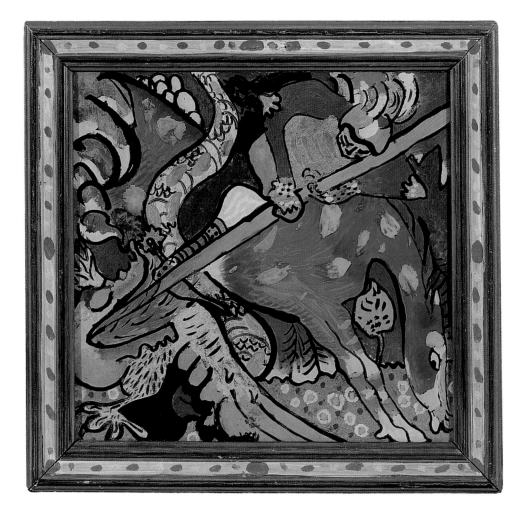

St. George I, 1911
St. Georg I
Glass painting, 19 x 19.7 cm
Munich, Städtische Galerie im Lenbachhaus

The dining room in the "Russians' Villa" in
Murnau, with glass paintings by Kandinsky, 1909
Photograph
Munich, Gabriele Münter and Johannes Eichner
Foundation

Improvisation 19, 1911
Oil on canvas, 120 x 141.5 cm
Munich, Städtische Galerie im Lenbachhaus

Kandinsky subtitled this painting *Blue Sound*. As in *Impression III (Concert)* from the same year, the composition is dominated by one colour in particular – in this case blue, applied with a dry brush.
"The deeper the blue becomes, the more strongly it calls man toward the infinite, awakening in him a desire for the pure and, finally, for the supernatural. It is the colour of the heavens, the same colour we picture to ourselves when we hear the sound of the word 'heaven'."
(Kandinsky in *On the Spiritual in Art*, 1912)

"My book *On the Spiritual in Art* and the *Blaue Reiter [Almanac]*, too," Kandinsky wrote in *Reminiscences* in 1913, "had as their principal aim to awaken this capacity for experiencing the spiritual in material and in abstract phenomena, which will be indispensable in the future, making unlimited kinds of experiences possible. My desire to conjure up in people who still did not possess it this rewarding talent was the main purpose of both publications."

Nude, 1911
Akt
Watercolour, 33.1 x 33 cm
Munich, Städtische Galerie im Lenbachhaus

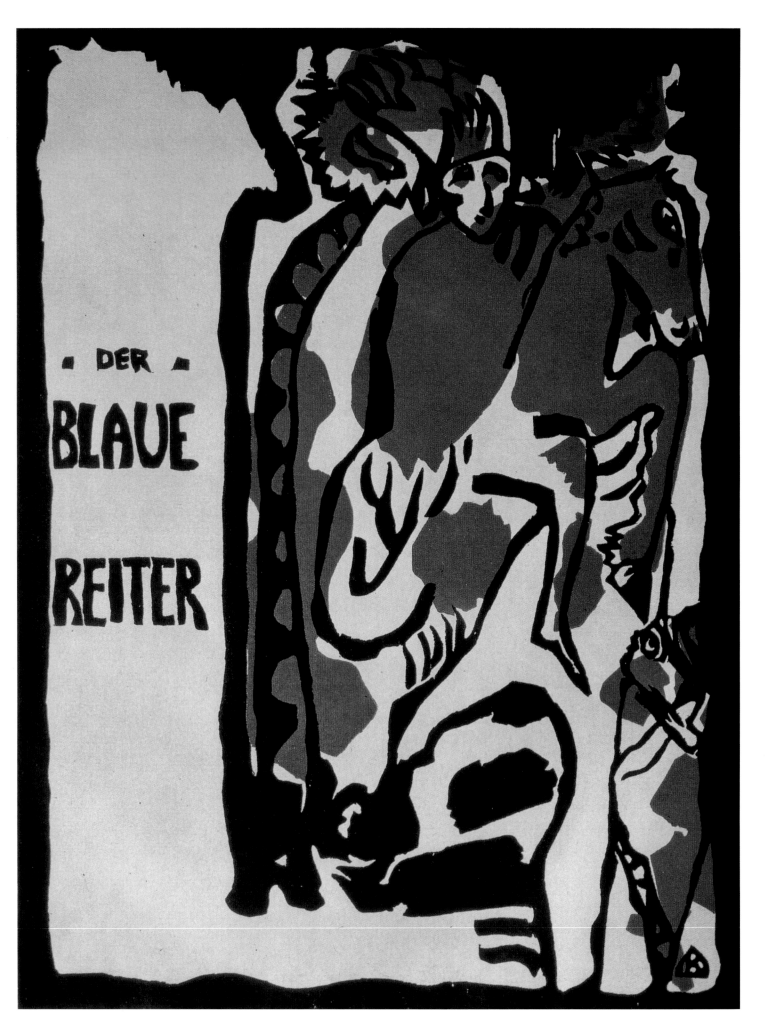

Der Blaue Reiter

"We've got our own room at Thannhauser's for the 2nd half of December, next door to the Vereinigung, in which we 2 can exhibit what we want", wrote Franz Marc to Kandinsky in November 1911. "So let's get down to business… My programme: Burliuk, Campendonk, August, some glass paintings, Schoenberg, Bloch, and if at all possible a Rousseau (not too big). Then Delaunay and perhaps two or three older things (rice-paper pictures, glass paintings, votives). It has to be a distinctive show."

Clearly, therefore, Marc had investigated the possibility of holding an alternative exhibition before making the official break with the Neue Künstlervereinigung. Thus it was that the first exhibition by the editors of Der Blaue Reiter opened on 18 December 1911 in Thannhauser's gallery (p. 80), in two rooms immediately adjoining the third and last show staged by the Neue Künstlervereinigung. The founders of Der Blaue Reiter (The Blue Rider), Marc and Kandinsky, had selected works by an international range of artists representing various stylistic trends. These included an *Eiffel Tower* shattering into particles of colour and form by Robert Delaunay (p. 82), a naïve village scene by Henri Rousseau (p. 83), who had just died in Paris, a portrait, dissolved into lozenges of colour, by the Russian painter Burliuk, Marc's exuberant *Yellow Cow* (p. 82), a realistic and charming bird painting by the Swiss artist Jean Bloé Niestlé, and Kandinsky's controversial *Composition V* (p. 81). There were also paintings by August Macke, Marc's close friend from Bonn, and by the composer and painter Arnold Schoenberg, with whom Kandinsky had conducted a regular exchange of ideas in letters since hearing the first concert of Schoenberg's music in Munich.

The first Blaue Reiter exhibition was accompanied by a modest five-page catalogue featuring a short introduction by Kandinsky:

"In this small exhibition, we do not seek to propagate any one precise and special form; rather, we aim to show by means of the variety of forms represented how the inner wishes of the artist are embodied in manifold ways."

On the very first day, Bernhard Koehler, Macke's uncle and an enthusiastic and generous patron of the Neue Künstlervereinigung and the Blaue Reiter, bought works by Kandinsky, Münter, Campendonk and Delaunay. Erbslöh and Jawlensky, "who have a positively inferior show in the neighbouring rooms and are simply flabbergasted by Franz and

Cover for the catalogue of the first Blaue Reiter exhibition, after 1911

"We invented the name 'Der Blaue Reiter' [The Blue Rider] while sitting at a coffee table in the garden in Sindelsdorf; we both loved blue, Marc horses and I riders. The name thus arose of its own accord."
(Kandinsky on the choice of the name for the *Blaue Reiter Almanac*)

PAGE 76:
Final design for the cover of the *Blaue Reiter Almanac*, 1911
Ink brush and watercolour over tracing and pencil, 27.9 x 21.9 cm
Munich, Städtische Galerie im Lenbachhaus

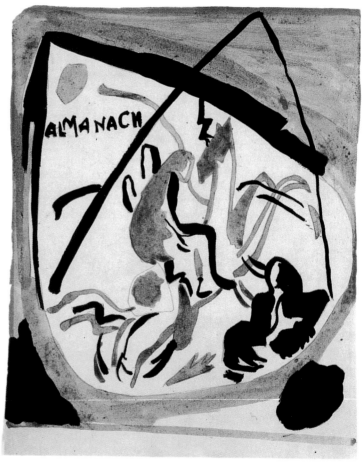

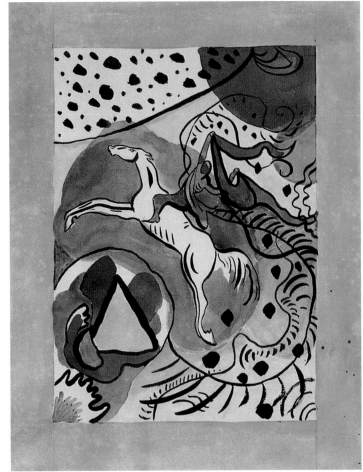

Kandinsky" (Maria Marc to Elisabeth Macke), each purchased a painting by Delaunay.

Kandinsky had long been toying with the notion of publishing some sort of almanac which, in addition to public exhibitions, would help propagate the latest ideas in art. It was particularly vital, he believed, to give artists themselves a chance to speak, since they were naturally the best qualified to talk about their aims and philosophies. He also deemed it necessary to offer an explanatory word on the contemporary trend away from naturalism, to which many critics were reacting with irritation. Such an explanation appeared all the more timely in view of the counter-offensive being launched from certain conservative – and especially anti-French – camps within Germany. Fears were being expressed that the country's museums were becoming dominated by foreign works of art, and that these posed a serious threat to home-grown art not just through their modernity but through their absorption of funds which could otherwise have gone to German artists.

It was in this climate that, at the start of 1911, the Worpswede artist Carl Vinnen published a militant paper protesting against the acquisition of French paintings by German museums. (The paper was actually inspired by the purchase of a van Gogh by the Bremer Kunsthalle; since van Gogh had spent the last years of his life in the South of France, he was generally counted as French.) Vinnen's paper prompted members of the Munich art scene to publish a counterattack, in which they argued on behalf of the French and their new art. The artists, critics, museum directors and gallery owners behind this second paper included Pauli, Osthaus,

Designs for the cover of the *Blaue Reiter Almanac*, 1911

PAGE 78, ABOVE LEFT:
Watercolour over pencil, 27.5 x 21.8 cm

PAGE 78, ABOVE RIGHT:
Watercolour over pencil, 28 x 21.7 cm

PAGE 78, BELOW LEFT:
Ink brush and watercolour over pencil, 30.6 x 23.9

PAGE 78, BELOW RIGHT:
Watercolour and ink brush over pencil and blue crayon, 27.7 x 22.3

PAGE 79, ABOVE LEFT:
Watercolour and ink over pencil, 27.7 x 21.8 cm

PAGE 79, ABOVE RIGHT:
Ink, watercolour and opaque white over pencil, 27.7 x 21.9 cm

All: Munich, Städtische Galerie im Lenbachhaus

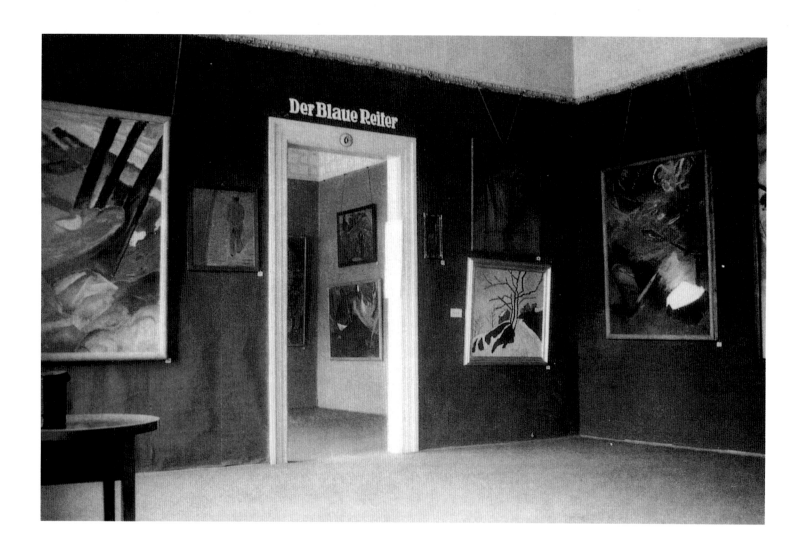

Gabriele Münter:
The first Blaue Reiter exhibition in Thann-
hauser's gallery, Munich, 1911–12
Photograph
Munich, Gabriele Münter and Johannes Eichner
Foundation

Inside the first Blaue Reiter exhibition (from left
to right): Franz Marc, *The Yellow Cow*; Arnold
Schoenberg, *Self-Portrait*; Vladimir Burliuk,
Portrait Study; Gabriele Münter, *Country Road
in Winter*; Franz Marc, *Deer in the Woods I*;
Wassily Kandinsky, *Composition V* (left-hand
edge only).

Inside the first Blaue Reiter exhibition at Thann-
hauser's gallery, Munich
Centre: Robert Delaunay, *Eiffel Tower*, 1911,
destroyed in 1945

Inside the first Blaue Reiter exhibition
Left: Robert Delaunay, *Saint-Séverin No. 1*, 1909
Right: Wassily Kandinsky, *Improvisation 22*,
1911

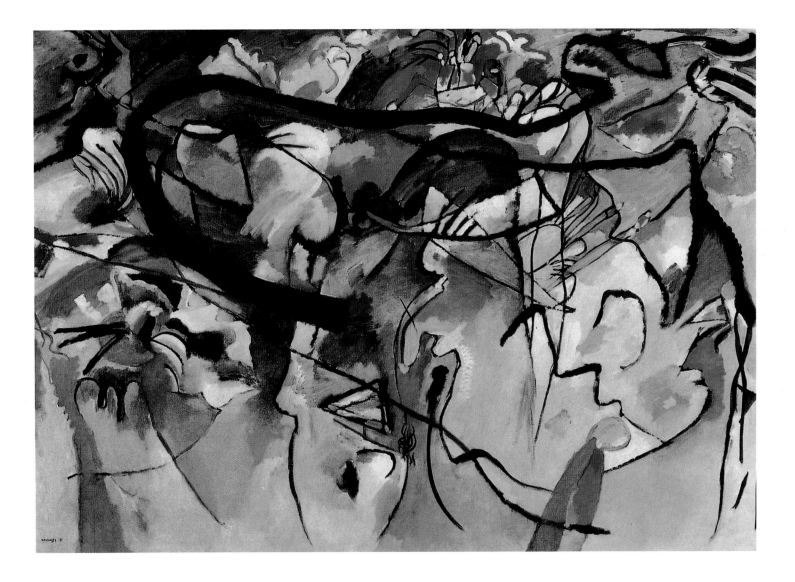

Reiche, Lichtwark, Liebermann, Slevogt, Rohlfs, Worringer, Hausenstein
and Uhde. It was a unique demonstration of solidarity by the leading
voices of modernism, who came together in defence of a liberal attitude
towards art untainted by nationalist bias. As Marc wrote in his own con-
tribution: "A strong wind is today blowing the germs of a new art across
all of Europe... The anger of a number of artists on German soil that the
wind is currently from the west seems truly ridiculous... For nor do they
want an east wind, since the same new seeds are blowing in from Rus-
sia... The wind bloweth where it listeth."

Kandinsky's idea of publishing a collection of essays by modern artists
began to take concrete shape over the course of 1911. Having already
completed a profound work of theory in his own *On the Spiritual in Art*,
he set about organizing the new project.

"I have a new idea," he wrote to Franz Marc in June 1911. "A kind of
almanac with reproductions and articles... and a chronicle!! that is, re-
ports on exhibitions reviewed by artists, and artists alone. In the book the
entire year must be reflected; and a link to the past as well as a ray to the
future must give this mirror its full life. The authors will probably not be
remunerated. Maybe they will have to pay for their own plates, etc. We
will put an Egyptian work beside a small Zeh [the surname of two Mun-
ich children at that time attracting attention with their talented draw-

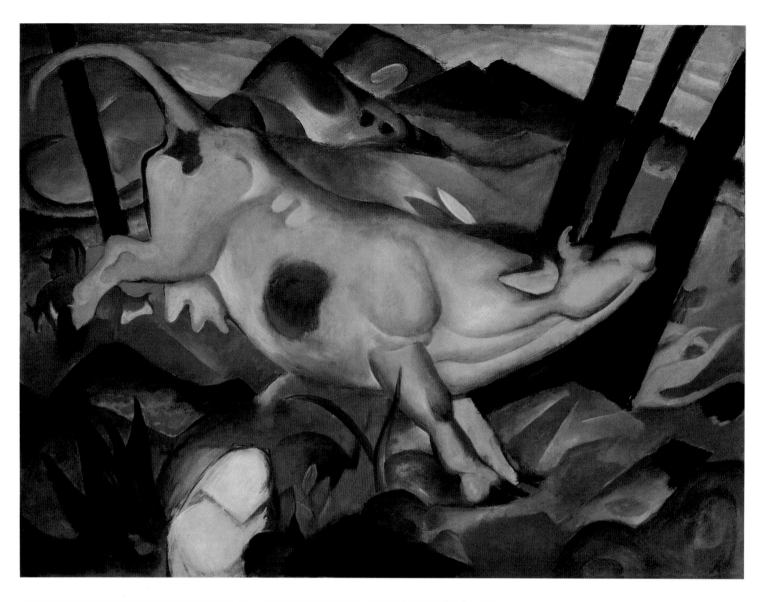

Franz Marc:
The Yellow Cow, 1911
Gelbe Kuh
Oil on canvas, 140.5 x 189.2 cm
New York, The Solomon R. Guggenheim
Museum

BELOW LEFT:
Robert Delaunay:
Eiffel Tower, 1911
Tour Eiffel
Oil on canvas, destroyed by fire in 1945, for-
merly Collection Bernhard Koehler, Berlin

BELOW RIGHT:
Franz Marc:
Deer in the Woods I, 1911
Reh im Walde I
Oil on canvas, 129.5 x 100.5 cm
Munich, Galerie Stangl, Franz Marc Bequest

"In this small exhibition, we do not seek to pro-
pagate any *one* precise and special form; rather,
we aim to show by means of the *variety* of forms
represented how the *inner wishes* of the artist are
embodied in manifold ways."
(Kandinsky in the foreword to the exhibition
catalogue)

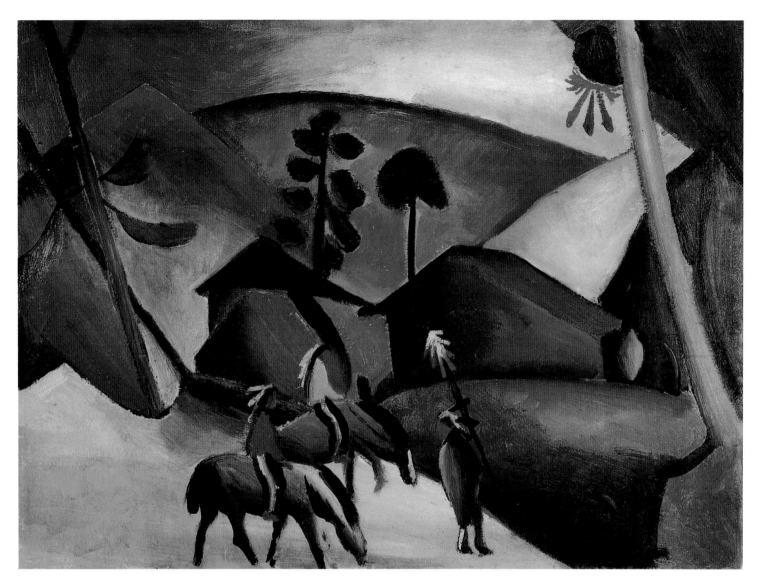

Henri Rousseau:
The Poultry Yard, 1896–98
La Basse-Cour
Oil on canvas, 24.6 x 32.9 cm
Paris, Musée National d'Art Moderne,
Centre Georges Pompidou

Gabriele Münter:
Dark Still Life (Secret), 1911
Dunkles Stilleben (Geheimnis)
Oil on canvas, 78.5 x 100.5 cm
Munich, Städtische Galerie im Lenbachhaus

August Macke:
Indians on Horseback, 1911
Indianer auf Pferden
Oil on panel, 44 x 60 cm
Munich, Städtische Galerie im Lenbachhaus

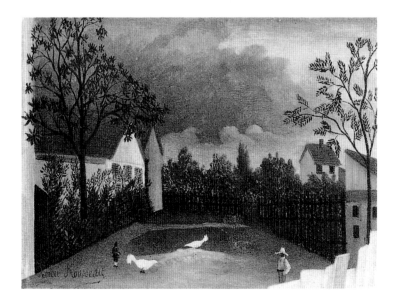

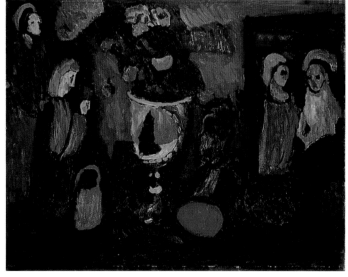

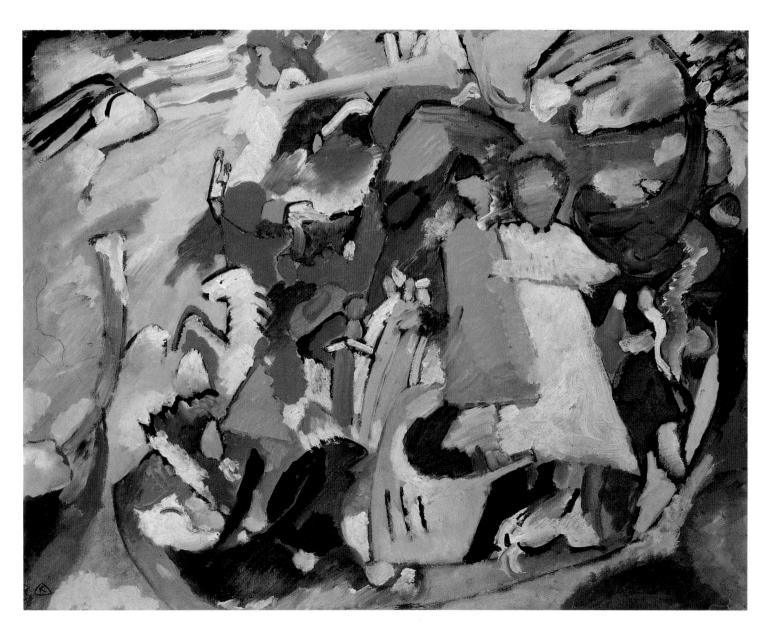

All Saints I, 1911
Allerheiligen I
Oil on card, 50 x 64.5 cm
Munich, Städtische Galerie im Lenbachhaus

ings], a Chinese work beside a Rousseau, a folk print beside a Picasso, and the like! Eventually we will attract poets and musicians. The book could be called 'The Chain' or some other title."

The *Blaue Reiter Almanac* was published in May 1912, backed by a guarantee of 3000 Marks put up by Bernhard Koehler. It was dedicated to the memory of Hugo von Tschudi, former director of the Bavarian State Galleries of Munich; von Tschudi, who had died in 1911, had been a friend of both Marc and Kandinsky and a vehement defender of modern art.

Kandinsky tells the following anecdote about the birth of the "Blue Rider" name: "We both loved blue, Marc horses and I riders. The name thus arose of its own accord." Blue, according to *On the Spiritual in Art*, is the typically heavenly colour. It points toward spiritual, transcendent spheres. The rider, a recurrent motif in Kandinsky's work, symbolizes the seeker and the fighter. As a name, therefore, Der Blaue Reiter stands for the spirit's battle against materialism, and for the victory of the avant-garde over tradition.

Kandinsky made ten preliminary watercolour studies for a cover for the *Almanac*, all of them exploring in different ways the notion of em-

All Saints I, 1911
Allerheiligen I
Glass painting, 34.5 x 40.5 cm
Munich, Städtische Galerie im Lenbachhaus

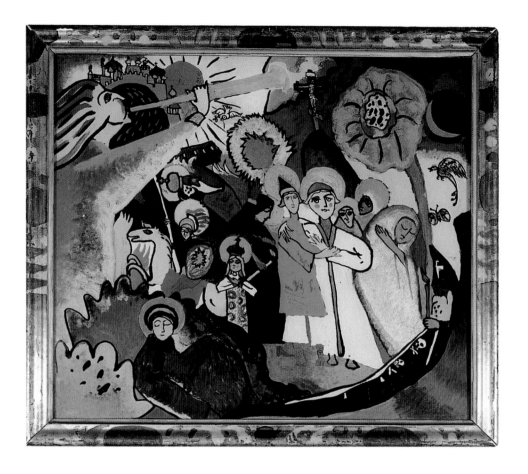

All Saints II, 1911
Allerheiligen II
Oil on canvas, 86 x 99 cm
Munich, Städtische Galerie im Lenbachhaus

Kandinsky treated the All Saints motif in a num-
ber of different ways: as a relatively figurative
glass painting inspired by naïve folk art, in a
semi-abstract oil painting incorporating elements
of the Apocalypse (p. 84), and in a dreamlike, vi-
sionary composition in which the proclamation
of the Last Judgement sends the formal compon-
ents spinning into animated confusion.

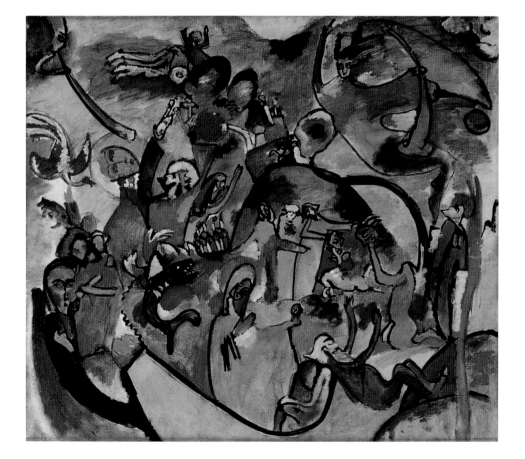

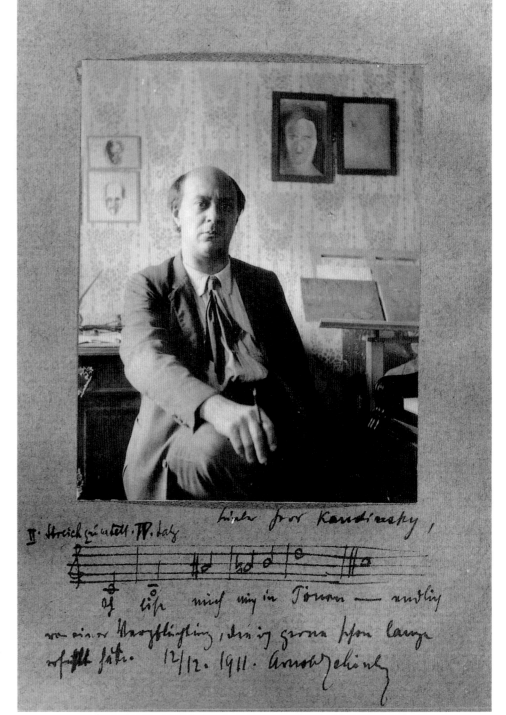

Arnold Schoenberg:
The Red Look, 1910
Der rote Blick
Oil on card, 32.3 x 24.6 cm
Munich, Städtische Galerie im Lenbachhaus
On loan from Mrs Nuria Nono

Arnold Schoenberg:
Postcard with dedication to
Wassily Kandinsky, 1911
Paris, Musée National d'Art Moderne,
Centre Georges Pompidou

Dedication to Kandinsky:
"Dear Mr. Kandinsky, I release myself (…?) in
notes – at last from an obligation which I would
like to have fulfilled long ago.
12.12.1911 Arnold Schoenberg"

Between 1911 and 1914 Kandinsky conducted a
lively correpondence with the composer and
painter Arnold Schoenberg, creator of atonal
music. Kandinsky was looking in painting for
what Schoenberg had already achieved in music:
a new harmony based purely on laws immanent
in art.

"Schoenberg's music leads us into a new realm,
where musical experiences are no longer acous-
tic, but *purely spiritual*. Here begins the 'music
of the future'."
(Kandinsky in *On the Spiritual in Art*, 1912)

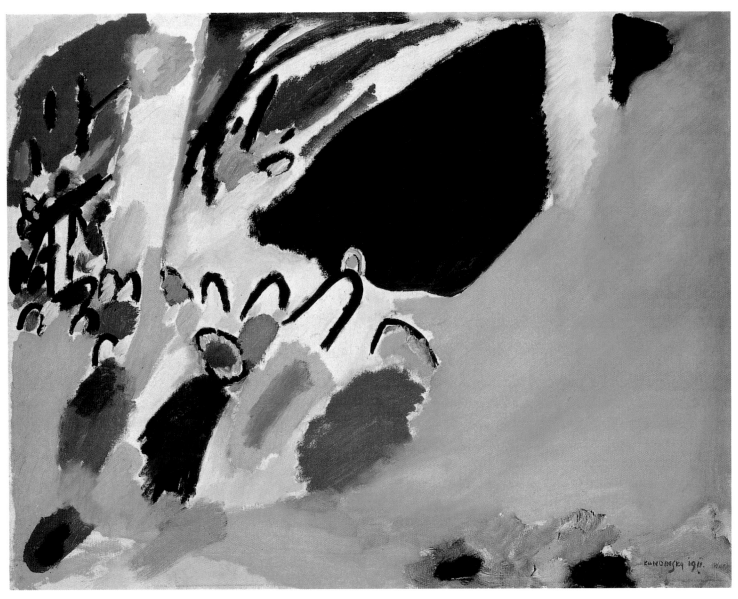

Impression III (Concert), 1911
Impression III (Konzert)
Oil on canvas, 77.5 x 100 cm
Munich, Städtische Galerie im Lenbachhaus

This painting arose shortly after Kandinsky had attended the first Munich concert of Schoenberg's music. The concert, given in January 1911, also marked the start of the correspondence between the two artists. The dominating colours are yellow and black, whereby the black form recalls the shape of a grand piano, the most important instrument in Schoenberg's concert. The painting reflects Kandinsky's capacity for intense synaesthetic experience. For him, the most powerful means of expression lay in the sound of colours, which he believed both could and should be dissonant ("The opposite of harmony is disharmony. And throughout the history of the painting the disharmony of yesterday has always become the harmony of today."). In *On the Spiritual in Art*, Kandinsky described the properties of yellow and black as follows: "Yellow...is disquieting to the spectator, pricking him, stimulating him, revealing the nature of the power expressed in this colour, which has an effect upon our sensibilities at once impudent and importunate. This property of yellow, a colour that inclines considerably toward the brighter tones, can be raised to a pitch of intensity unbearable to the eye and to the spirit. Upon such intensification, it affects us like the shrill sound of a trumpet being played louder and louder, or the sound of a high-pitched fanfare...

Black has an inner sound of...an eternal silence without future, without hope... Black is externally the most toneless colour, against which all other colours...sound stronger and more precise."

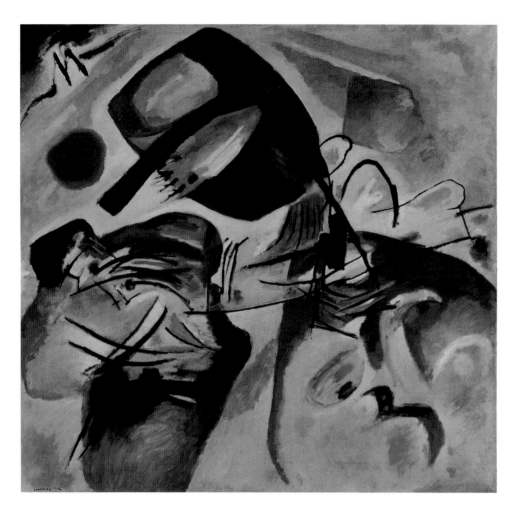

Picture with a Black Arch, 1912
Bild mit schwarzem Bogen
Oil on canvas, 188 x 196 cm
Paris, Musée National d'Art Moderne,
Centre Georges Pompidou

"Painting is like a thundering collision of differ-
ent worlds that are destined in and through con-
flict to create that new world called the work.
Technically, every work of art comes into being
in the same way as the cosmos – by means of
catastrophes, which ultimately create out of the
cacophony of the various instruments that sym-
phony we call the music of the spheres."
(Kandinsky in *Reminiscences*, 1913)

barking upon the new, and all of them featuring the motif of the rider. In
one case this takes the form of a static combination of a horse and child
rider on the summit of a mountain (p. 78, above left), in which the rider
holds aloft a blue cloth to greet a new age in a flat, almost symmetrical
composition reminiscent of traditional glass painting. Elsewhere, on the
other hand, Kandinsky places greater emphasis on movement, setting a
galloping rider holding a blue cloth against a red halo (p. 78, above right).
Blue and red are here employed in a powerfully resonant contrast.

In another study (p. 79, above left), the rider appears deep in the top
left-hand corner, charging across the heavens. Kandinsky's use of oppos-
ing diagonals infuses the composition with a powerful dynamism and car-
ries it further away from the representational world. This pronounced di-
agonal movement reappears in another version (p. 79, above right), al-
though in this case it is modified by compositional elements such as the
field of black dots above left, the daubs of black scattered across the sur-
face and the independent undulating lines below right. This picture in-
cludes a new motif, seen in the bottom left-hand corner: a yellow triangle
against a blue, irregularly-shaped background, which has been variously
interpreted as a sailing boat, a geometrical form in the mystical sense,
and a miniature mountain over which the rider is jumping.

In another case (p. 78, below left), the rider is depicted only schemati-
cally by a black outline within a blue oval, while the remaining forms in
the picture correspond to no obviously recognizable objects. The motif of
the charging rider has here been reduced to an emblem.

Kandinsky adopts a more narrative, situational approach in another version (p. 78, below right): horse and rider are stopped by the irregular dark form of a figure kneeling before them. This figure may be interpreted as the beggar who appeared before St. Martin or the dragon confronting St. George.

St. George is also the centrepiece of the design finally chosen for the cover of the *Blaue Reiter Almanac* (p. 76). Beneath the horse's rearing front hooves we see the king's daughter, destined to be sacrificed to the dragon before her legendary rescue by St. George. Of the dragon itself, only the mottled tail is visible.

The story of St. George and the dragon was a popular theme both in Russian icon painting and in Bavarian votive art. Kandinsky treated the motif of the dragon-slayer in a number of media, including oils, glass paintings, woodcuts and sketches. In *St. George I*, a glass painting of 1911 (p. 73), the saint is a fearless knight portrayed in the act of dealing the deathblow to his opponent. Kandinsky expresses the dramatic tension of the situation through his use of opposing diagonals. The chief line of movement runs top right to bottom left though the lance, ending in a patch of orangey-red – the wound in the dragon's hindquarters. This line is crossed by the second main diagonal, indicated by the fiercely-braking horse. Line and colour – the unnatural blue of the horse, the yellow dots and strident patches of red – combine to form an animated composition which captivates the viewer through its dramatic intensity and immediacy.

The rider in the final design for the *Almanac's* cover is similarly a symbol of the warrior and the saviour. He brings society, personified in the virgin, salvation from the evils of materialism, represented by the dragon.

Picture with a White Form, 1913
Bild mit weißer Form
Oil on canvas, 120.3 x 139.6 cm
New York, The Solomon R. Guggenheim Museum

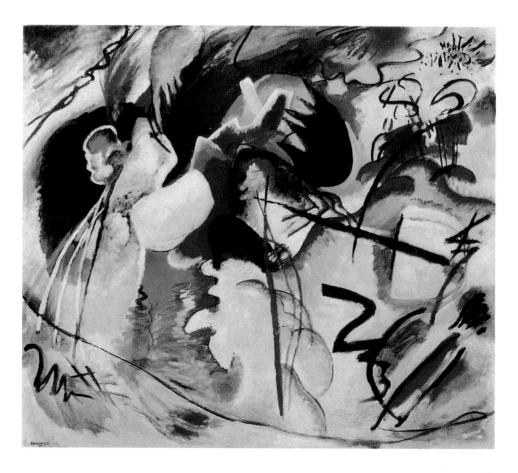

Lady in Moscow, 1912
Dame in Moskau
Oil on canvas, 108.8 x 108.8 cm
Munich, Städtische Galerie im Lenbachhaus

A woman in a street is surrounded by an aura blue shadow. A yellow sun shines above her. A black form is thrusting its way in front of the sun, threatening to obscure it and thereby extinguish all life. A dramatic confrontation between sun and darkness as the spiritual and the material, symbolized by the colours yellow and black: "Black has an inner sound of nothingness bereft of possibilities, a dead nothingness as if the sun had become extinct…"

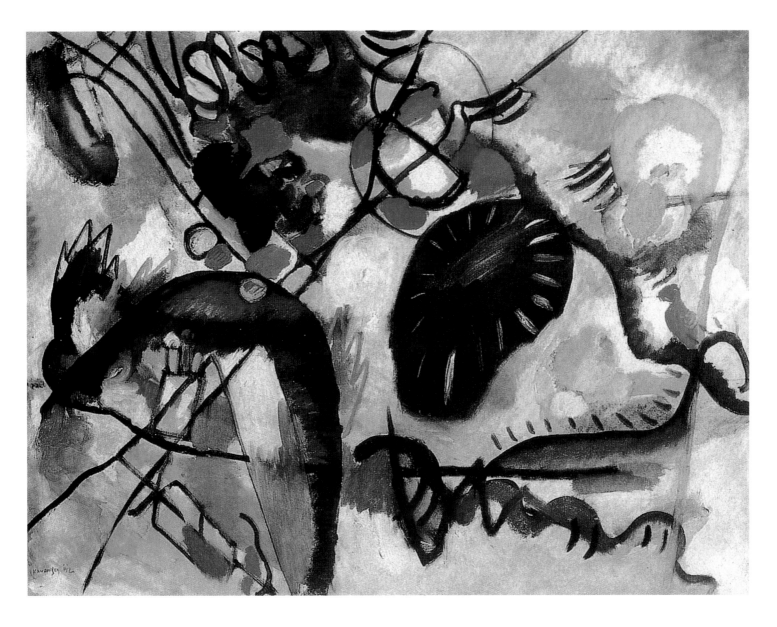

Black Spot I, 1912
Schwarzer Fleck I
Oil on canvas, 100 x 130 cm
St. Petersburg, State Russian Museum

Painted shortly after *Lady in Moscow*, this picture takes up the same motif of the
black form, here set within an abstract composition. Further links between the two
works are established by the troika and the yellow, sun-like circular form. Repres-
entationalism is here replaced by a free handling of pictorial elements; the drama of
the scene is determined by the charged constellation of colour and form.

Composition VI, 1913
Komposition VI
Oil on canvas, 195 x 300
St. Petersburg, Hermitage

"In this picture one can see two centres:
1. on the left the delicate, rosy, somewhat blurred centre, with weak, indefinite lines in the middle;
2. on the right (somewhat higher than the left) the crude, red-blue, rather discordant area, with sharp, rather evil, strong, very precise lines. Between these two centres is a third (nearer to the left), which one only recognizes subsequently as being a centre, but is, in the end, the principal centre. Here the pink and the white seethe in such a way that they seem to lie neither upon the surface of the canvas nor upon any ideal surface. Rather, they appear as if hovering in the air, as if surrounded by steam. This apparent absence of surface, the same uncertainty as to distance can, e.g., be observed in Russian steam baths. A man standing in the steam is neither close to nor far away; he is just somewhere. This feeling of 'somewhere' about the principal centre determines the inner sound of the whole picture." (Kandinsky in *Reminiscences*, 1913)

The motif of the rider as saviour featured in other works reproduced in the *Almanac*, for example in a Bavarian mirror painting showing St. Martin cutting his cloak in half to give it to the beggar, which appeared as the frontispiece opposite the title page. It subsequently recurred in *Archer*, the colour woodcut forming the second frontispiece to the de luxe edition of the *Almanac*, whose motif is the same as that of Kandinsky's large oil, *Picture with Archer*, of 1909 (p. 45). Peg Weiss has identified the rider here as Apollo, the divine archer who wards off evil and brings salvation.

The *Almanac* embraced a broad range of topics. It comprised essays on painting, music and theatre, plus modern compositions by Arnold Schoenberg, Anton von Webern and Alban Berg. The texts were accompanied by 144 illustrations, including Bavarian and Russian folk art, medieval woodcuts, Egyptian shadow-play figures, dance masks, sculpture from Cameroon and Mexico, Chinese paintings, Japanese pen-and-ink drawings, classical art and children's drawings. In addition to works by Kandinsky, Marc and Kubin, modern art was represented by Picasso, Delaunay, Matisse and the Berlin group Die Brücke (The Bridge), as well as by the "fathers of Modernism" van Gogh, Cézanne, Gauguin and Rousseau. In keeping with the ideas of Blaue Reiter editors Kandinsky and Marc, the illustrations were chosen for their "internal life", their true "inner sound". They were then juxtaposed within the *Almanac* so that the "inner sound" of one work would bring out the "counter-resonance" of another. "If the reader of this book is temporarily able to banish his own wishes,

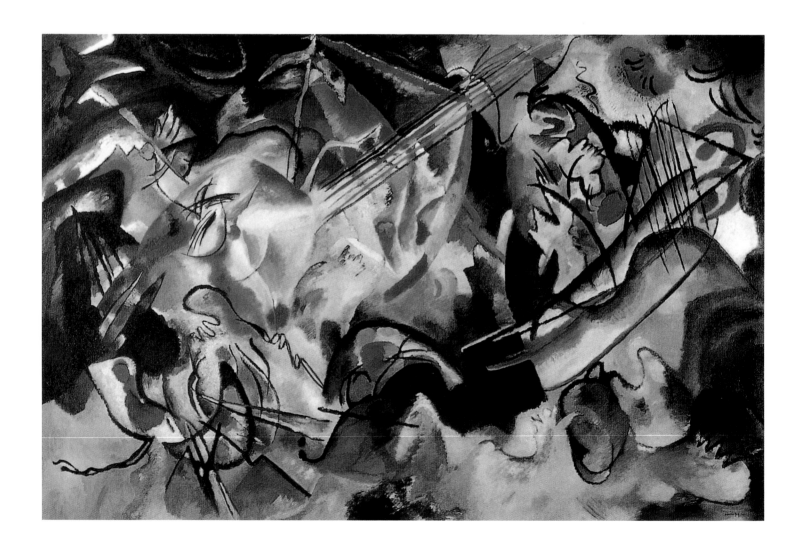

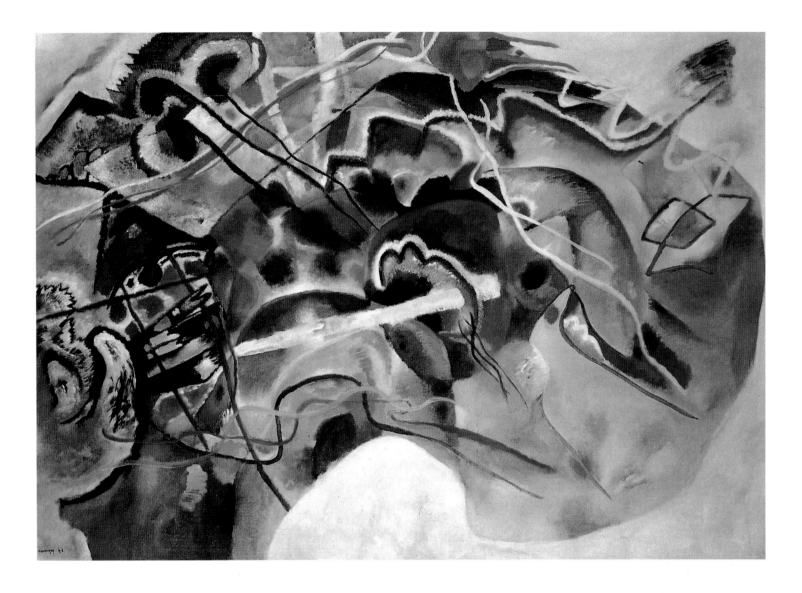

thoughts and feelings, and then leafs through the book, passing from a vo-
tive picture to Delaunay, from Cézanne to a Russian folk-print, from a
mask to Picasso, from a glass picture to Kubin, etc.," wrote Kandinsky in
his *Almanac* essay "On the Question of Form", "then his soul will experi-
ence a multitude of vibrations and enter into the realm of art… These vi-
brations and the plus that derives from them will be a kind of enrichment
of the soul that cannot be attained by any other means than those of art."

Almost half the texts in the *Almanac* were written by Kandinsky him-
self. He was the driving force behind the project, editing and translating
the contributions from Russian authors and organizing the reproductions.
He was enthusiastically supported by Franz Marc, "an absolute magician
and on top of that a true friend," as Kandinsky wrote to Alfred Kubin.

In 1914 the *Almanac* went into a second edition. A second volume was
planned, but never published. There was, however, one more Blaue Rei-
ter exhibition, held in 1912 at Hans Goltz's gallery in Munich. The ex-
hibition was devoted to over 300 works on paper by German, French and
Russian artists, and included a large number of watercolours by the art-
ists of Die Brücke – still largely unknown in Munich – which Marc had
brought back from Berlin. Paul Klee, Kandinsky's neighbour in Ainmil-
lerstraße, also exhibited for the first time with the Blaue Reiter at this ex-
hibition. He had met Kandinsky, Marc and Macke at the anatomy class

With a White Border, 1913
Mit weißem Rand
Oil on canvas, 140.3 x 200.3 cm
New York, The Solomon R. Guggenheim
Museum

"I had no desire to introduce into this admittedly
stormy picture too great an unrest. Rather, I
wanted, as I noticed later, to use turmoil to ex-
press repose… I treated this white edge itself in
the same capricious way it had treated me: in the
lower left a chasm, out of which rises a white
wave that suddenly subsides, only to flow
around the right-hand side of the picture in lazy
coils, forming in the upper right a lake…, disap-
pearing toward the upper left-hand corner, where
it makes its last, definitive appearance in the pic-
ture in the form of a white zigzag."
(Kandinsky in *Reminiscences*, 1913)

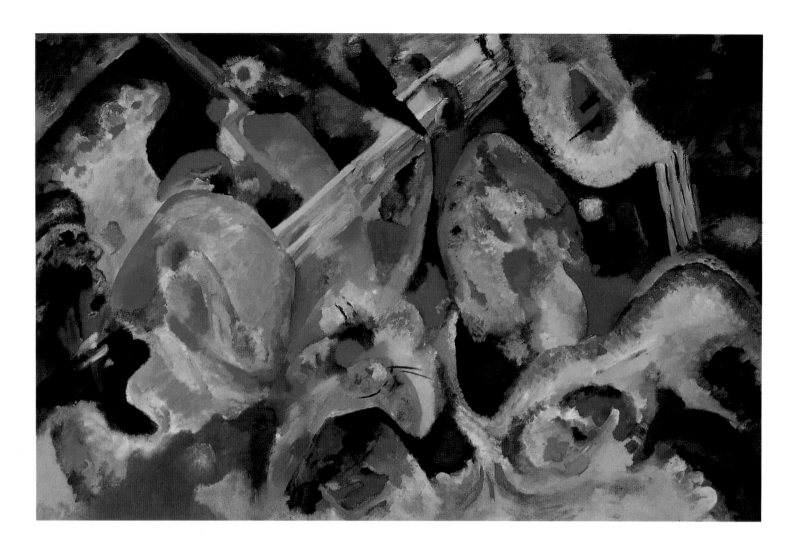

Improvisation Deluge, 1913
Improvisation Sintflut
Oil on canvas, 95 x 150 cm
Munich, Städtische Galerie im Lenbachhaus

"Nothing could be more misleading than to dub
this picture the representation of an event. What
thus appears a mighty collapse in objective terms
is, when one isolates its sound, a living paean of
praise, the hymn of that new creation that fol-
lows upon the destruction of the world."
(Kandinsky in the album *Sturm*, 1912)

run by Louis Moilliet and was particularly impressed by Kandinsky:
"Since meeting him personally I have come to have faith in him. He def-
initely is somebody, and he has an exceptionally beautiful and clear head."

While the second Blaue Reiter exhibition was on show in Munich, the
first exhibition went on tour. Its first stop was the Gereonsclub in Co-
logne, run by Emmi Worringer. Emmi was the sister of Wilhelm Wor-
ringer, whose book *Abstraction and Empathy* (*Abstraktion und Ein-
fühlung*), published in 1907, had particularly fascinated the Blaue Reiter
artists. Worringer contradicted the traditional assumption that fine art had
to be an imitation of nature. He argued that each work of art was an inde-
pendent organism, and that abstraction was the primary means by which
art could assimilate reality. Understandably, the artists around Kandinsky
drew upon Worringer's ideas in support of their own endeavours.

Cologne was followed by Berlin, Bremen, Hagen and finally Frankfurt
am Main. In Berlin, significantly, the exhibition was held in Herwarth
Walden's newly-opened *Sturm* gallery. Herwarth Walden was a writer,
composer and art critic who had become an ardent supporter of Expres-
sionism, championing the new style both in his magazine *Der Sturm*,
founded in 1910, and in his gallery of the same name. By Expressionism
Walden meant all the new movements in art that were turning away from
the imitation of nature and exploring non-representational forms of ex-
pression.

In October 1912 Herwarth Walden organized Kandinsky's first large

one-man show, comprising 73 works from the years 1902 to 1912 and including Murnau landscapes, lyrical compositions and purely abstract works. In 1913, the Sturm Verlag also published Kandinsky's essay *Painting as Pure Art*. Despite Walden's support, however, criticism of Kandinsky's work was growing. His pictures were derided as "idiocy" by the press. Kandinsky, by now very close to his goal of abstraction, found himself increasingly misunderstood and forced onto the defensive: "I do not want to paint music. I do not want to paint states of mind... I do not want to alter, contest, or overthrow any single point in the harmony of the masterpieces of the past. I do not want to show the future its true path. Apart from my theoretical works, which until now from an objective, scientific point of view leave much to be desired, I only want to paint good, necessary, living pictures, which are experienced properly by at least a few viewers."

"I myself don't believe that painting must necessarily be objective. Indeed, I firmly believe the contrary. Nevertheless, when imagination suggests objective things to us, then, well and good – perhaps this is because our eye perceives only objective things. The ear has an advantage in this regard! But when the artist reaches the point at which he desires only the expression of inner events and inner scenes in his rhythms and tones, then the 'object in painting' has ceased to belong to the reproducing eye."
(Schoenberg to Kandinsky, 1911)

Improvisation 26 (Rowing), 1912
Improvisation 26 (Rudern)
Oil on canvas, 97 x 107.5 cm
Munich, Städtische Galerie im Lenbachhaus

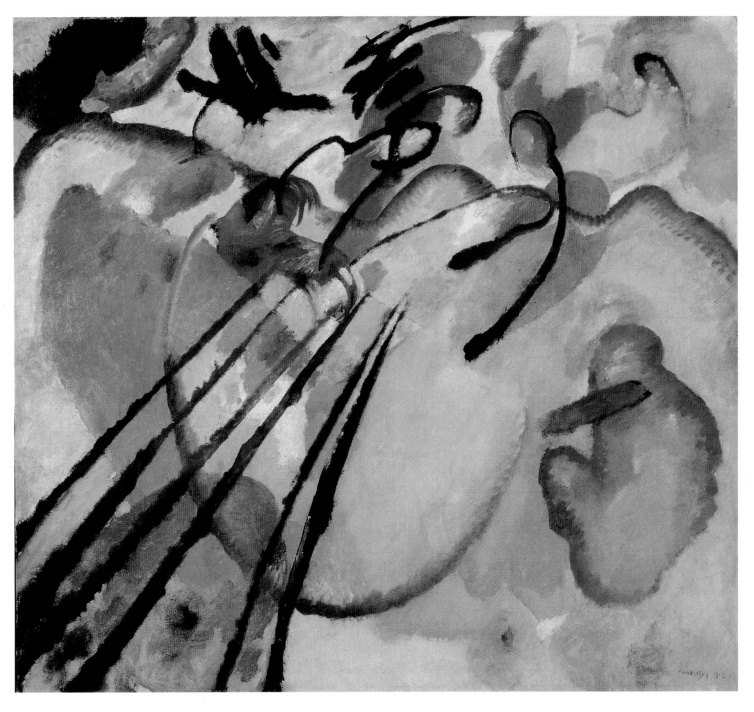

Notes and Sketches on Colour Theory, c. 1913
Ink and black chalk on writing paper, each 27.5 x 21.1 cm
Munich, Städtische Galerie im Lenbachhaus

Here Kandinsky explores the relationship between colour and contour and the effects of colour on the edges of neighbouring colours. Following his exhaustive investigations into the interplay of colour and form, Kandinsky was later to conclude: "'Absolute means' do not exist in painting; its means are relative only. This is a positive and cheering fact, since it is from interrelation that the unlimited means and inexhaustible richness of painting arise."
(Kandinsky in "The Value of a Concrete Work", *XXe Siècle*, 1938)

These words, cited from the Cologne lecture of 1914, reveal Kandinsky's despondent and almost sullen reaction to public criticism. It is significant that this lecture, which Kandinsky wrote to mark the opening of an exhibition of his work in Cologne, was not in fact delivered – the public was considered "confused enough already" by his pictures. Kandinsky's theories were too new and too irritating; his "principle of internal necessity", which he understood as a "spiritual" principle, the sole authority, free from all obligation to nature, met with little comprehension amongst his audience.

To this must be added Kandinsky's own reticent nature and his unwillingness to "thrust something under people's noses like a market crier". Kandinsky found displays of personal emotion embarrassing, which is why he had little time for German Expressionism, especially when it came to the pathos of Die Brücke. How he was feeling was of no one else's concern. His work on his art, his breakthrough to abstraction, was itself a way of hiding his feelings. As he also stated in his writings, he believed that certain spirtually-enriching experiences could be attained solely through art, and through no other means. "Vibrations from the soul" of this kind could only be produced by art, and not by words. Thus every attempt to explain his latest steps along the road to abstraction was doomed from the outset.

The years between the publication of the *Blaue Reiter Almanac* and the outbreak of the First World War were decisive in Kandinsky's artistic development. Slowly but surely he freed himself from naturalism. Although objects are not entirely left out of his pictures, they are reduced to their formal essentials (a process of "the exclusion of the real" which intensifies "the inner sound of the picture"), while colour is absolved of all descriptive duties and given its autonomy. Thus Kandinsky arrived at an entirely new pictorial language consisting of purely pictorial means, in which the work of art became "a being with its own inner life".

Since 1909 Kandinsky had been titling his works "Impression", "Improvisation" or "Composition", depending on the source of their inspiration. Thus an "impression" was the result of a direct impression of external nature, while an "improvisation" was inspired by an impression of internal nature, something unconcious and spontaneous. A "composition", on the other hand, was conscious and deliberate, and was often preceded by numerous studies.

In *Improvisation 26 (Rowing)* of 1912 (p. 95), the degree of abstraction is already far advanced. For viewers familiar with Kandinsky's simplified formal language, however, the curving black lines above the oars can quickly be deciphered as three figures, the red line scooping beneath as a boat, and the undulating red line passing through the figures as the surface of the water. These graphic elements are utterly ignored by the large and small fields of colour lying behind them, which pay no attention to the linear boundaries they indicate. We are dealing here with two different pictorial planes: one graphic, object-related plane, which is dominated by the pronounced diagonal of the oars and which infuses a powerful element of tension into the almost square painting, and a second plane of free zones of luminous, modulated colours which determine the picture's resonance. The eye is drawn first to the large area of bright yellow,

Compositional sketch for *Black Strokes*, 1913
Schwarze Striche
Black chalk on grey paper, 21 x 20.5 cm
Munich, Städtische Galerie im Lenbachhaus

Nervous graphic elements overlay a field of resonant colour masses. The picture abandons all reference to concrete reality to become a purely formal and chromatic experience, anticipating characteristics of Tachisme and the automatic writing of Abstract Expressionism.

PAGE 99:
Black Lines I, 1913
Schwarze Linien I
Oil on canvas, 129.4 x 131.1 cm
New York, The Solomon R. Guggenheim Museum, Gift of Solomon R. Guggenheim, 1937

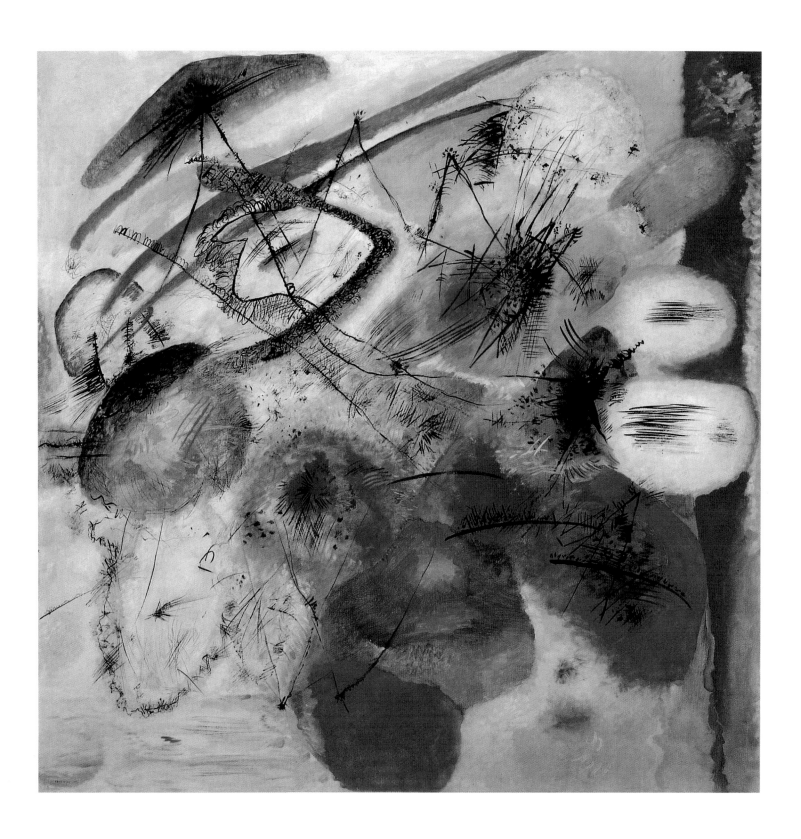

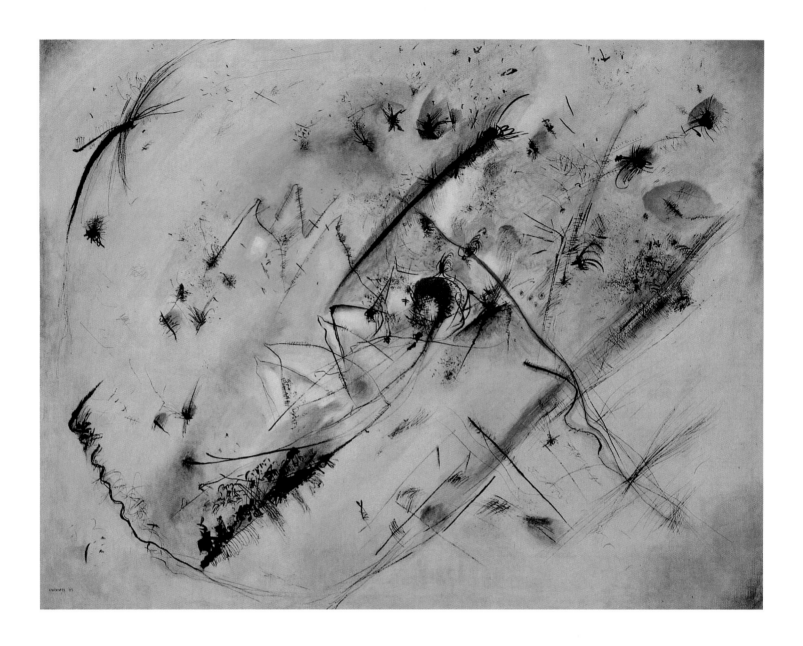

Bright Picture, 1913
Helles Bild
Oil on canvas, 77.8 x 100.2 cm
New York, The Solomon R. Guggenheim Museum, Gift of Solomon R. Guggenheim, 1937

which is tensely juxtaposed with a patch of outward-thrusting blue. Red, the third primary colour, is used more sparingly. In its warmth, however, it replies to the sharp contrast of blue and yellow. "Opposites and contradictions – this is our harmony," wrote Kandinsky in *On the Spiritual in Art*. "Composition on the basis of this harmony is the juxtaposition of colouristic and linear forms that have an independent existence as such, derived from internal necessity, which create within the common life arising from this source a whole that is called a picture."

Not all Kandinsky's works from this period are as close to abstraction as *Improvisation 26 (Rowing)*, however. Around 1911 he produced a number of pictures with religious themes in which figures and objects are stylized in the manner of folk art (*All Saints, Deluge, St. George*). In this case his inspiration came from Bavarian glass painting, with its bold colours and naïve forms of expression.

Kandinsky painted a number of versions of *All Saints* in watercolour, oil, and on glass (pp. 84/85). Underlying such All Saints pictures was the vision of an *unio sanctorum*, a chorus of saints which, together with representatives of every race, nation and language, worships the Lamb,

the symbol of Christ. Kandinsky frequently expanded this theme to include the Last Judgement and the Apocalypse. In the oil painting *All Saints I* of 1911 (p. 84), he focusses upon the onset of natural catastrophes and the Apocalypse. Only a few details can be confidently identified: a trumpeting angel (heralding the arrival of the Last Judgement), a rider, and two figures standing close together facing towards the viewer. The remaining fragments can no longer be deciphered. The picture dissolves into an animated tangle of splintered forms in light, cool colours, thrown into a spiralling vortex by the blast of the trumpet. In *All Saints II* (p. 85, below), by contrast, numerous figures are clearly outlined and the whole is closer to the glass paintings. The composition is nevertheless looser than in the first version, with the figures appearing to float in space as if in a trance.

Entirely different again was the monumental *Picture with a Black Arch* of 1912 (p. 88). It is a wholly abstract composition. The pictorial plane is dominated by three powerful colour forms which appear to be moving towards collision. The underlying theme of the painting is battle and conflict, bringing to mind Kandinsky's words from *Reminiscences*: "Painting is like a thundering collision of different worlds that are destined in and through conflict to create that new world called the work. Technically, every work of art comes into being in the same way as the cosmos – by means of catastrophes, which ultimately create out of the cacophony of the various instruments that symphony we call the music of the spheres." As if in a cosmic vortex, the forms in *Picture with a Black Arch* appear to rotate around the centre in a slow but inexorable movement. The dramatic atmosphere of coalition and opposition between the colours and forms is fuelled above all by the threateningly heavy red-violet form at the upper edge of the composition.

In its shape and position, this red-violet form resembles the enigmatic black form in *Lady in Moscow* (p. 90), which also dates from 1912. Here, two purely painterly inventions – an opaque black block and a pink, cloud-like disk – are incorporated into a relatively naturalistic Moscow street scene in a strange and disconcerting manner. The icon-like figure of the woman in the foreground, surrounded by a blue aura, harks back to glass painting, while the street vanishing towards the towers of the Kremlin, with its carriage, dog and messenger, recall Kandinsky's street scenes from Murnau and Munich. These influences combine with abstract formations, such as the black, sharply defined form appearing to insert itself between the woman and the sun, into a mysterious and dramatic composition. The woman's aura can be interpreted as a protective cloak, a zone of vital energy which issues from the sun. The black patch is steering towards this vital energy and is already starting to block the sun. According to Riedl, the black patch can be read as the "fall of materialistic darkness over the sphere of communication between eternal light and beings in search of enlightenment", a reference to theosophical ideas, which Kandinsky had studied in depth.

Shortly after *Lady in Moscow*, Kandinsky painted *Black Spot I* (p. 91). The only surviving allusions to the representational world are found in an onion-domed church perched on a mountain in the bottom left-hand corner, and a three-horse carriage driving out of the picture above left – the

Kandinsky in Munich, 1913
Photograph
Paris, Collection Gilles Néret

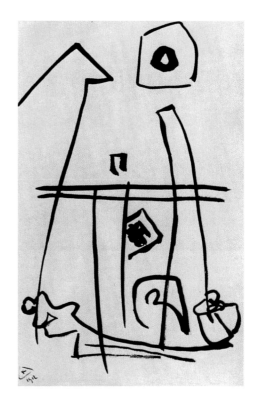

Drawing No. 5, 1912
Zeichnung Nr. 5
Ink, 29.5 x 14 cm. Paris, Musée National d'Art Moderne, Centre Georges Pompidou

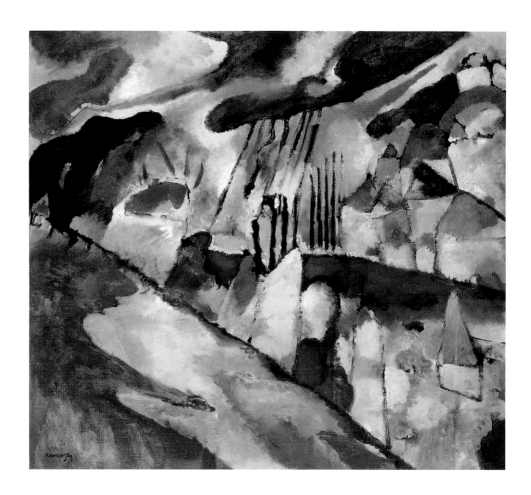

Landscape with Rain, 1913
Landschaft mit Regen
Oil on canvas, 70.2 x 78.1 cm
New York, The Solomon R. Guggenheim
Museum

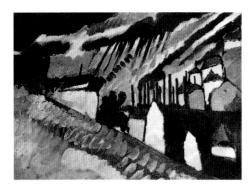

Study for *Landscape with Rain*, 1910
Landschaft mit Regen
Oil on card, 33 x 45.5 cm
Paris, private collection

motif of the Russian troika which appeared frequently in Kandinsky's work. A preliminary sketch for the picture also indicates a boat carrying two people whose oars overlap the black spot of the title. In the final oil painting, the black spot is a kidney-shaped form positioned slightly to the right of centre. The blue-black arch located to the left and in front of the spot and the sun-like circular form above it to the right give rise to a diagonal line of movement which, in conjunction with the black graphic elements, maintains the composition in a state of taut equilibrium. Unlike its counterpart in *Lady in Moscow*, the black spot here is not a monochrome plane, but is modulated by lines and rays of white. According to Kandinsky, the "pure colour black" upset him even as a child. Recalling a trip to Europe with his parents when he was three, he remembered the whole of Italy as "coloured by two memories in black". He perceived black as a toneless colour, "extinguished, like a spent funeral pyre". On the other hand, black served to amplify the resonance of all the other colours, including even the weakest. It was this property that attracted Kandinsky to employ black not just for outlines but as an independent pictorial form in its own right.

One of the most significant paintings of Kandinsky's Munich years is undoubtedly his *Composition VI* of 1913 (p. 92). It is all the more interesting since Kandinsky has left us a detailed account in his *Reminiscences* of the difficulties he experienced during its composition: "I carried this picture around in my mind for a year and a half, and often thought I would not be able to finish it." The starting-point for the composition was *The Deluge*, a now lost glass painting "that I had made more for my own

Improvisation Gorge, 1914
Improvisation Klamm
Oil on canvas, 110 x 110 cm
Munich, Städtische Galerie im Lenbachhaus

This picture was painted directly after a trip to
the Höllental gorge with Gabriele Münter in July
1914. Shortly afterwards, following the outbreak
of the First World War, Kandinsky separated
from Gabriele Münter and left Munich to return
to Russia. The painting undoubtedly contains
some personal reminiscences (couple in Ba-
varian dress, rowing boat); in its structural tur-
moil and shrill blue-yellow contrasts, however, it
assumes a more general, threatening significance.

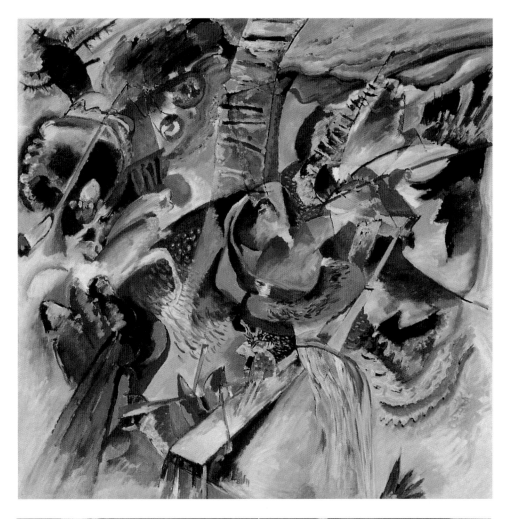

Improvisation 30 (Cannons), 1913
Improvisation 30 (Kanonen)
Oil on canvas, 109.2 x 109.9 cm
Chicago (IL), The Art Institute of Chicago,
Arthur Jerome Eddy Memorial Collection,
1931.511

"The designation 'Cannons', selected by me for
my own use, is not to be conceived as indicating
the 'contents' of the picture. These contents are
indeed what the spectator lives, or feels, while
under the effect of the form and colour combina-
tions of the picture."
(Kandinsky to A. J. Eddy)

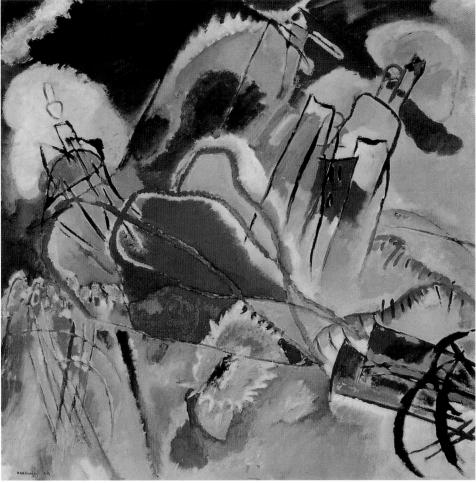

satisfaction", which featured numerous narrative motifs such as animals, naked figures, the ark, palm trees, lightning and rain. Kandinsky wanted to develop the subject into a *Composition*, and he made a number of preliminary designs and sketches as part of this process. In some of them he partially dissolved the corporeal forms, in others he sought to achieve his effect with purely abstract means. For a long time, however, he was unable to capture the "inner sound" of the word "Deluge" and to free himself from external, mimetic impressions. Kandinsky compares himself during this phase to "a snake not quite able to slough its skin". "Finally," however, "the day came, and a well-known, tranquil, inner tension made me fully certain. I at once made, almost without corrections, the final design, which in general pleased me very much. Now I knew that under normal circumstances I would be able to paint the picture... Nearly everything was right the first time. In two or three days the main body of the picture was complete. The great battle, the conquest of the canvas, was accomplished."

How exactly does Kandinsky succeed in freeing himself from the external impression of the word "Deluge"?

He begins by placing small, splintered and interlocking forms on the canvas; he then calms the unrest these produce with long, "solemn" lines. To mitigate the dramatic effect of the lines, he creates "a whole fugue out of flecks of different shades of pink, which plays itself out on the canvas. Thus, the greatest disturbance becomes clothed in the greatest tranquility, the whole action becomes objectified. This solemn, tranquil character is, on the other hand, interrupted by the various patches of blue, which produce an internally warm effect. The warm effect produced by this (in itself) cold colour thus heightens once more the dramatic element in a noble and objective manner. The very deep brown forms (particularly in the upper left) introduce a blunted, extremely abstract-sounding tone, which brings to mind an element of hopelessness. Green and yellow animate this state of mind, giving it the missing activity... So it is that all these elements, even those that contradict one another, inwardly attain total equilibrium, in such a way that no single element gains the upper hand, while the original motif out of which the picture came into being (the Deluge) is dissolved and transformed into an internal, purely pictorial, independent, and objective existence."

From Kandinsky's lengthy description of the genesis of the painting, it is clear that he leaves no element of the composition to chance. He takes delight even in the tortuous task of balancing the individual elements one against the other, precisely calculating their weights according to a "hidden law" – something he finds no less fascinating than the initial piling-up of masses on the canvas.

Composition VI (p. 92), a huge canvas measuring almost 2 x 3 metres, formed one of the highlights of Herwarth Walden's First German Autumn Salon, which opened on 20 September 1913 in the Sturm gallery in Berlin. The exhibition also included Franz Marc's *The Tower of Blue Horses* (now lost), *Tyrol* and *Animal Destinies*, and August Macke's *Zoological Garden*, *Four Girls* and *Girls Bathing*. An entire room was devoted to graphic works by Paul Klee and Alfred Kubin, and a memorial exhibition was also mounted of paintings by Henri Rousseau, who had died in 1910.

Gabriele Münter:
Kandinsky in Munich in front of
Small Pleasures, c. 1913
Photograph
Munich, Gabriele Münter and Johannes Eichner
Foundation

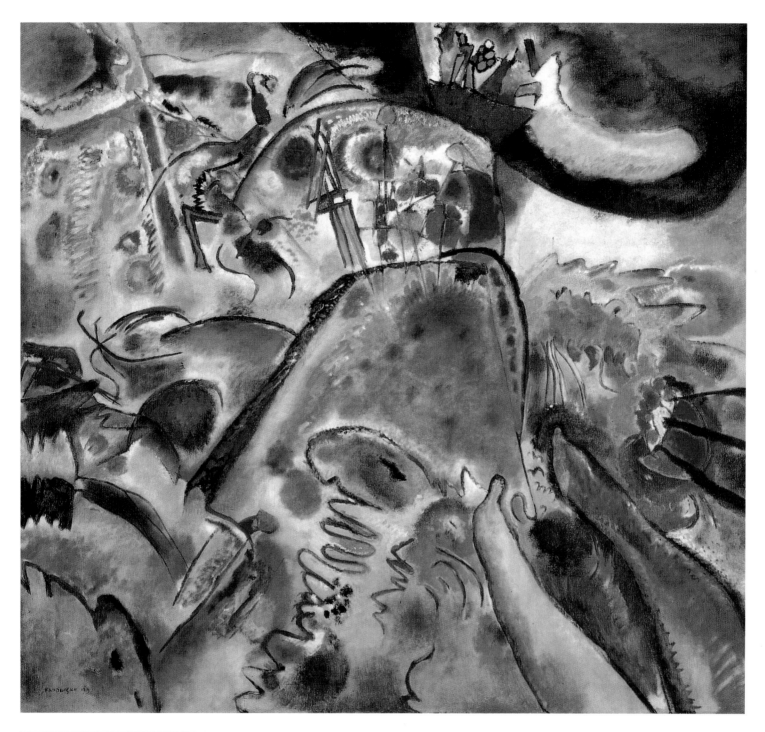

Study for *Small Pleasures*, 1913
Kleine Freuden
Ink, in places over pencil, on grey paper,
24 x 24.7 cm
Munich, Städtische Galerie im Lenbachhaus

Small Pleasures, 1913
Kleine Freuden
Oil on canvas, 109.8 x 119.7 cm
New York, The Solomon R. Guggenheim
Museum

"Based on my *Glass Painting with Sun*… First I
made a drawing, in order to remove the element
of displacement in the large composition and to
make the composition cool and very balanced in
its parts for the picture… I now know that this
was the best starting-point from which to create
the right playground for *Small Pleasures*… The
painting as a whole reminds me of the joyous
sound of small drops falling into water, each one
different."

Robert Delaunay showed pictures from his new abstract *Windows* and *Circular Forms* series. Italian Futurism was represented in works by Boccioni, Balla and Severini, French Cubism by Léger, Metzinger and Gleizes. A section of contemporary Russian art, put together by Kandinsky, complemented the international spectrum of the exhibition.

Marc, who was asked to supervise the hanging, expressed his amazement at the high quality of the exhibits in a letter to Kandinsky: "I was shamed by all these pictures, since I had to admit that, in my little Sindelsdorf, I had never imagined there was so much spirit at work; and above all, that the goals were so numerous and varied, with many perspectives that I didn't know... a significant preponderance (including in terms of quality) of abstract forms, which only speak as form, almost entirely without representational echo, over representational imagery."

The First German Autumn Salon was savaged by the critics and proved a financial fiasco. For the history of art, however, it was an important milestone.

For Kandinsky, 1913 was the most productive year of the pre-war era. He had now mastered the keyboard of abstract forms of expression. He had not yet entirely renounced object-related composition, however, as can be seen in *Landscape with Rain*, painted at the start of 1913 (p. 102 above). The organization closely follows a study from 1910 (p. 102 below) which still belongs clearly to Kandinsky's Murnau style. In the 1913 painting, however, the forms are geometrically simplified, with bands of rain and chimneys now forming linear compositional elements.

Improvisation 30 (Cannons) (p. 103) also dates from January 1913. In a letter to the Chicago collector Arthur Jerome Eddy, Kandinsky explained the function of the subtitles which he frequently attached to his pictures. They were intended solely "for my own use", as an identification aid, and were "not to be conceived as indicating the 'contents' of the picture". The cannons in this particular picture had arisen unconsciously, perhaps because there was already much talk of war. He had painted the picture in a state of great inner tension; the four corners were heavier than the two centres (the central blue plane and the green patch below it). The picture was thus lighter in the middle and heavier in the corners, thereby disguising its construction.

The letter does not mention the picture's steep-sided mountains, onion-domed churches or the group of figures in the bottom left-hand corner, now familiar elements in Kandinsky's personal iconography. Like the cannons, these have no figurative significance, but have simply arisen from an inner emotion. For this reason, Kandinsky believed, they should not be suppressed. The fortress-topped mountain reappears in *Small Pleasures* (p. 105), painted in Murnau in the summer of 1913. Kandinsky was particularly fond of this picture and reproduced in his *Reminiscences*. *Small Pleasures* is modelled on *Glass Painting with Sun* of 1911 (p. 68 above), and the earlier painting provides a useful key to some of the motifs. Here again, however, Kandinsky is uninterested in narrative or figurative concerns. His aim in *Small Pleasures* is to avoid the "element of displacement" contained in the glass painting and make the composition "cool and very balanced in its parts". Whereas *Glass Painting with Sun* employs a landscape format which underlines its narrative character,

"...the abstract element in art gradually has come increasingly to the fore, [that same element] which only yesterday concealed itself shyly, hardly visible behind purely materialistic strivings. And this growth and eventual predominance of the abstract is a natural process. Natural, because the more organic form is pushed into the background, the more this abstract element comes to the fore of its own accord, with increasing stridency."
(Kandinsky in *On the Spiritual in Art*, 1912)

Small Pleasures uses an almost square format right from the start, as seen in Kandinsky's numerous preliminary studies for the composition (p. 105 below).

In an unpublished essay on *Small Pleasures*, Kandinsky discusses the pictorial means by which he arrives at its harmonious compositional equilibrium. The centre is composed of two parts, one a confusion of lines and colours, and the other a large plane.

The four corners have different strengths and characteristics:
1. "top left – trapped forms
2. bottom left – entangled large planes and lines
3. top right – large masses, modelled
4. bottom right – large masses, flat."

"I did not want to use a secret language here, and so I set out the composition in a thoroughly clear and naïve manner. This picture, therefore, is composed in a different manner to all my other pictures, and even a blind man would be able to recognize its construction." Having laid down his compositional framework, Kandinsky allows himself to be guided by his brush, spontaneously placing coloured flecks and lines on

Untitled (First Abstract Watercolour), 1910 (1913)
Ohne Titel (Erstes abstraktes Aquarell)
Pencil, watercolour and ink on paper,
49.6 x 64.8 cm
Paris, Musée National d'Art Moderne,
Centre Georges Pompidou

Kandinsky dated his famous *First Abstract Watercolour* to 1910. In the light of recent research, however, it is now generally considered to belong to the studies executed for Kandinsky's major work of the pre-war era, *Composition VII* of 1913, to which it is closely related both in terms of motif and style.

Sketch for **Composition VII (2)**, 1913
Komposition VII (2)
Pen, 21 x 33.2 cm
Munich, Städtische Galerie im Lenbachhaus

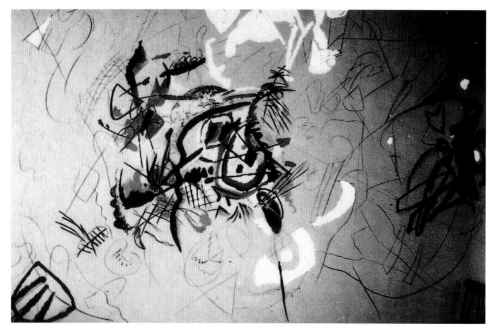

Gabriele Münter:
Composition VII: 1. stage of execution, 1913
Photograph
Munich, Gabriele Münter and Johannes Eichner
Foundation

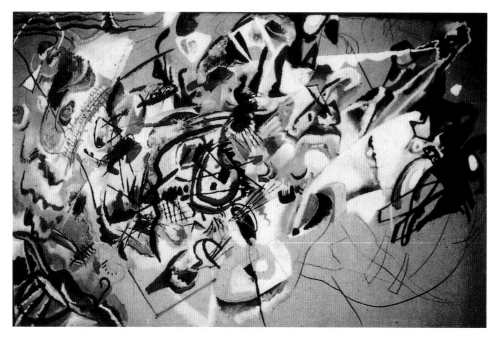

Gabriele Münter:
Composition VII: 3. stage of execution, 1913
Photograph
Munich, Gabriele Münter and Johannes Eichner
Foundation

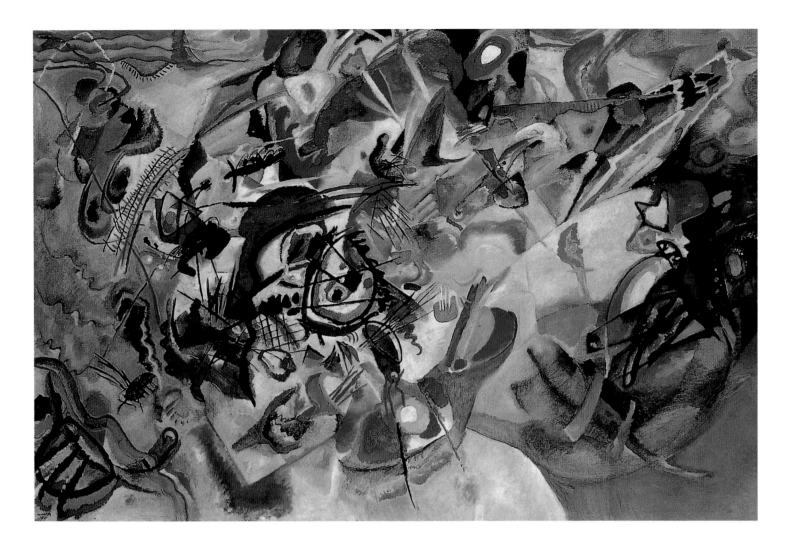

the canvas "without thinking of the final result". "My aim was simply to let myself go and pour a quantity of small pleasures onto the canvas."

Small Pleasures has been the subject of various interpretations; for some it offers a glimpse of impending doom, an apocalyptic vision such as found elsewhere in Kandinsky's art and writings. Others stick closer to the artist's own remarks on the painting and see it as an expression of pulsating *joie de vivre*.

The masterpiece of these latter Munich years is *Composition VII* of 1913 (p. 109), an entirely abstract work. Like *Composition VI*, it is a painting of monumental proportions and enormous formal and thematic complexity. The canvas is fragmented into innumerable small colour segments. These appear to extend beyond the upper edge of the painting, and at the same time to reach towards the top right-hand corner. In conjunction with the larger, modulated colour planes filling the lower and left-hand edges, this gives the composition a powerful diagonal orientation, whereby the picture is divided into a nervous upper half and a calmer lower half. This dominant diagonal is already present in an early ink sketch (p. 108 above). Kandinsky did almost thirty preliminary studies for *Composition VII*, amongst them oil sketches, watercolours and ink drawings. The majority concentrate upon the compositional structure, although there are also detailed sketches of individual pictorial motifs, while some of the oil studies are virtually paintings in their own right.

Composition VII, 1913
Komposition VII
Oil on canvas, 200 x 300 cm
Moscow, State Tretyakov Gallery

Kandinsky executed over 30 studies (oils, watercolours and drawings) for this painting, which he himself described as the most important of his pre-war years. *Composition VII* is a splendid symphony of complex, multi-layered forms and colours. Will Grohmann, Kandinsky's biographer, described it as a "smouldering fire, approaching disaster, excessive tempo". Grohmann was thereby referring to the threat of war looming ever closer on the horizon, which may have affected Kandinsky's mood during the painting of this picture.

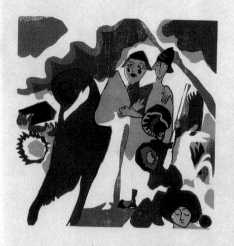

Einmal besuchte ich eine Villenkolonie, wo niemand lebte. Alle
Häuser waren schmuckweiß und hatten festgeschloße grüne
Läden. In der Mitte dieser Villenkolonie war ein grasbewachse-
ner grüner Platz. In der Mitte dieses Platzes stand eine sehr
alte Kirche mit einem hohen Glockenturm mit spitzem Dach.
Die große Uhr ging, schlug aber nicht. Am Fuße dieses Glok-
kenturmes stand eine rote Kuh mit einem sehr dicken Bauch.
Sie stand unbeweglich und kaute schläfrig. Jedesmal, wenn
der Minutenzeiger an der Uhr eine Viertel-, Halbe- oder Ganze-
stunde zeigte, brüllte die Kuh: „ei! sei doch nicht so bange!"
Dann kaute sie wieder.

3 double pages from Kandinsky's book *Sounds*
(*Klänge*), 1913
Munich, Städtische Galerie im Lenbachhaus

Between 1908 and 1912 Kandinsky wrote 38
prose-poems, which he illustrated with wood-
cuts. The abstract poems, which play with
sounds rather than meaning, were published in
book form by Piper Verlag in 1913, accompanied
by the woodcuts.

LENZ

Im Westen der neue Mond.
Vor des neuen Mondes Horn ein Stern.
Ein schmales hohes schwarzes Haus.
Drei beleuchtete Fenster.
Drei Fenster.

1.

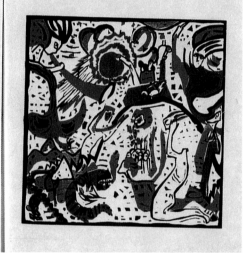

WARUM?

„Keiner ist da herausgekommen."
„Keiner?
„Keiner.
„Einer?
„Nein.
„Ja! Aber als ich vorbeikam, stand doch einer da.
„Vor der Tür?
„Vor der Tür. Er breitete die Arme aus.
„Ja! Weil er niemanden hineinlassen will.
„Keiner ist da hineingekommen?
„Keiner.
„Der, der die Arme ausbreitet, war der da?
„Drin?
„Ja. Drin.
„Ich weiß nicht. Er breitet nur die Arme aus, damit keiner
hinein kann.
„Wurde er hingeschickt, damit Keiner hineinkann? Der die
Arme ausbreitet?
„Nein. Er kam und stellte sich selbst hin und breitete die
Arme aus.
„Und Keiner, Keiner, Keiner ist herausgekommen?
„Keiner, Keiner."

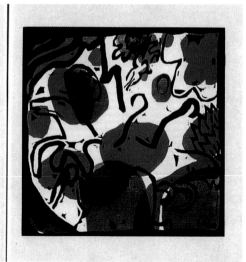

"Kandinsky has undertaken the rarest spiritual
experiments in his poems. Out of 'pure exist-
ence' he has conjured beauties never previously
heard in this world. In these poems, sequences of
words and sentences surface in a way that has
never happened in poetry before… In a poem by
Goethe, the reader is poetically instructed that hu-
mankind must die and be transformed. Kandin-
sky, on the other hand, confronts the reader with
a dying and self-transforming image, a dying and
self-transforming phrase, a dying and self-trans-
forming dream. In these poems we experience
the cycle, the waxing and waning, the transfor-
mation of this world. Kandinsky's poems reveal
the emptiness of appearances and of reason."
(Jean Arp on *Sounds*).

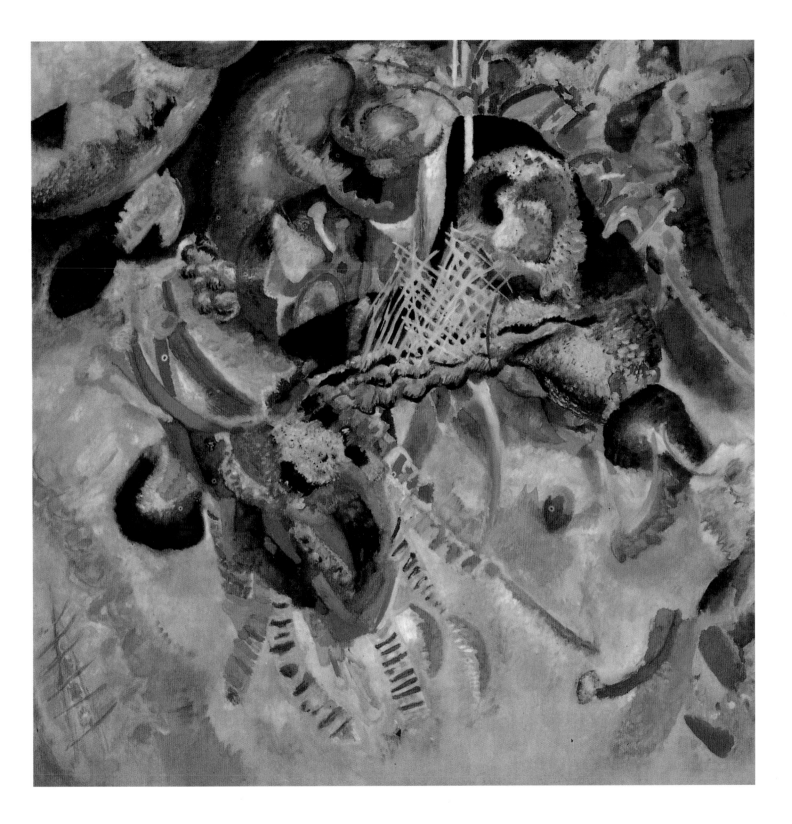

Fugue, 1914
Fuga
Oil on canvas, 129.5 x 129.5 cm
Basle, Collection Ernst Beyeler

Kandinsky believed that painting should take its bearings from music in its search for
rhythm and mathematical construction. He gave the title *Fugue* to this composition
after its completion, in recognition of its "polyphonal order". The lower half of the
picture is a zone of relative calm, with movement increasing towards the middle. "The
network of crisscrossing white lines is like a 'boiling' arising from the collision of the
forces."

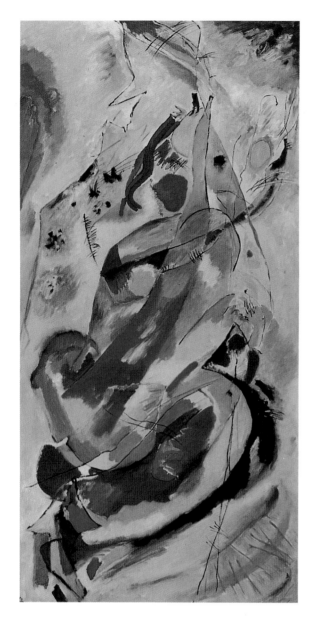

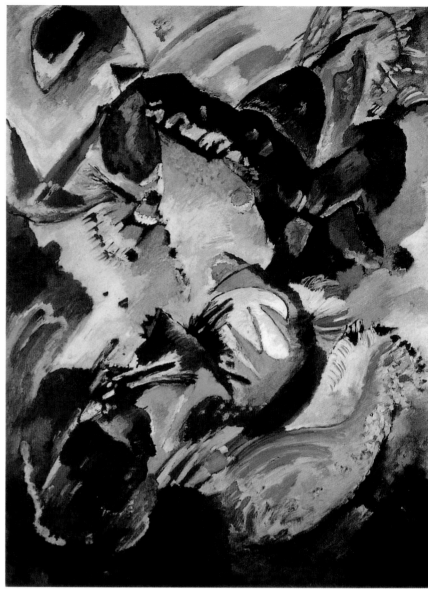

Wall Panel for Edwin R.Campbell, No.1, 1914
Wandbild für Edwin R. Campbell, No.1
Painting Number 200
Oil on canvas, 162.5 x 80 cm
New York, Collection The Museum of Modern
Art, Mrs. Simon Guggenheim Fund

Wall Panel for Edwin R.Campbell, No.2, 1914
Wandbild für Edwin R. Campbell, No.2
Painting Number 201
Oil on canvas, 163 x 123.6 cm
New York, Collection The Museum of Modern
Art, Mrs. Simon Guggenheim Fund

The four wall panels for the American art collec-
tor Edwin R. Campbell, founder of the Chevrolet
motor works, were the last pictures that Kandin-
sky completed before leaving Germany in late
1914. They were destined for the entrance hall of
Campbell's New York apartment, but due to the
war they were not shipped to America until
1916. The commission had been arranged by art
dealer Arthur J. Eddy.

It is in the context of these preliminary studies that we should view
Kandinsky's so-called *First Abstract Watercolour* (p. 107). In its free,
spontaneous style and motival details, this work is so closely related to
the watercolour studies for *Composition VII* that art historians have as-
signed it to the 1913 canvas, despite the fact that Kandinsky himself
dates it to 1910.

Having spent a considerable time developing the idea for *Composi-
tion VII*, Kandinsky finally painted the huge picture within the space of
just a few days, between 25 and 28 November 1913. Gabriele Münter
documented his progress in a series of photographs (p. 108). From
these it is clear that Kandinsky started from the oval form outlined in
black at the centre of the picture and proceeded to cover the canvas
with vibrant and splintered forms. Although he largely follows the pre-
paratory drawing, it is revealing to see how he treats, for example, the
small triangle near the centre of the lower edge. In the preparatory
drawing this can be seen as a fairly distinctive form, but in the final
painting it is almost entirely absorbed into the transparent background
and can only be distinguished by its white aura – a mysterious entity

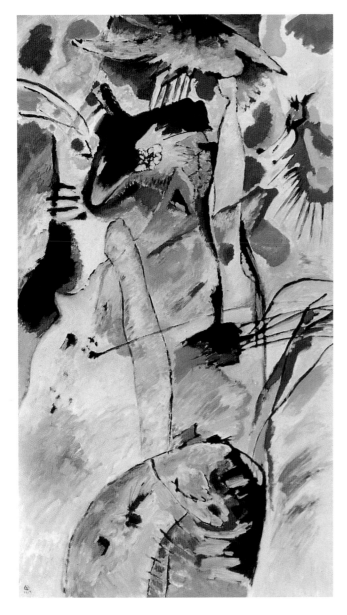

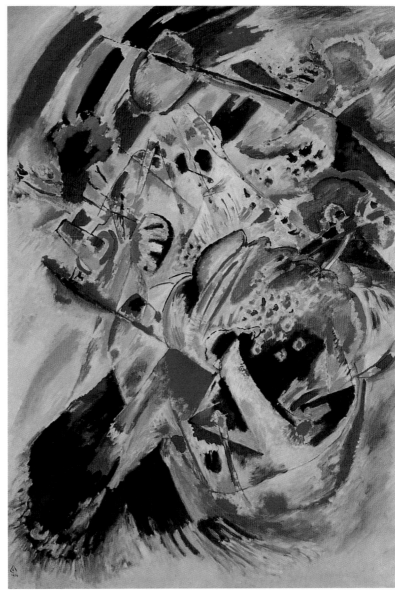

alongside the noisy, powerful colour forms of the surrounding composition.

With a little detective work, *Composition VII* also yields up a number of abbreviated motifs from earlier works: a rowing boat (bottom left-hand corner), a rider (right edge) and a troika (top left-hand corner). These rotate around a seething, exploding centre whose oval graphic form resembles the eye of a Cyclops. "I immersed myself more and more in the manifold value of abstract elements," wrote Kandinsky in his Cologne lecture of 1914. "In this way, abstract forms gained the upper hand and softly but surely crowded out those forms that are of representational origin."

Wall Panel for Edwin R.Campbell, No.3, 1914
Wandbild für Edwin R. Campbell, No.3
Painting Number 198
Oil on canvas, 162.5 x 92.1 cm
New York, Collection The Museum of Modern Art, Mrs. Simon Guggenheim Fund

Wall Panel for Edwin R.Campbell, No.4, 1914
Wandbild für Edwin R. Campbell, No.4
Painting Number 199
Oil on canvas, 162.3 x 122.8 cm
New York, Collection The Museum of Modern Art, Nelson A. Rockefeller Fund

"... I was glad to get this commission for Herr Kandinsky because it gives him an entrance in New York, and while the price is not large, yet it is quite a venture for my friend to hang four such extremely modern pictures in a place where everybody must see them.
With kindest regards to Herr Kandinsky, I am
Yours very sincerely,
A.J. Eddy"
(Letter to Gabriele Münter, June 1914)

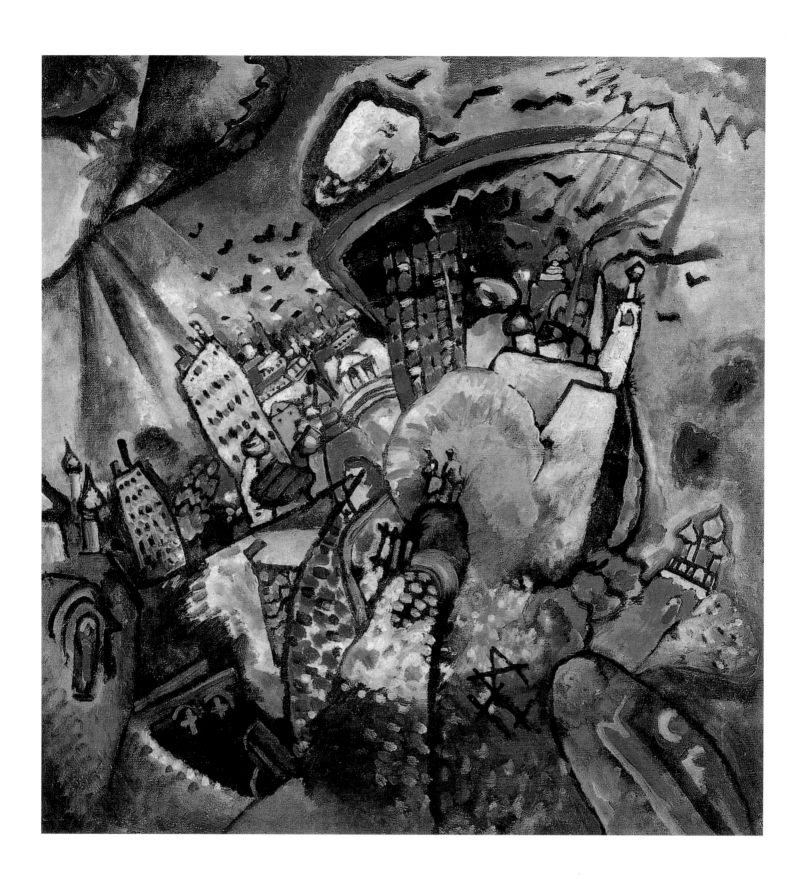

Return to Moscow

"...so this is it! Isn't it terrible? I've been roused out a dream. I've been living in an inner world where such things are completely impossible. I have been stripped of my illusions. Mountains of corpses, dreadful suffering of all kinds, inner culture put on hold for an indefinite period.... Of the 16 years that I have been living in Germany, I have given myself entirely to the German art world. How am I now suddenly supposed to feel myself a foreigner?" (Kandinsky to Herwarth Walden, 2 August 1914).

The outbreak of the First World War took Kandinsky by surprise in Murnau. His Russian passport now branded him an enemy alien. On 3 August, two days after the war was declared, he and Gabriele Münter left Germany for Switzerland. They spent three months on Lake Constance at the home of his Munich landlady, in the hope of a rapid end to the war. Here Kandinsky started exploring the question of form in theoretical writings that would provide the basis of his later Bauhaus book, *Point and Line to Plane (Punkt und Linie zu Fläche)*. On 16 November, with no end to hostilities in sight, Kandinsky returned to Russia. Gabriele Münter moved back to Munich.

Relations between Kandinsky and Münter had become increasingly strained, and Kandinsky felt it was impossible for them to continue living together. The fact that he simultaneously promised to marry her is an indication of the complexities of their relationship and of his own unstable and indecisive mood: one day he would announce that he wanted to give up the relationship altogether and live alone, and the next he would assure her of his most tender feelings. He was essentially seeking a sensitive and flexible partner who would understand his eccentric style of love. Gabriele Münter, who was both strong-headed and down-to-earth, could not be that person. They met once more in Stockholm in December 1915 (p. 116 right), when they attended the opening of an exhibition of works by both artists in the Gummeson gallery. It was to be the last time they saw each other, although they continued writing for a while.

For Kandinsky, the move from Munich to Moscow marked a profound break. 1915 was a year of depression and self-doubt, during which he painted not a single picture. Kandinsky's enthusiasm for life only began to return with an exhibition of his works in Stockholm, which he combined with a lengthy stay in Sweden, and with his introduction to the young Russian Nina Andreevsky. Leaving aside drawings, watercolours, etchings and glass paintings, however, in the five years between 1916

Etching, No. 1, 1916
Radierung, Nr. 1
Drypoint on zinc, printed on copperplate paper,
27.8 x 26.4 cm
Munich, Städtische Galerie im Lenbachhaus

PAGE 114:
Moscow I, 1916
Moskau I
Oil on canvas, 51.5 x 49.5 cm
Moscow, State Tretyakov Gallery

"I would love to paint a large landscape of Moscow – taking elements from everywhere and combining them into a single picture – weak and strong parts, mixing everything together in the same way as the world is mixed of different elements. It must be like an orchestra."
(Kandinsky to Gabriele Münter, June 1916)

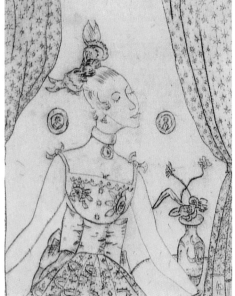

Etching, No. 6, 1916
Radierung, Nr. 6
Drypoint on zinc, printed on copperplate paper,
33 x 25.5 cm
Munich, Städtische Galerie im Lenbachhaus

Kandinsky and Gabriele Münter in Stockholm,
1916
Photograph
Munich, Gabriele Münter and Johannes Eichner
Foundation

Kandinsky spent the four months from Decem-
ber 1915 to March 1916 in Stockholm, where he
met Gabriele Münter for the last time. During
this period he executed grotesque-style watercol-
ours and etchings which he sold through the
Gummeson gallery.

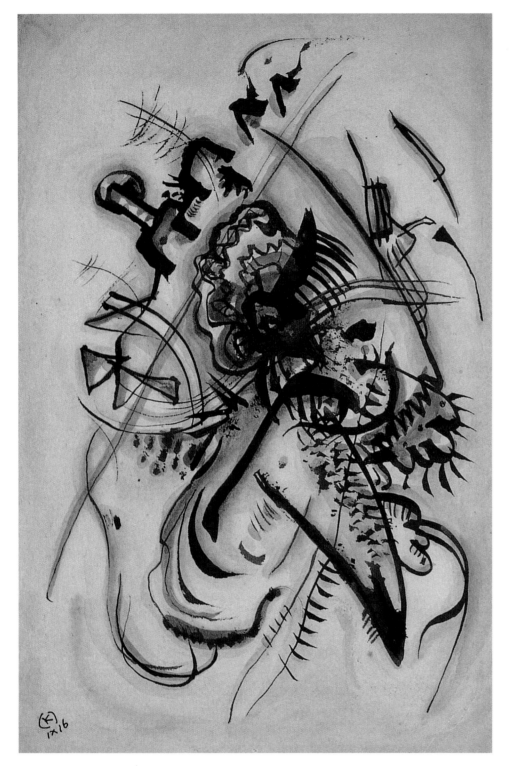

To the Unknown Voice, 1916
Der unbekannten Stimme
Watercolour and ink on paper, 23.7 x 15.8 cm
Paris, Musée National d'Art Moderne,
Centre Georges Pompidou

"Your voice made a great impression on me."
This watercolour arose following Kandinsky's
first – telephone – conversation with Nina, subse-
quently to become his wife, and is dedicated to
her voice. The dense complex of black lines sur-
rounding a central motif is typical of Kandin-
sky's etchings and watercolours of 1916.

Nina Andreevsky before her marriage to
Kandinsky, Moscow, 1913/14
Photograph
Paris, Musée National d'Art Moderne,
Centre Georges Pompidou

Kandinsky's Russian passport photo, 1921
Photograph
Paris, Musée National d'Art Moderne,
Centre Georges Pompidou

"Kandinsky had the noble air of a grand sei-
gneur… I was immediately fascinated by his
kindly, beautiful blue eyes."
(Nina Kandinsky in *Kandinsky and I*)

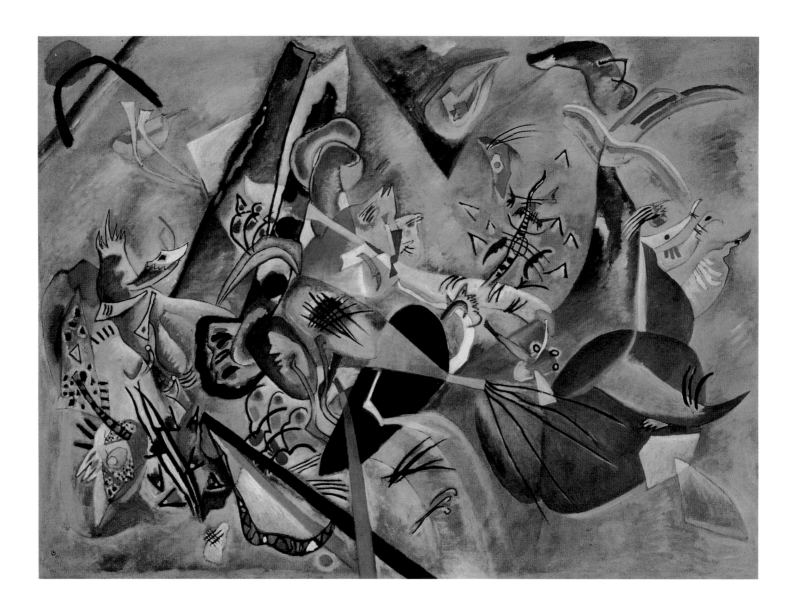

and 1921 he was to complete only 41 oil paintings, a relatively small out-
put compared to the enormous productivity of his latter Munich years.

Kandinsky met Nina Andreevsky in the autumn of 1916 (p. 117). The
daughter of a general, she was almost a whole generation younger than
him, and precisely the understanding, admiring partner that Kandinsky
had yearned for. This new relationship enlivened him and gave him fresh
stimulus for his work.

In June 1916, he wrote to Gabriele Münter: "I felt that my old dream
was closer to coming true. You know that I dreamt of painting a big pic-
ture expressing joy, the happiness of life and the universe. Suddenly I
feel the harmony of colours and forms that come from this world of joy."

It was during this period of high spirits that Kandinsky painted *Mos-
cow I* (p. 114). The romantic, fairytale-like Moscow pictures of Kandin-
sky's early Munich years are here fused with the familiar church motifs
and the splintered forms and animated dynamism of his pre-war composi-
tions to create a dramatic, explosive vision, a magnificent harmony of
colours and forms of varying strengths. "The sun dissolves all of Mos-
cow into a single spot, which, like a wild tuba, sets all one's soul vibrat-
ing." The almost naïve character of certain motifs suggests a return to
Kandinsky's pre-abstract days. The couple in the centre in particular hark

back to the two figures in Bavarian dress in *Improvisation Gorge* of 1914 (p. 103 above) and introduce a romanticising element into the composition, which is otherwise dominated by the powerful sound of the primary colours red, blue and yellow.

In February 1917 Kandinsky, now aged 51, married the much younger Nina. "Our marriage marked the start of spring in the autumn of his life. We fell in love at first sight, and for that reason we were never apart for one day," wrote Nina Kandinsky in her memoirs. As the son of a prosperous tea merchant, Kandinsky was independently wealthy: he already owned a large apartment block in Moscow containing 24 flats, and he now planned to build a house with a large studio for himself and his new wife. The October Revolution changed everything, however. Kandinsky lost his property and was now obliged to supplement his income by selling his pictures.

Nina Kandinsky was undiscouraged, however: "We were adequately compensated for the privations of the Revolution by the promising situation for the arts in the years that followed. The arts experienced a revolutionary spring, which put everything that had previously been done in this field in Russia into the shade. Unlimited possibilities suddenly opened up before every creative person."

In 1918 Kandinsky became involved in the development of cultural policy in post-Revolution Russia. At the invitation of Vladimir Tatlin, he became a member of the Fine Arts Department of the People's Commissariat of Enlightenment, where his responsibilities included the running of the theatre and film section. In autumn 1918 he was given a professorship at the Higher State Artistic and Technical Workshops, and in 1920 he was appointed professor of aesthetics at Moscow University. In 1919 he

Study for *In Grey*, 1919
Im Grau
Pencil on paper, 20 x 26.9 cm
Paris, Musée National d'Art Moderne,
Centre Georges Pompidou

Second and last exhibition of Kandinsky's works
in Moscow, including *In Grey*, 1920
Photograph
Paris, Musée National d'Art Moderne,
Centre Georges Pompidou

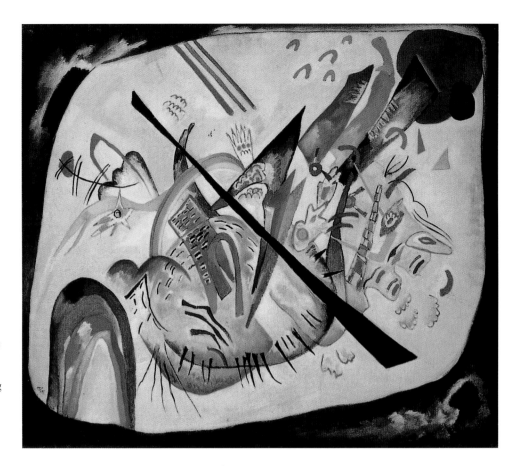

White Oval, 1919
Weißes Oval
Oil on canvas, 80 x 93 cm
Moscow, State Tretyakov Gallery

The framing device which Kandinsky introduces
here for the first time serves to defuse the rigid
rectangularity of the canvas. The internal pictor-
ial elements are now set in an undefined, floating
space. The diagonal orientation of the composi-
tion and the increasing geometrization of forms
into triangles, arches and lines are characteristic
features of Kandinsky's style during this period.

founded the Moscow Institute of Artistic Culture (INKhUK), for whose
curriculum he once again formulated his ideas of a reciprocal relationship
between the arts. Finally, as the head of the state commission for acquisi-
tions, he was also responsible for equipping and opening new museums
in other parts of Russia. Twenty-two such museums were created under
his direction between 1919 and 1921. This enormous workload took up
the greater part of Kandinsky's time.

Kandinsky's artistic production during these seven years in Russia is
strikingly heterogeneous. 1916, for example, saw him producing watercol-
ours and etchings with a somewhat coarse flavour and an almost naïve
style (p. 116 left), which were clearly intended to sell. In other works, such
as *Moscow I*, he revisited the more object-related pictorial world of earlier
years. Two other trends also emerge from the works of this Moscow
period: an increasing geometrization and the inclusion of a border. This
latter appears in *White Oval* of 1919 (p. 120), where a black border is
employed as a compositional means of freeing the inner motif from the
rectangular rigidity of the edges of the canvas. The law of gravity and
the orientations of top and bottom are thereby removed, allowing space to
be perceived in a new way. The white plane floats against a black back-
ground, while opposing directional indicators within it suggest a rotational
movement. Forms are sharper and more pointed and are growing ever
closer to geometric shapes. The diagonals found so frequently in Kandin-
sky's work are emphasized by wedge-shaped triangles.

In Grey (p. 118), also painted in 1919, is a complex composition with
no clear directional indicators. It is one of the largest and most thor-
oughly prepared works of this Russian phase. "*In Grey* marks the end of

my 'dramatic' period, i.e. the very thick piling-up of so many forms."
From a preliminary pencil study, it is clear that Kandinsky started from a composition of representational motifs: steep mountains, sun, boats with oarsmen, and figures. In the finished oil painting, these have been translated into abstract hieroglyphs, gyrating and floating against an indefinable grey ground. In terms of its density and complexity, *In Grey* may be compared with *Composition VII* of 1913 (p. 109). But whereas, in the earlier work, shrill colours modelled themselves into bizarre, often angular forms in an expressive artistic flourish, the large, abstract colour planes of the Moscow painting create a cooler and more disciplined atmosphere. *In Grey* denotes a significant stage in Kandinsky's transition from his romantically expressive "dramatic" period to the development of an abstract geometric pictorial language.

Kandinsky's theories and works were already well-known in Russia. Throughout his years in Munich he had remained in regular contact with Russia and Russian artists; he had exhibited regularly in Moscow from 1900 onwards, and later also in Odessa and St. Petersburg. In 1910 he accepted an invitation to take part in the first Jack of Diamonds exhibition in Moscow. The Jack of Diamonds was a group of artists who, having initially drawn inspiration from Russian folk art, subsequently oriented

Arch and Point, 1923
Bogen und Spitze
Watercolour, ink and pencil on paper,
46.5 x 42 cm
New York, The Solomon R. Guggenheim Museum

The construction of this picture, which dates from Kandinsky's early years in Weimar, reveals a similar diagonal orientation to *White Oval* (p. 120). Here, however, the directional indicators consist of purely geometric forms. While Kandinsky never quite let go of all organic and expressive elements in his Moscow works, he nevertheless made the important transition to the geometric style of his Bauhaus years.

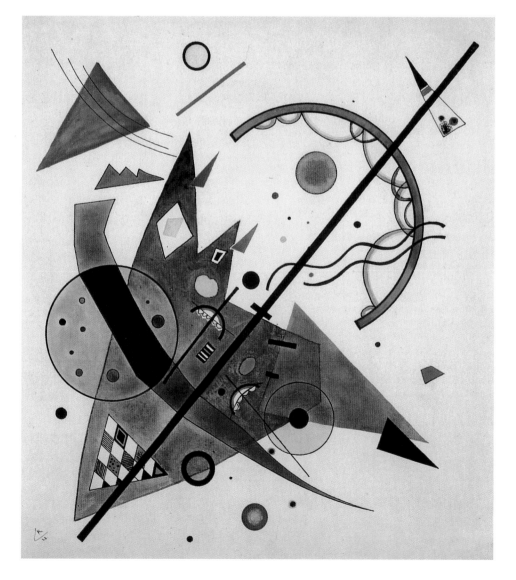

themselves increasingly towards western Europe, and in particular Paris. The group's founders included Mikhail Larionov, Natalia Goncharova, Kasimir Malevich, and brothers David and Vladimir Burliuk. The two Burliuks took part in the second Neue Künstlervereinigung exhibition in Munich in 1910, and all five Russians were involved with the Blaue Reiter: the two Blaue Reiter exhibitions featured Cubist portraits by Vladimir Burliuk and Malevich and more figurative works by Larionov and Goncharova, while an article by David Burliuk on the Russian "Savages" and their new definition of beauty was published in the *Blaue Reiter Almanac*.

Kandinsky had also contributed regular articles on art and theory to Russian magazines, enabling him to take part in the artistic dialogue in his homeland. In 1914 *On the Spiritual in Art* was published in Russian translation, and Kandinsky's ideas of a complete elimination of the associative and representational were not without influence on his Russian contemporaries. They went even further, however: in place of Kandinsky's abstract-expressive non-representationalism, they embraced a purely geometric abstraction. Malevich's *Black Square on a White Ground* (p. 125), first exhibited in 1915 and described by the artist as a "naked, unframed icon of my age", is an example of the negation of the associative, imitative and expressive taken to its extreme. Malevich called this new movement Suprematism, by which he understood the supremacy of pure feeling. The Suprematist artists sought to free art entirely from the "ballast of objectivity". Only when the starting-point was a "void", freed from all practical utility and all obligation to tradition – by which Malevich also meant artistic traditions such as perspective, anatomy, and so forth – could humankind arrive at pure perception.

Malevich's *Suprematism (Supremus No. 58)* of 1915 (p. 122) presents a constellation of clear geometric forms moving over a white canvas. Like Kandinsky, Malevich employs the diagonal as a central compositional element. But whereas the diagonal sweep of the host of small planes in Kandinsky's *Composition VII* (p. 109) evokes an impression of highly dynamic movement, the large, oblique quadrilateral in Malevich's *Suprematist Painting* exudes a sense of weightlessness and floating, of mystical indefinability in a seemingly infinite space. Geometrically speaking, the form is a trapezoid, a quadrilateral without parallel sides or right angles. The trapezoid, which looks like a rectangular plane seen from an angle, became a Suprematist emblem frequently employed by Malevich and his followers from 1915 onwards.

Kandinsky refers to Malevich's Suprematist construction in his *Red Oval* (p. 123) of 1920. A yellow, diagonally-positioned quadrilateral form floats against a green ground. Here, however, Kandinsky overlays the quadrilateral with coloured forms and lines which are unhomogeneous and strongly differentiated in hue. Instead of intensifying the outward movement of the yellow plane, they pin it to the background. This frozen, static impression is reinforced by the square format, which is almost entirely filled by the quadrilateral and its outriggers. Different techniques are employed in the handling of paint: freely worked in the atmospheric, cloudy background, colours are applied more crudely in contours and planes, while the red and yellow forms are monochrome and flat. Kandin-

Kasimir Malevich:
Suprematism (Supremus No. 58), 1915
Oil on canvas, 70.5 x 70.5 cm
St. Petersburg, State Russian Museum

For the Russian Constructivists, the trapezoid was the "emblem" of Suprematism. In *Red Oval* (p. 123), Kandinsky takes up the trapezoid motif in the form of a yellow plane and places it against a modulated green background, where it appears to float in an undefined, atmospheric space – far removed from Constructivism's disciplined and two-dimensional compositional structure. In contrast to the Constructivists, Kandinsky gave first priority to composition rather than construction, and to intuition rather than reason.

PAGE 123:
Red Oval, 1920
Rotes Oval
Oil on canvas, 71.5 x 71.2 cm
New York, The Solomon R. Guggenheim Museum

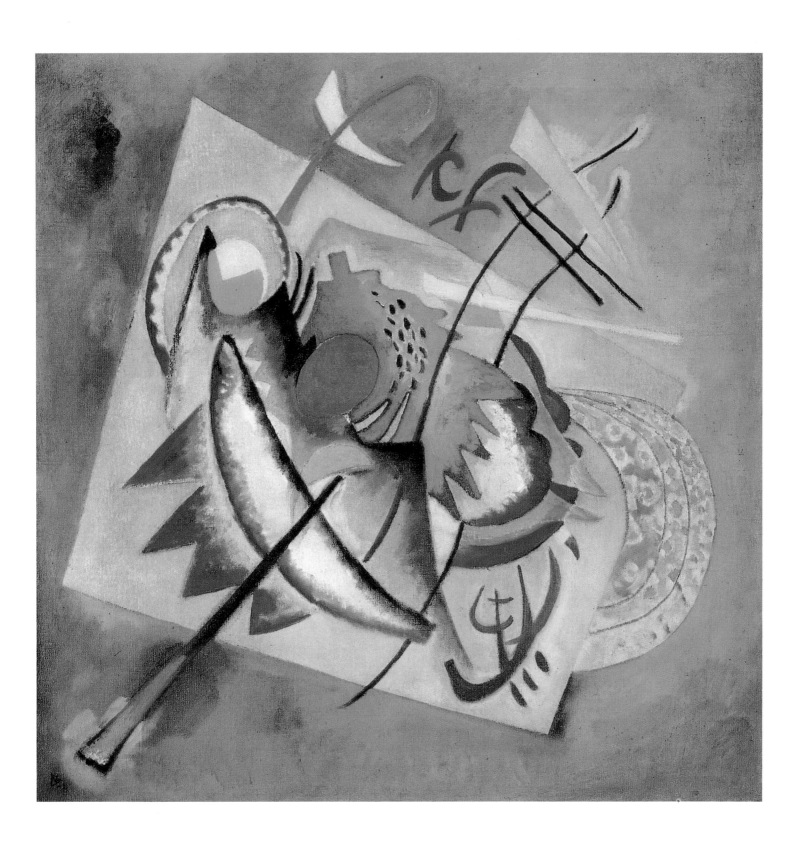

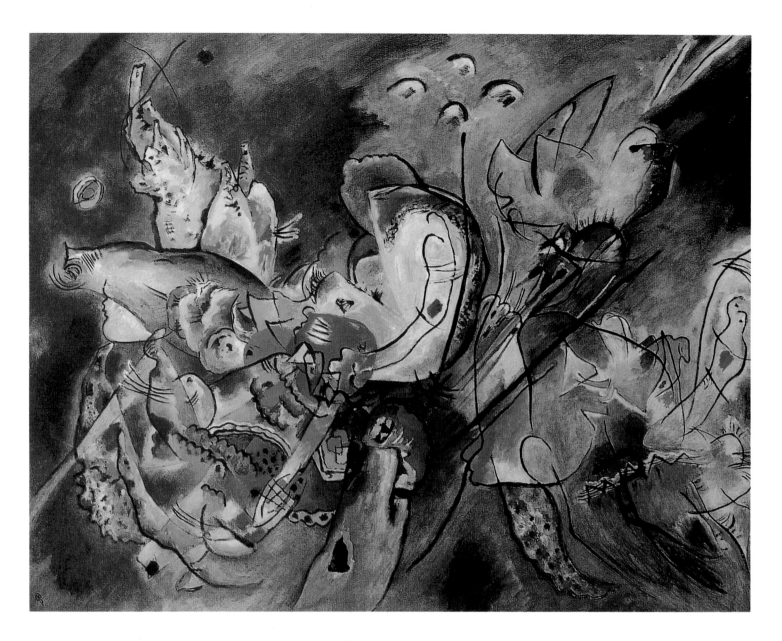

Overcast, 1917
Trübe
Oil on canvas, 105 x 134 cm
Moscow, State Tretyakov Gallery

Kandinsky remained in close touch with artistic developments in Russia throughout his years in Munich. Although he came from an upper middle-class family, he initially welcomed the Revolution and pledged his organizational and teaching skills to its service. As head of the Institute of Artistic Culture, INKhUK, he came into contact with the leading members of the Russian avant-garde. His ideas of a synthesis of the arts, however, and his orientation towards the principles of music, literature, theatre and dance, were rejected by his colleagues as subjectivistic and irrational. The growing ideological differences between Kandinsky and the Russian avant-gardists, coupled with an increasing barrage of personal criticism, finally resulted in his decision to leave Russia a second time. Kandinsky's adaptation of geometric elements nonetheless remains clearly indebted to the influence of Suprematism and Constructivism.

sky thus takes the formal and structural variety of his Munich works and introduces new, geometrizing elements.

The last pictures which Kandinsky painted in Moscow similarly combine free and geometrizing elements. In *Red Spot II* of 1921 (p. 127), scenic and metaphorical reminiscences give way even more than in *Red Oval* to a non-objectivity no longer resulting from forms abstracted from nature. Whereas, in *Red Oval*, points of intersection were portrayed as overlapping forms and thus continued to suggest a certain three-dimensionality, in *Red Spot II* they have become points of penetration with other interfaces, usually of a different colour, underlining the flatness of the pictorial plane. Here, a pale Suprematist-like trapezoid is spanned tautly across the surface in such a way that its four corners are cut off by the edges of the canvas. It thus acquires a direct, immediate presence and becomes the exercise ground for a company of symbols.

Red Spot II also marks the first appearance of circles as constructive elements in the composition. They reinforce the overall impression of calm and cool tension. From now on the pictorial motifs of points, circles and spots would play an increasingly prominent role in Kandinsky's work, gradually assuming the importance that the rider had earlier en-

Defamatory exhibition of Russian avant-garde
art in the Tretyakov Gallery in Moscow, 1937.
The writing reads:
*Bourgeois art in the blind-alley
of formalism and self-negation*

Alexander Rodchenko:
Composition No. 64, 1918
Oil on canvas, 74.5 x 74.5 cm
Moscow, State Tretyakov Gallery

Kasimir Malevich:
Dynamic Suprematism, 1916
Oil on canvas, 80.3 x 80.2 cm
London, Tate Gallery

Kasimir Malevich:
Black Square on a White Ground, 1915
Oil on canvas, 79 x 79 cm
Moscow, State Tretyakov Gallery

Cup and saucer, decorative design c. 1920
Manufactured by the Petrograd State Porcelain
Factory, 1921
Porcelain, cup 7 cm, saucer 13.8 cm
Private collection

Kandinsky's interest in the applied arts dated
back to Munich, where he had designed bead-
work embroidery and clothes for Gabriele
Münter. He subsequently designed a tea service
for the Petrograd State Porcelain Factory. The
cup and saucer carry abstract motifs from the
paintings of his Moscow years.

joyed in 1912. The point is capable of "altering its outer shape, whereby
it can change from the purely mathematical form of a larger or smaller
circle to forms of unlimited versatility and variability, far removed from
any schematism."

Formal schematism was precisely the danger which Kandinsky be-
lieved accompanied the use of strict geometric forms such as those
preferred by the Russian avant-garde. It is true that Suprematism exerted
a decisive influence upon the development of Kandinsky's art between
1919 and 1921, as can be seen in his adoption of diagonality and the illu-
sion of movement, of geometric figures and their inherent energies, and
of an unhierarchic manner of composition. There is nevertheless a fun-
damental difference between Kandinsky's art and that of his Suprematist
compatriots. Whereas the Suprematists gave priority to the construction
of a picture, employing radically streamlined elements and materials, pre-
cise analysis and conscious design, Kandinsky saw the expressive, true
essence of the picture solely in its composition, namely the free combina-
tion of manifold pictorial elements.

Kandinsky's ideas brought him into conflict with his Constructivist col-
leagues at INKhUK, Moscow's Institute for Artistic Culture. The Con-
structivists banned all subjective and atmospheric elements from their
painting ("It will only be possible to create a science of art when there
are quantifiable, objective characteristics that define the true achieve-
ments in the field of art"), and therefore rejected Kandinsky's art as "har-
monious" and "painterly", as "spiritualistic malformations".

Meanwhile, the political situation in Russia was making it increasingly
difficult to pursue an independent artistic career. The pressure on artists
to place their work in the service of Marxist-Leninist ideology was in-
creasing. In 1921 the Communist Party announced its new economic pol-
icy, as part of which art, literature, film and theatre were to be employed
for propaganda purposes. Abstract art was branded damaging and sub-
versive. The ground for socialist realism was now prepared. Kandinsky
was denigrated as a "bourgeois iconoclast", a "typical metaphysician and
individualist in art". When Kandinsky – who always described himself as
non-political and consequently was not a member of the Communist
Party – was passed over for the directorship of the Moscow Academy, the
decision to turn his back on Russia edged another step closer.

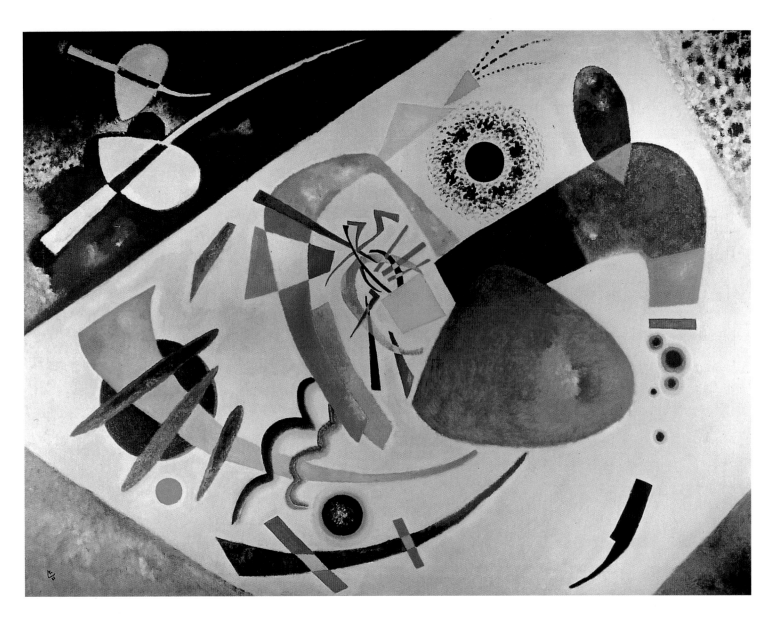

Red Spot II, 1921
Roter Fleck II
Oil on canvas, 131 x 181 cm
Munich, Städtische Galerie im Lenbachhaus

A pale trapezoid is angled across the foreground in such a way that its corners are cut off by the edges of the canvas, propelling it into a rotational movement. This plane provides the backdrop for a dynamic interplay of freely-invented pictorial forms, whereby the red spot assumes the dominant role. Red, according to Kandinsky, is "burning and glowing", an "immense, almost purposeful strength". A new geometric element also appears here for the first time: the circle, a form which would assume elemental significance for Kandinsky at the Bauhaus.

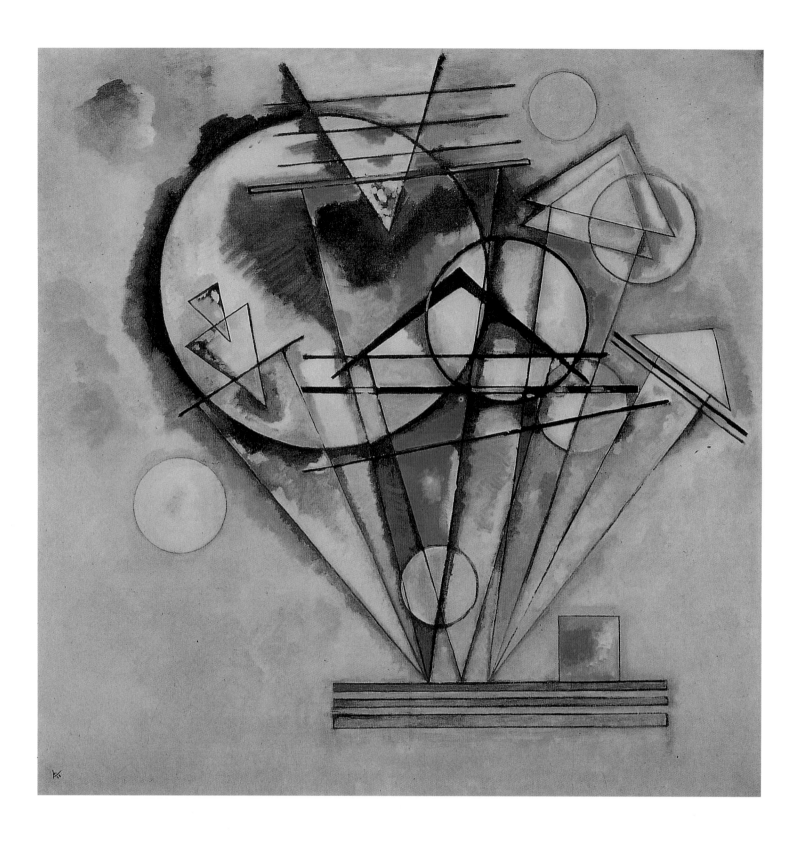

Kandinsky at the Bauhaus

One autumn day in 1921, Kandinsky received a summons from Comintern secretary Karl Radek ordering him to present himself immediately at the Kremlin. Since Radek – according to Nina Kandinsky – was renowned as a cynical misanthrope, and since no reason for the summons was given, Kandinsky was highly disquieted: in view of the altered political situation in the arts in Russia, he suspected the worst. In the event, his fears were unfounded. Radek informed Kandinsky that Walter Gropius wished to offer him a teaching post at the Bauhaus in Weimar.

Kandinsky now made ready to leave Moscow for a second time. In December 1921 he and Nina set off for Berlin, travelling via Riga and accompanied by twelve of Kandinsky's pictures (the rest having been deposited with the Moscow Museum). The couple arrived in the German capital on Christmas Eve, to be welcomed by streets glittering with lavish decorations and the city's four million inhabitants in festive mood. After their years of privation, hunger and cold in Russia, the bustling metropolis felt both overwhelming and liberating.

Before moving to Weimar in June 1922, where he was to take over the running of the mural-painting workshop, Kandinsky and his wife spent six months in Berlin. During this period they took almost no part in the social or cultural life of the city, however. Undernourishment and exhaustion, and the need to process the Moscow years, led the Kandinskys to live as self-imposed recluses, venturing out only for long walks and trips to the cinema – Kandinsky's great passion. Of the many Russian artists living in Berlin, Archipenko and Jawlensky were their only contacts.

Kandinsky nevertheless took part in several exhibitions during these months, including the First International Art Exhibition in Düsseldorf, in a preface to whose catalogue he returned again to the concept of "internal necessity" as the basis of artistic creation. The Gummeson gallery also held another exhibition of Kandinsky's pictures in Stockholm. The Swedish press criticized the coolness and lack of humanity of these latest works – a reference to their trend towards greater geometrization and more rigorous construction.

Kandinsky also took part in the Unjuried Art Show in Berlin, for which he produced four monumental murals (pp. 134 and 135). They were conceived for the octagonal entrance hall of a proposed new Berlin Museum of Modern Art – a project which was never realized due to lack of funds.

Kandinsky's Dessau Bauhaus identity card
Paris, Musée National d'Art Moderne,
Centre Georges Pompidou

PAGE 128:
***On Points**, 1928*
Auf Spitzen
Oil on canvas, 140 x 140 cm
Paris, Musée National d'Art Moderne,
Centre Georges Pompidou

A cluster of acute angles terminating in circles and triangles rises from a triple grey bar and seems to lift upwards like a fire-balloon. The colours are independent of the forms and create a transparent, immaterial space which is characteristic of Kandinsky's works of this period.

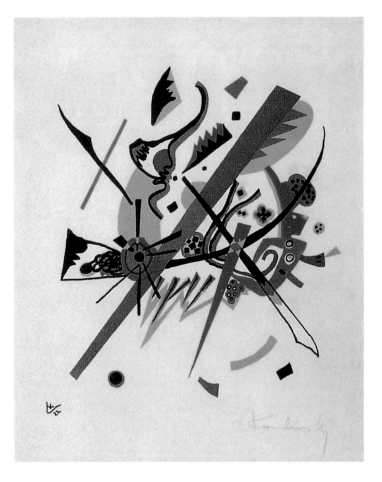

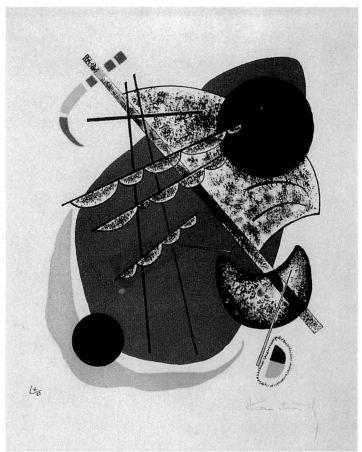

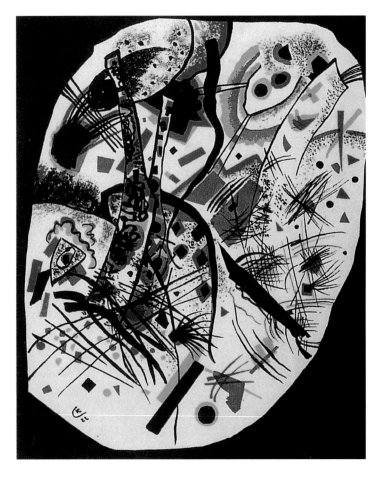

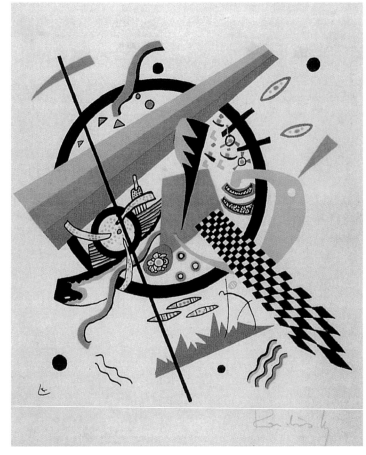

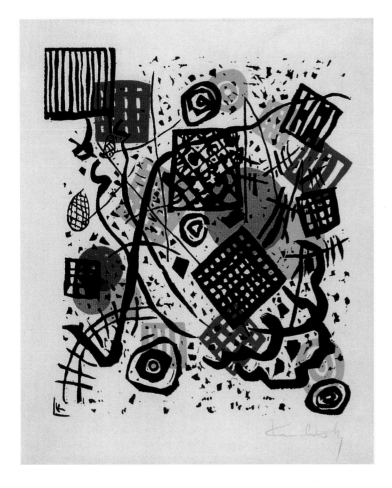 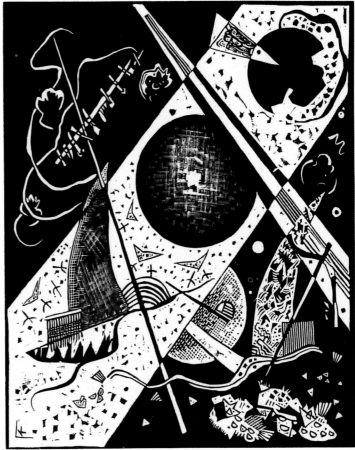

He completed the huge canvases, measuring some 4 x 8 metres, in the summer of 1922, with the aid of pupils from his Bauhaus workshop. Although the paintings themselves no longer exist, preliminary studies – gouaches on brown and black paper – have survived. In 1977 the Musée d'Art Moderne in Paris installed a model of the octagon and reconstructed Kandinsky's murals on the basis of these surviving studies. There, until recently, it was possible to re-experience the overwhelming impression made in Berlin in 1922 by Kandinsky's cosmos of colour and forms. In their combination of free and geometric forms, the murals belong to the style of Kandinsky's last Russian works. Their brilliant palette revives memories of Kandinsky's homeland and of the almost mystical, oriental colours of the Russian farmhouses that had fascinated him on his research expedition as a Moscow student. Finally, their abstract and in places geometric forms look forward to the strict, balanced formal vocabulary of his later Bauhaus years.

An exhibition at the Goldschmidt-Wallerstein gallery in Berlin provided him with a further opportunity to illustrate his artistic development since his departure from Munich. The exhibition included the twelve works which he had brought with him from Moscow, and the two works *White Cross* and *Blue Circle* (p.138) painted in Berlin. The critics, however, regretted the absence of the explosive colours familiar from his Munich period and accused him – rather like the Swedes – of producing a cool and intellectual type of art. "People only want what they know," was Kandinsky's reaction. "They barricade themselves against anything new. But this is precisely where the artist's task lies: to fight, to paint against

Small Worlds I–VI, 1922
Kleine Welten I–VI
PAGE 130, ABOVE LEFT:
Colour lithograph on mould-made paper,
36 x 28 cm
PAGE 130, ABOVE RIGHT:
Colour lithograph on mould-made paper,
36.3 x 28.1 cm
PAGE 130, BELOW LEFT:
Colour lithograph on mould-made paper,
36 x 28 cm
PAGE 130, BELOW RIGHT:
Colour lithograph on mould-made paper,
36 x 28 cm
PAGE 131, ABOVE LEFT:
Colour lithograph on mould-made paper,
36.2 x 28 cm
PAGE 131, ABOVE RIGHT:
Colour woodcut on mould-made paper,
35.5 x 33.8 cm

All: Berlin, Bauhaus-Archiv

Kandinsky began work on the portfolio *Small Worlds* immediately after arriving in Weimar. Within just a few weeks he had produced twelve graphic compositions (lithographs, woodcuts and etchings) testifying to the immense wealth of his imagination. Each of these compositions is a creation, a microcosm in itself.

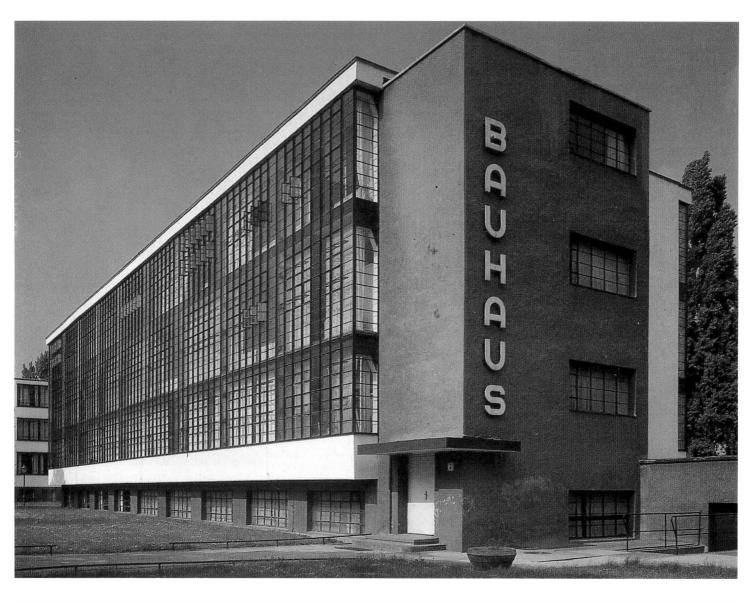

Cover of a 1928 issue of the *bauhaus* journal, designed by Herbert Bayer. Kandinsky kept a copy of every number but one.
Paris, Musée National d'Art Moderne, Centre Georges Pompidou

PAGE 132 ABOVE:
View of the workshop wing of the Dessau Bauhaus
Berlin, Bauhaus-Archiv

PAGE 132 BELOW:
The Bauhaus Masters, photographed in 1926 on the roof of the studio building in Dessau. From left to right: Josef Albers, Hinnerk Scheper, Georg Muche, László Moholy-Nagy, Herbert Bayer, Joost Schmidt, Walter Gropius, Marcel Breuer, Wassily Kandinsky, Paul Klee, Lyonel Feininger, Gunta Stölzl, Oskar Schlemmer
Paris, Musée National d'Art Moderne, Centre Georges Pompidou

Kandinsky teaching the preliminary course ("Vorkurs"), Dessau 1931
Photograph
Berlin, Bauhaus-Archiv

Design for a mural in the Unjuried Art Show:
Wall A, 1922
Wand A
Gouache and white chalk on black paper,
mounted on card, 34.7 x 60 cm
Paris, Musée National d'Art Moderne,
Centre Georges Pompidou

the commonplace. Art must push forward. Mere explosions in art are ultimately boring."

In view of his thinking on art, Kandinsky seems almost predestined for a career at the Bauhaus. His gift for teaching, together with his artistic theories – developed further in Moscow – aiming at a synthesis of all the arts, made him an appropriate teacher for a modern-style establishment such as the Bauhaus, which rejected traditional Academy methods of art education in favour of theoretical and practical training in a wide range of artistic skills.

The reforms being pioneered in art education by such craft-oriented schools as the Bauhaus had their origins in the second half of the 19th century, when the desire to marry industry and art gave birth to the Arts and Crafts movement in England. This movement was taken up in Germany at the start of the 20th century with the founding of the Deutscher Werkbund (German Work Federation), a joint venture between art and industry. Companies affiliated to the Werkbund were encouraged to employ artists to design their products, with the scope of commissions ranging from household utensils to architecture. Following the First World War, the Weimar Republic then brought forth a generation of artists' associations who argued that the arts should be adapted to the needs of the new "socialist society". These included the Arbeitsrat für Kunst (Art Soviet) and the Novembergruppe (November Group), as well as the Bauhaus in Weimar.

The State Bauhaus in Weimar was founded in 1919 by the architect Walter Gropius. It represented the amalgamation of the former Academy of Fine Art and the former School of Arts and Crafts (previously headed, until 1914, by Henry van de Velde). Its foundation took place in a period of revolutionary unrest and political confusion as to where administrative au-

thority for the new school actually lay. Had the situation been otherwise, however, such a progressive institution would never have been approved. And indeed, as the conservative forces regrouped over the ensuing months and years, the Bauhaus' existence became increasingly threatened.

In April 1919 Gropius published the first *Bauhaus Manifesto*, in which he declared the aim of the Bauhaus to be the union of all the arts under the primacy of architecture: "The ultimate aim of all creative activity is the building!... Architects, painters and sculptors must learn again to know and comprehend the multi-faceted structure of the building in its entirety and in its parts. Only then will their works fill themselves again of their own accord with the architectonic spirit which has been lost in salon art... There is no essential difference between the artist and the craftsman... Craftsmanship is the imperative foundation for every artist; it is the source of creative invention. Let us desire, conceive and create together the new building of the future, comprising everything in one form – architecture and sculpture and painting..."

The *Bauhaus Manifesto*, which was rapidly publicized throughout Germany, was accompanied by an educational programme in which Gropius sought to combine artistic and theoretical elements with practical and technical skills. The artist was once again to become a craftsman in the original sense of the word. The choice of the name Bauhaus (lit. "Building House") is itself significant in this respect: it evokes associations in German with the medieval *Bauhütten*, the guilds of artisans involved in the building of a cathedral. Conventional art teaching needed to be changed, even revolutionized: specialization and dogmatic academic tradition were to be thrown out of the window. The teachers were called not professors but "masters" (although the title "professor" was reintro-

Design for a mural in the Unjuried Art Show:
Wall B, 1922
Wand B
Gouache and white chalk on black paper,
mounted on card, 34.7 x 60 cm
Paris, Musée National d'Art Moderne,
Centre Georges Pompidou

Kandinsky was able to realize his dream of uniting painting and architecture in these designs for monumental murals for the entrance hall of a museum of modern art – even if the project was never actually executed. The paintings, which line the entire room, aroused in him the same feeling that had overwhelmed him as a student upon encountering the richly decorated houses in Vologda province:
"In these magical houses I experienced something I have never encountered again since. They taught me to *move within the picture*, to live in the picture."

Unbroken Line, 1923
Durchgehender Strich
Oil on canvas, 115 x 200 cm
Düsseldorf, Kunstsammlung Nordrhein-
Westfalen

Trapezoid, triangle and circle make up the three
elementary forms in this picture. They are over-
laid with large and small forms, some geometric
and some free. Strict constructive elements
mingle with unpredictable and expressive ones
in a composition which is dominated by the
themes of movement and repose, tension and
equilibrium.

duced in Dessau, as can be seen from Kandinsky's Dessau Bauhaus iden-
tity card; cf. p. 129), while the students were divided into "apprentices"
and "journeymen". The Bauhaus admission procedure took no account of
applicants' previous diplomas, age or social status.

The most important part of the Bauhaus programme was the *Vorkurs*, a
six-month preliminary course consisting of practical work in one of the
workshops and a course on the elements of form. This was followed by
three years of workshop training (mural painting, ceramics, typography,
furniture, weaving), throughout which apprentices were supervised by a
Master of Form and a Master of Craft.

150 students applied to the Bauhaus immediately upon its foundation.
Astonishingly, almost half of these were women, who had been granted
unrestricted freedom of education by the new Weimar constitution. (Gro-
pius indicated the equality of women at the Bauhaus in his first speech to
the students: "No distinction for women: when it comes to work, every-
one is a craftsman.") After the disaster of World War I, all the students
were fired with the desire to design and build for the "new men and
women" of post-Wilheminian Germany. Naturally, to make these ambi-
tions a reality, exceptional teachers were needed. In the first year, Gro-
pius appointed the painter and art theoretician Johannes Itten, who would
decisively shape the *Vorkurs*, the sculptor Gerhard Marcks, and the
painter Lyonel Feininger, who was considered radically Expressionist and

whose appointment therefore drew immediate criticism from the Weimar press.

Indeed, the sleepy city of Weimar could not have been a more unsuitable setting for such a revolutionary educational establishment as the Bauhaus. As the centre of 19th-century German Classicism, Weimar clung to the memory of its illustrious past and the days of Goethe, Schiller and Herder. The local press was conservative and regularly attacked the Bauhaus until it moved to Dessau in 1925.

The following years saw Paul Klee, Oskar Schlemmer and Kandinsky appointed to the Bauhaus staff. Each Master took charge of one of the workshops. Thus Feininger was responsible for graphic printing, Klee (for a period) for bookbinding, Schlemmer for stone sculpture, Itten for the metal workshop, Gropius for furniture and Kandinsky for mural painting. The idea of this system was that each Master should be able to input his or her artistic ideas into practical workshop activities.

In June 1922, a Thuringian government loan to the Bauhaus was awarded with the proviso that the school held an exhibition of its achievements to date. Gropius immediately mobilized all the forces at his disposal to prepare the First Bauhaus Exhibition, which opened in July 1923. Oskar Schlemmer designed a leaflet detailing the school's aims and organization in typical Bauhaus typography. The very wide-ranging ex-

El Lissitzky:
Beat the Whites with the Red Wedge, 1919
Poster, colour lithograph on paper, 47.9 x 59 cm
Eindhoven, Stedelijk Van Abbemuseum

El Lissitzky here employs the geometric language of the Suprematists, as later adopted by Kandinsky, for an agitprop poster.

In Blue, 1925
Im Blau
Oil on canvas, 80 x 110 cm
Düsseldorf, Kunstsammlung Nordrhein-Westfalen

Blue Circle, 1922
Blauer Kreis
Oil on canvas, 110 x 100 cm
New York, The Solomon R. Guggenheim Museum

In the six months that Kandinsky spent in Berlin before taking up his appointment in
Weimar, he painted only two pictures. One was *Blue Circle*. The composition consists
of geometrizing and organic-seeming elements which appear to rotate in a centrifugal
movement around the centre.

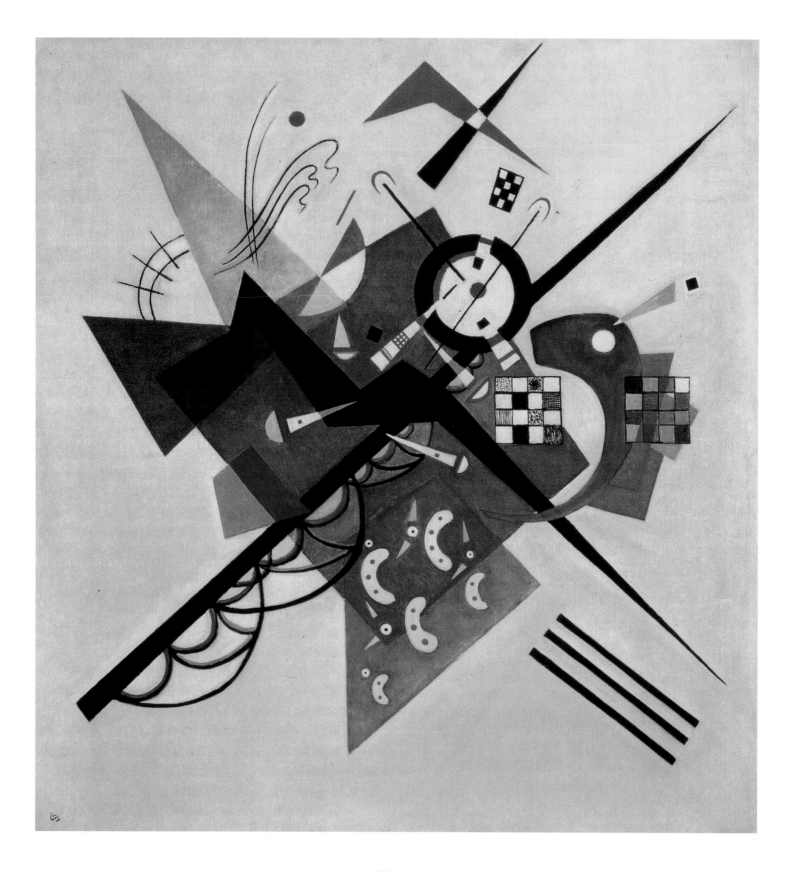

On White II, 1923
Auf Weiß II
Oil on canvas, 105 x 98 cm
Paris, Musée National d'Art Moderne, Centre Georges Pompidou

A disciplined, almost square composition whose corners are accentuated by intersecting diagonals. Kandinsky's forms are growing ever clearer and more geometric. The independent undulating lines seen a year earlier in *Blue Circle* have now become rigid parallel bars (bottom right-hand corner). The white ground provides a neutral backdrop against which the black lines and coloured planes explode.

hibition programme included a performance of Schlemmer's *Triadic Ballet*, an exhibition of contemporary architecture, concerts of music by Hindemith and Stravinsky, jazz events and film projects. A fully-furnished house illustrating the Bauhaus concept of new living was also planned and built in rapid time. Articles from the workshops and pictures by Masters and students were put on display, and Gropius gave a keynote lecture on "Art and technology, a new unity". The Dutch architect Jacobus Oud spoke on modern architecture in Holland, and Kandinsky talked on "Synthetic art". Invitations to the exhibition were designed by both Masters and students and sent out as postcards (p. 140 below). The response was remarkable: a total of some 15,000 visitors came to the various exhibition events to learn at first hand about the Bauhaus and its products.

Kandinsky, who arrived in Weimar in 1922, found himself almost fully occupied with teaching. The thoroughness with which he prepared his classes left him little time for his own artistic activities. Over a few weeks in the summer of 1922, however, he managed to produce *Small Worlds*, a portfolio of twelve prints published by the Propyläen Verlag in Berlin (pp. 130 and 131). The colour lithographs, woodcuts and etchings which make up *Small Worlds* take up the formal vocabulary of Kandinsky's earlier works, for example the landscape motifs of his Munich years (p. 130, below left) and sails and oars (p. 130, above right, p. 131 right). Constructivist elements from Kandinsky's Moscow period (and also in use at the Bauhaus) also resurface in chessboard and grid patterns (p. 130, below right; p. 131 left), while diagonals, circles and rings are borrowed from Suprematism (p. 130, below right; p. 131 right). Kandinsky also experiments with new formal components such as free arches, clusters of lines, parallel bars and wedges. All these elements are integrated into new and highly original compositions. *Small Worlds* can thus be seen as a sort of grammar of pictorial forms, which Kandinsky uses to test the effects of expressive and constructive elements of form, yet without relapsing into schematization. The twelve prints bear witness to his remarkable creative imagination and carry his very personal signature, vibrating with inner tension.

In 1923 Kandinsky produced two large paintings which rank amongst the major works of his Weimar period. Calmer and more thoughtful than the polyphonic cosmos of *Small Worlds*, these are *Composition VIII* and *Unbroken Line*. In *Unbroken Line* (p. 136), the pictorial ground is occupied by three large, somewhat overlapping geometric forms, namely a trapezoid, a triangle and a circle. Like pictures within a picture, the trapezoid and the circle each contain their own galaxy of forms, in part citing elements from *Small Worlds*. A continuous diagonal line slices across the trapezoid and triangle and brushes tangentially past the circle. It is halted top right by a bar lying across its course; a yellow circle surrounds their point of intersection. This diagonal movement is emphasized by the straight black lines above the tangent. At the same time, however, it is countered by the broad arching line, cluster of lines and free linear forms in the bottom right-hand corner. Each constructive element is meaningful in itself and remains autonomous even when overlapped. As in a mobile, all the forms are moving, set in motion by their position on the pictorial plane and in relation to one other. Movement and repose, opposition and

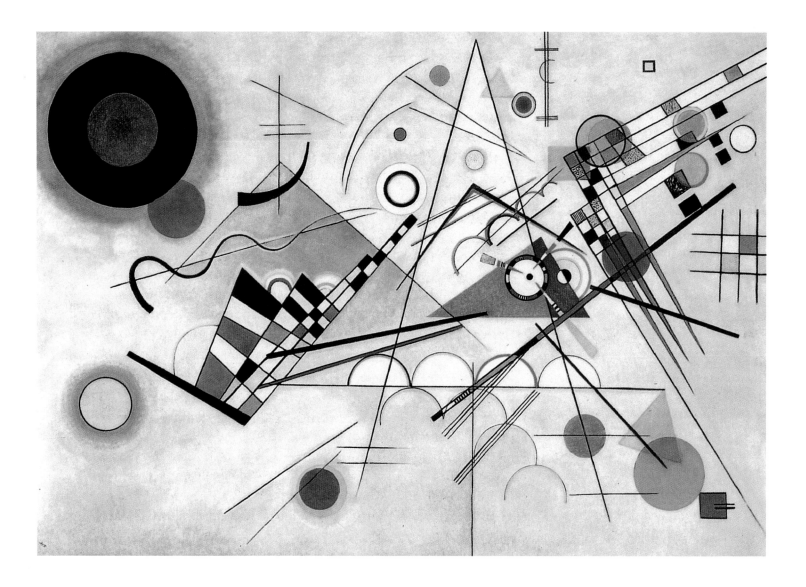

equilibrium of forces are the themes of this picture from Kandinsky's early Bauhaus years.

By contrast, *Composition VIII* (p. 141) creates a cooler and more static impression. Circles and straight lines are the dominant forms and combine into a strict geometry. The sense of intellectuality and coolness is heightened by the matt, restrained colours of the pictorial ground. A black circular form in the top left-hand corner sounds an authoritative, sombre note and provides a strong accent within the composition. Its red aura, the black wavy line beneath it and the haloes surrounding the yellow and blue circles are the only non-geometric elements in the picture, yet even these are still far from being figurative. Indeed, none of the elements in *Composition VIII* can be traced back to representational origins.

Kandinsky himself viewed *Composition VIII* as one of the most important works of his post-war years. In it he converts the landscape motifs familiar from his earlier works into the abstract style of his post-Russian period. At the same time, it marks his first systematic application of his ideas on the correspondences between colours and forms and the rich "contrapuntal" effects these produce: warm yellow and cold blue as the fundamental polarities which he had already analyzed in *On the Spiritual in Art*, and circle and triangle as contrasting elements symbolizing movement (triangle) and stability (circle).

Composition VIII, 1923
Komposition VIII
Oil on canvas, 140 x 201
New York, The Solomon R. Guggenheim Museum

"The contact between the acute angle of a triangle and a circle has no less effect than that of God's finger touching Adam's in Michelangelo."
(Kandinsky in *Reflections on Abstract Art*, 1931)

Indeed, the correspondences between colours and forms and the systematic study of individual elements were amongst Kandinsky's chief preoccupations at the Bauhaus. Alongside his activities in the mural-painting workshop, Kandinsky – like his colleague Paul Klee – also ran a course on the theory of form as part of the *Vorkurs*, as well as offering a class on analytic drawing.

Kandinsky devoted particular attention in his classes to the relationship between colour and form. He believed that certain colours correspond to certain forms, i.e., that certain forms heighten the impact of certain colours. In order to test his theory, he drew up a questionnaire which he issued to the students in his mural-painting workshop. The students were asked to fill in the three elementary forms of triangle, square and circle in the primary colour they felt suited it most. By far the largest number coloured the triangle yellow, the square red and the circle blue, thereby confirming Kandinsky's own conclusions (p. 144 above). The next step was to find geometric forms corresponding to the secondary colours of green, orange and violet, a task which Kandinsky set his pupils in the classroom. Forerunners of these experiments can be seen in Suprematist works by Malevich and Rodchenko, in which overlapping geometric forms in contrasting colours serve to illustrate spatial relationships and principles of tension.

Kandinsky had already introduced the idea of interaction between colour and form in *On the Spiritual in Art*: in view of our synaesthetic association of "yellow" with "sharp", he believed, the effect of yellow is emphasized when combined with a sharp form. Similarly, the effect of a deeper colour such as blue is reinforced by rounded forms.

Kandinsky applied these colour theories to his art throughout his years at the Bauhaus. A particularly revealing example is *Yellow-Red-Blue* of 1925 (p. 145). Here, as the title suggests, the main emphasis falls on the three primary colours, and notably on the opposition between yellow and blue. The left-hand side of the picture appears bright, light and open; its dominant yellow is accompanied by delicate black lines and framed by a cloud-like violet-blue border. By contrast, the right half of the composition, with its large blue circle set against a pale yellow ground, appears dark, heavy and dramatic. These two contrasting halves are linked by the red colour planes and the grey quadrilateral at the centre of the canvas. The black-and-white chequered form inside the grey quadrilateral takes up both the blacks of the right-hand, blue half (whiplash line, small circle, diagonal) and the whites of the left-hand, yellow half (set of white semicircles on a black line). Kandinsky thereby links and simultaneously accentuates the polarities within the composition. *Yellow-Red-Blue* is thus an example of opposition and mediation, of the abstract representation of elementary contrasts. In its rich palette and formal variety it is closer to *Unbroken Line* than to the rigidly-organized *Composition VIII*, whereby its atmospheric background gives it an additional intensity.

Kandinsky painted *Yellow-Red-Blue* during the school's last few months in Weimar, shortly before it moved to Dessau. Having been the regular target of criticism from conservative right-wing forces ever since its foundation, the Bauhaus was now suspected of nurturing Communist intrigues, placing its existence under growing threat. When the Thuringian regional

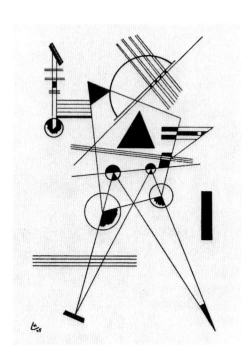

Inner Relationship between Complex of Straight Lines and Curve (left-right), 1925
Innere Beziehung eines Komplexes von Geraden zu einer Gebogenen
Drawing accompanying the painting *Black Triangle*

This drawing appears in Kandinsky's book *Point and Line to Plane* of 1925 and was therefore probably made after the oil painting itself. Diagrammatic drawings of this kind expose the most important linear structures within a pictorial composition and thus emphasize the constructive dimension of the paintings they accompany.

PAGE 143:
Black Triangle, 1925
Schwarzes Dreieck
Oil on card, 79 x 53.5 cm
Rotterdam, Collection Museum Boymans-van-Beuningen

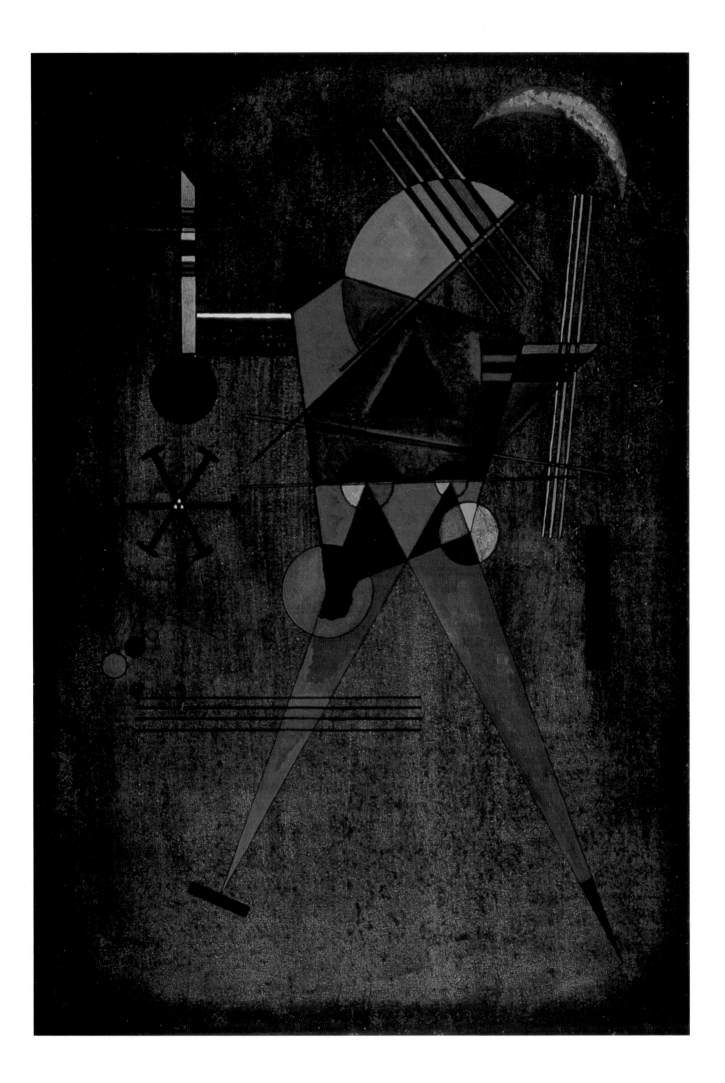

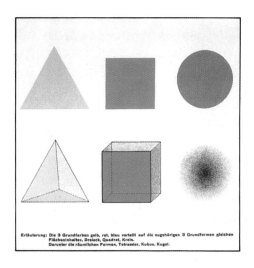

The three primary colours assigned to the three elementary forms, 1923
Colour lithograph with letterpress on card,
24.5 x 25 cm
Berlin, Bauhaus-Archiv

Influenced by combinations of geometric forms in Russian Suprematism, Kandinsky made the investigation of colour-form relationships an important part of his colour seminar at the Bauhaus. He believed that certain colours corresponded particularly well with certain forms: "Sharp colours have a stronger sound in sharp forms (e.g. yellow in a triangle). The effect of deeper colours is emphasized by rounded forms (e.g. blue in a circle)." Kandinsky established similar colour-form associations for the secondary colours.

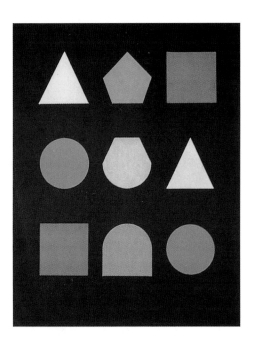

Eugen Batz:
Correspondence between Colours and Forms,
1929/30
Korrespondenz zwischen Farben und Formen
Tempera over pencil on black paper,
42.3 x 32.9 cm. Berlin, Bauhaus-Archiv

government elections of 1924 produced a majority for the parties on the right, the fate of the Bauhaus was sealed. Funding was cut; yet when Gropius proposed the setting-up of a limited company which would sell Bauhaus products and thus bring the school a certain degree of financial security and independence, the suggestion was rejected. From a political point of view, at least, the Bauhaus was no longer wanted in Weimar.

A number of other German cities now offered the progressive institute a new home, amongst them Darmstadt, Hagen and Krefeld. In the end, however, the Bauhausers opted for Dessau, which was governed by the Social Democrats. Dessau was facing an acute housing shortage as a result of its rapidly expanding industry, and the municipal authorities hoped that the Bauhaus would bring new stimulus and fresh solutions to the problem. And indeed, in 1926 Gropius designed a large estate of sixty detached houses for the Dessau suburb of Törten.

The most important architectural project in Dessau, however, was the design and construction of the new Bauhaus building and Masters' houses. For the school itself, Gropius designed a large, three-wing complex incorporating classrooms, workshops, an administrative section, student accommodation, an auditorium, a canteen and a theatre – a building, in other words, in which Gropius was able to realize his aim of uniting all areas of living and working under one roof. The finished building, with its glazed southwest façade (p. 132 above), was nothing short of a sensation; described as a "giant light cube" by one visitor, its inauguration in December 1926 was attended by large numbers of guests.

Equally striking were the Masters' houses, with their strict cubist form (p. 147). These were also designed by Gropius and consisted of three semi-detached houses with studios, plus one detached house for Gropius himself. Wassily and Nina Kandinsky lived alongside Klee and his family in one of the semi-detached houses, with Feininger and Moholy-Nagy sharing a second, and Muche and Schlemmer the third. The houses were decorated and furnished with remarkable generosity by the standards of the times. The artists chose their own interior colour schemes: Kandinsky's living room was painted light pink, for example, with a niche decorated with gold leaf (p. 146, below right). The furniture for the Masters' houses was designed by Marcel Breuer. Inspired by the handlebars of a bicycle, and in close collaboration with the Dessau-based Junkers aircraft construction plant, Breuer experimented with furniture designs employing bent tubular steel. He developed a chair whose formal clarity and objectivity made a tremendous impression on Kandinsky. Indeed, Kandinsky was the first person to buy one, and Breuer subsequently named the model the "Wassily" in his honour (p. 146, below left). Breuer also built a chair for Kandinsky's living room on the basis of Kandinsky's own detailed designs. This second model, in black and white, takes up the circular elements which Kandinsky loved so much (p. 146, above left and above right). Although Kandinsky's chair is somewhat rigid, and cannot compare with the graceful elegance of the "Wassily", its composition reveals much about his artistic thinking. Its circular seat, rectangular back, cylindrical legs and rectangular stabilizing elements, in combination with a colour scheme of black and white, represent a geometric arrangement of forms and colours that might be taken straight from one of his pictures.

Yellow-Red-Blue, March–May 1925
Gelb-Rot-Blau
Oil on canvas, 128 x 201.5 cm
Paris, Musée National d'Art Moderne,
Centre Georges Pompidou

This picture, with its programmatic title, is the
most important work of Kandinsky's Weimar
period. The underlying structure of the composi-
tion is determined by the three primary colours.
As in a colour chart, the colours are shaded from
light (left) to dark (right). But any danger of sche-
matization is removed by the atmospheric
ground and the diversity of forms, which turn the
composition into a complex structure of colour
relationships.

Once in Dessau, the Bauhaus began to develop its contacts with the
outside world. The limited company which Gropius had proposed in Wei-
mar was finally founded. This "Bauhaus GmbH" marketed and sold a
range of Bauhaus products, including furniture by Marcel Breuer, lamps
by Marianne Brandt and wall-paper designs by Gropius and Hermann Fi-
scher, all of which met with an unexpectedly high response. An official
Bauhaus journal was started up, with the first number appearing in 1926
to coincide with Kandinsky's 60th birthday. That same year saw the publi-
cation of Kandinsky's *Point and Line to Plane* as no. 9 in the series of
Bauhaus books. According to Kandinsky, *Point and Line to Plane* rep-
resented the organic continuation of *On the Spiritual in Art* and was
based on notes he had made at Lake Constance during the first weeks of
the war, prior to his return to Russia.

This second, generously illustrated essay contains a significant part of
the theory of form which Kandinsky taught to his *Vorkurs* students, and
which also formed the basis of his free painting class. The book is sub-
titled "A Contribution to the Analysis of Pictorial Elements" and offers a
systematic investigation into the basic pictorial elements of point, line
and plane. Kandinsky seeks to compile a "dictionary of elements" which
will lead to a "grammar of art", revealing the internal laws according to
which the act of painting proceeds. The creation of a picture, he believed,
does not unfold in a totally arbitrary fashion – an accusation regularly le-
velled at abstract art – but represents a free play of forms within strict

Lucia Moholy:
Wassily and Nina Kandinsky in the dining room
of their Master's house in Dessau, 1926
Photograph
Berlin, Bauhaus-Archiv

Marcel Breuer:
Chair for Kandinsky's dining room in Dessau
(based on designs by Kandinsky), 1926
Wood, painted black and white, nickel-plated
metal and black fabric
Paris, Musée National d'Art Moderne,
Centre Georges Pompidou

Marcel Breuer:
Tubular-steel chair, 1925/26
Nickel-plated steel and Eisengarn fabric
Berlin, Bauhaus-Archiv

146

Masters' houses, Dessau, 1926
Photograph
Paris, Musée National d'Art Moderne,
Centre Georges Pompidou

The Masters' houses at the Dessau Bauhaus were
designed by Walter Gropius, who saw them as
experimental examples of the lifestyle of the fu-
ture. They were intended to illustrate "modern
living" right down to their finest details and to
demonstrate the harmony of technical function-
ality and aesthetic extravagance.

PAGE 146, BELOW RIGHT:
View of the niche, partially decorated with gold
leaf, in Kandinsky's Dessau living room, c. 1928
Photograph
Paris, Musée National d'Art Moderne,
Centre Georges Pompidou

rules. These rules are not determined by the artist at will, but are laws
which arise from the compositional elements themselves and their im-
manent energies.

The first object of Kandinsky's investigation is the point, which for
him forms the primordial element of painting, and which he submits to a
microscopic analysis.

He examines the various outer forms that a point can assume as soon
as it has overstepped its ideally small form, namely that of a circle
(p. 148, below left). The point can assume an infinite variety of appear-
ances; it may tend towards geometric forms or towards free forms. "It is
impossible to determine any limits, for the realm of the point is limit-
less." The external form and size of the point thereby determine its
"basic sound".

The "multiplicity and complexity of expression in the case of the
'tiniest' form – achieved by only minimal variations in size – offer even
the non-specialist a convincing example of the expressive power and ex-
pressive depth of abstract forms."

A circular point, for example, has a concentric tension and displays no
inclination to move in any direction. "This lack of any impulse to move

Independent Undulating Line with Emphasis – Horizontal Position
Freie Wellenartige mit Nachdruck – Horizontale Lage

The Same Undulating Line Accompanied by Geometrical Elements
Dieselbe Wellenartige mit Begleitung von Geometrischen

Examples of Different-Shaped Points
Beispiele der Punktformen

Diagonal Tensions and Countertensions with a Point, which Causes an External Construction to Pulsate Internally
Diagonale Spannung und Gegenspannungen mit einem Punkt, der eine äußere Konstruktion zu innerem Pulsieren bringt

either upon or from the surface reduces to a minimum the amount of time required to perceive a point, which excludes the element of time almost entirely." The point is thus the temporally most concise form.

A point becomes a line when its concentric tension is obliterated by an external force which pushes it across the surface in one or another direction. Line thus comes about through movement; it is dynamic and, as such, the ultimate contrast to the point. Whereas both point and line carry tension, line alone has direction. Kandinsky proceeds to investigate the geometric straight line in its three typical forms of horizontal, vertical and diagonal. Coolness and flatness are the basic sounds of the horizontal, warmth and height those of the vertical. The diagonal combines the properties of both its fellows. All other straight lines are deviations from the diagonal; the extent to which they tend towards coolness or warmth determines their respective inner sounds.

Next Kandinsky examines the curve, which constitutes the opposite to the straight line, since – unlike the straight line – it "bears the kernel of the plane within itself". The curved line has "great stamina" and "mature, justly self-confident energy". The curve can exist in an inexhaustible number of variations. Kandinsky illustrates what he calls independent undulating (as opposed to geometrical undulating) lines "with emphasis": these are curves whose lines are thickened in places and which therefore lean towards becoming planes (p. 148, above left). Such variations produce a certain vibration and loosen up the stiff atmosphere of the whole. If an independent undulating line is combined with geometrical elements (p. 148, above right), the properties of the individual elements combine together to create an animated complex based on inner tensions.

The numerous black-and-white drawings and diagrams illustrating *Point and Line to Plane* were accompanied by just one colour reproduction, *Small Dream in Red* of 1925 (p. 152). Kandinsky also included a schematic representation of this painting, revealing a complicated structure of geometrical and independent lines in manifold relationships (p. 153). The composition starts from a central concentration which dissipates outwards towards the sides in a circular movement. This concentric tension is interrupted by the almost vertical lines near the right-hand edge of the picture. These establish a link with the pair of straight lines with the slight bulge hovering between the vertical and the diagonal. This complex linear structure is given an added dimension of depth in the oil painting by a cloud-like ground of yellows and browns, where patches of red, green and blue also serve to reinforce the impression of pulsating animation.

The complexity of *Small Dream in Red* cannot be explained simply by analyzing its constituent elements; nor could it ever be, since the inner value of a work of art far exceeds that which can be comprehended by the reason. "The external forms do not materialize the content of a pictorial work, but rather, the forces = tensions living within these forms," wrote Kandinsky in *Point and Line to Plane*. These "tensions" draw reactions which Kandinsky had earlier described in terms of "vibrations from the soul" – a subjective response, in other words, which is of primary importance in our experience of a work of art.

Kandinsky's Dessau phase was not to get properly under way until *Tension in Red* (p. 154), painted one year after the expressive *Small Dream in*

Dust jacket of the first edition of *Point and Line to Plane* (*Punkt und Linie zu Fläche*), 1925
Berlin, Bauhaus-Archiv

Point and Line to Plane was Kandinsky's second major publication on pictorial theory, in which he subjects the point, the line and the plane to a strict analysis. He believed that "the analysis of artistic elements constitutes a bridge leading to [the] inner pulsation of the work".

PAGE 148:
Kandinsky's illustrations of points and lines in *Point and Line to Plane*, 1925

PAGES 150/151:
Dance curves based on Palucca's dances, 1926
Berlin, Bauhaus-Archiv

The dancer Gret Palucca (1902–1993) was famed for the height and length of her jumps. Her physical style of dancing expressed light-heartedness and *joie de vivre*. She performed at the Bauhaus several times over the course of the 1920s. Kandinsky translated her figures and jumps into schematic diagrams in an attempt to render the tension of her bodily expressions and their spatial effect in a two-dimensional medium.

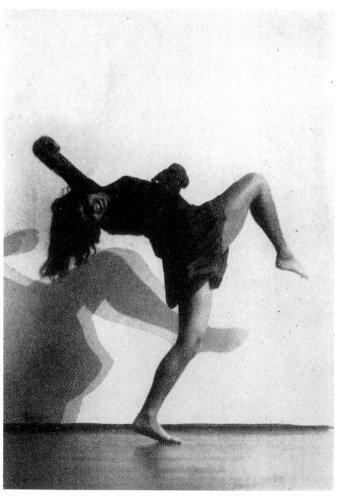

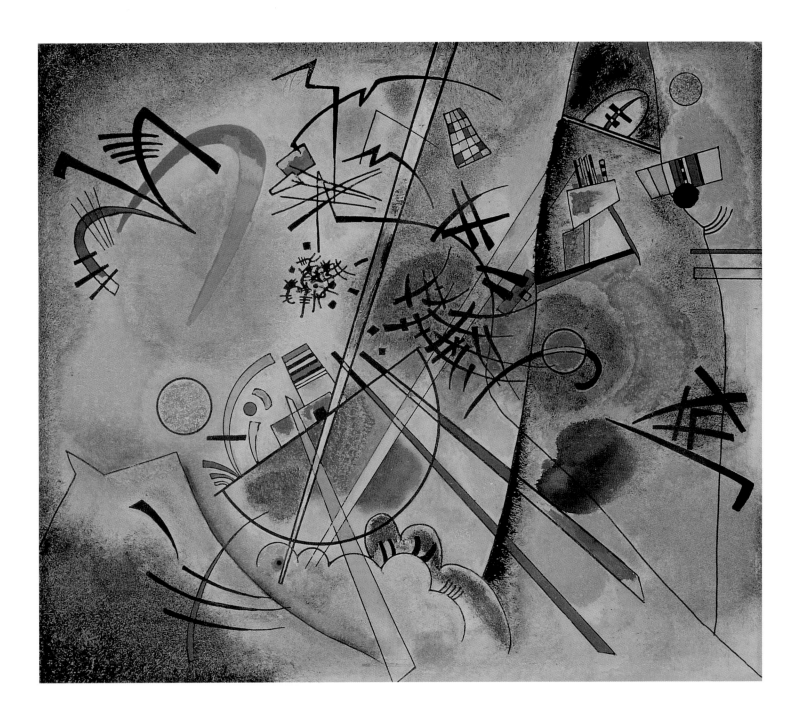

Small Dream in Red, 1925
Kleiner Traum in Rot
Oil on paper on card, 35.5 x 41.2 cm
Berne, Kunstmuseum Bern

The only colour reproduction to appear in the first edition of Kandinsky's *Point and
Line to Plane* was this warm, almost intimate picture with its playful wealth of forms –
and not one of his stricter geometric compositions.

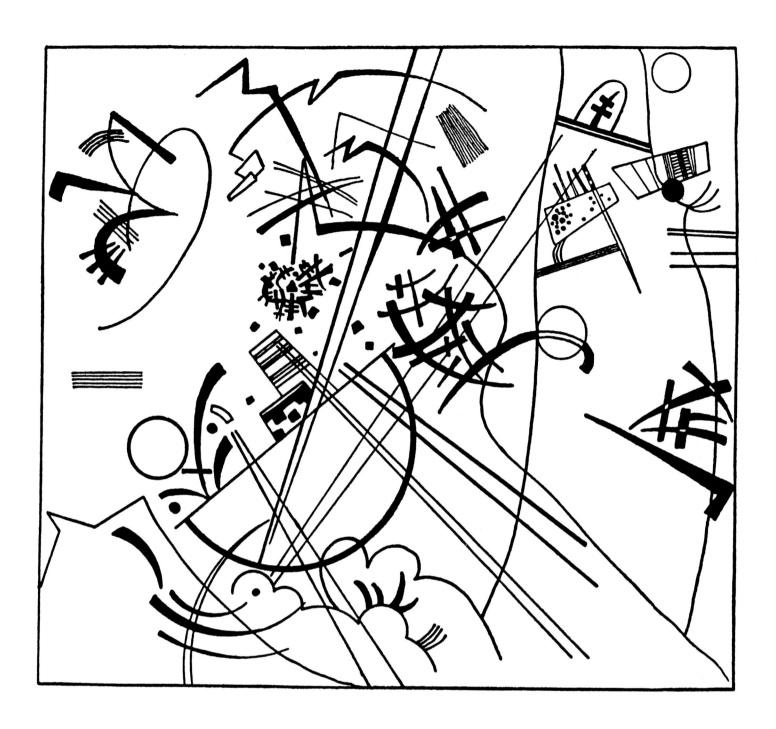

Linear structure of the picture **Small Dream in Red**, 1925
Kleiner Traum in Rot
(from the book *Point and Line to Plane*)

This schematic drawing makes the diagonal tensions and countertensions in *Small Dream in Red* particularly clear. The small oil painting, a present for Nina, shows a happily animated play of pictorial elements set against a cloud-like ground of earthy colours. It thereby reflects Kandinsky's concept of a free play of forms according to strict internal laws.

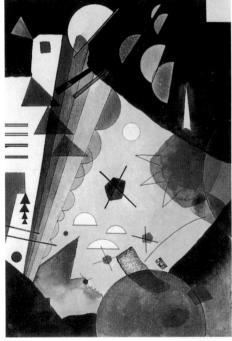

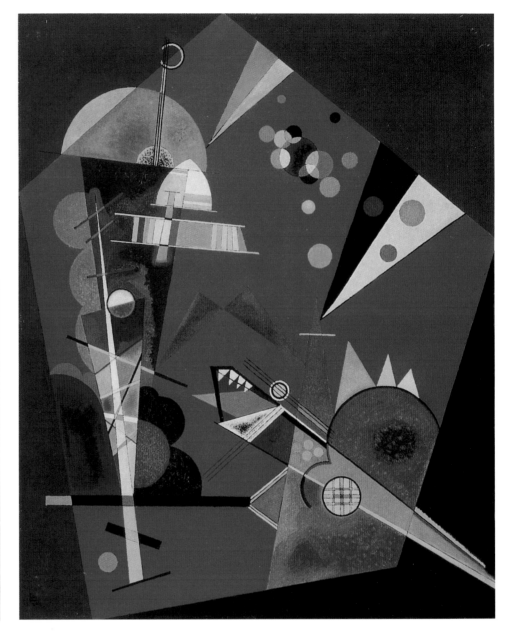

Upward Tension, 1924
Spannung nach oben
Watercolour on paper, 49 x 34 cm
Paris, Musée National d'Art Moderne,
Centre Georges Pompidou

Tension in Red, 1926
Spannung in Rot
Oil on card, 66 x 53.7 cm
New York, The Solomon R. Guggenheim
Museum, Gift of Solomon R. Guggenheim, 1938

An increasing geometrization and a greater two-
dimensionality are amongst the characteristic fea-
tures of Kandinsky's early Dessau works. Here
he establishes the tension in the title by employ-
ing large-area, unusual forms and by deviating
from his theory of colour-form correspondences,
according to which red is normally assigned to
the square: "The incompatibility of certain forms
and colours should be regarded not as something
'disharmonious', but conversely, as offering new
possibilities – i.e. also [a form of] harmony."
(Kandinsky in *On the Spiritual in Art*, 1912)

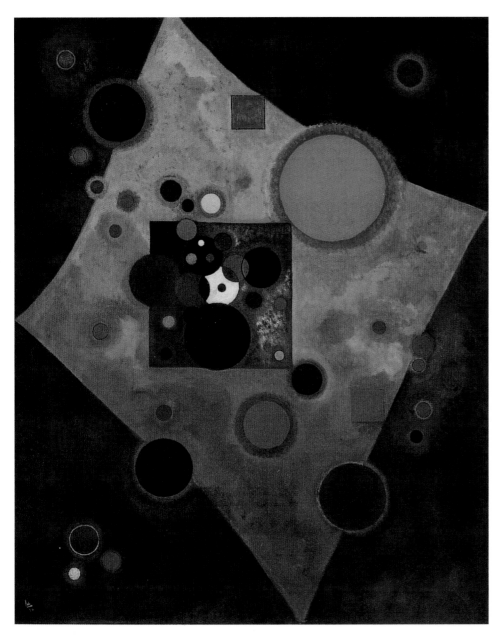

Accent in Pink, 1926
Akzent in Rosa
Oil on canvas, 100.5 x 80.5 cm
Paris, Musée National d'Art Moderne,
Centre Georges Pompidou

This painting, a gift for Nina's name day, draws
its inner tension from colour polarities (the con-
trast of black and white in the centre) and com-
plementary contrasts (yellow rhombus versus
blue-violet corners; red, pink and green circles).
The conflict between angular forms and Kandin-
sky's beloved circles gives the picture additional
energy. "The circle is the synthesis of the great-
est oppositions. It combines the concentric and
the eccentric in a single form, and is in balance."
(Kandinsky to Will Grohmann, 1930)

Untitled, c. 1926
Chinese ink on paper, 37.2 x 36.4 cm
Paris, Musée National d'Art Moderne,
Centre Georges Pompidou

Red. This new phase was characterized by a stronger leaning towards strict geometric forms, often large in scale, and a reduced use of linear elements. Colours became more opaque, compressing space almost to the point of nontransparency. In *Tension in Red*, Kandinsky creates the tension of the title by deviating from his theory of correspondences, according to which red is assigned to the square. But as he acknowledged in *On the Spiritual in Art*: "The incompatibility of certain forms and colours should be regarded not as something 'disharmonious', but conversely, as offering new possibilities – i.e. also [a form of] harmony."

The circle represents the dominant pictorial element in Kandinsky's work at the Dessau Bauhaus between 1926 and 1929. Kandinsky produced a series of ten pictures in which the circle is the only form employed (e.g. *Several Circles*, p. 156). The circle had already played an important role in many of his earlier works: *Composition VIII* (p. 141), for example, is dominated by the black circle with the glowing red halo in the top left-hand corner, while in *Yellow-Red-Blue* (p. 145) the circles establish a counterpoint to the diagonal orientation of the composition. In such works the circle is always treated as an abstract formation; associations with the representational world are not intended. This is equally true of *Several Circles* (p. 156), Kandinsky's most important circle painting in Dessau, where he is concerned not with figurative associations but with pure abstract forms floating in a certain constellation against a plane.

For Kandinsky, the circle was the "synthesis of the greatest oppositions", since it brought together concentric and eccentric forces and maintained them in equilibrium. During these Bauhaus years, the mystical quality of the circle assumed the importance previously enjoyed by the rider in Kandinsky's Munich period. In 1930 Kandinsky wrote to Will Grohmann, his friend and biographer: "If I have, e.g., in recent years so frequently and so enthusiastically made use of the circle, the reason (or the cause) is not the 'geometrical' form of the circle, or its geometrical characteristics, but rather my own extreme sensitivity to the inner force of the circle in all its countless variations. I love circles today in the same way that previously I loved, e.g., horses – perhaps even more, since I find in circles more inner possibilities, which is the reason why the circle has replaced the horse. All this has, I have already mentioned, no role to play in the course of working; I do not choose form consciously, it chooses itself within me."

In 1926, the year in which he produced *Several Circles*, Kandinsky also celebrated his 60th birthday. It was the start of an intensely creative phase: during this Dessau period he produced 259 oil paintings and almost 300 watercolours. To coincide with Kandinsky's birthday, Paul Klee wrote a short appreciation of his colleague's work in an exhibition catalogue published by the Arnold gallery in Dresden. Klee, who lived next door to Kandinsky in one of the semi-detached Masters' houses, described himself "in a certain sense" as Kandinsky's pupil – a description undoubtedly inspired more by the 13-year age difference between them and by Klee's admiration for his older friend than by any actual teacher-pupil relationship. The two artists were simply too different. Both Klee and Kandinsky taught Bauhaus courses on the theory of pictorial form and ran their own free painting classes. Kandinsky based his teaching on

Drawing No. 1, 1923
Zeichnung Nr. 1
Pencil and ink on card, 31.5 x 22.7 cm
Paris, Musée National d'Art Moderne,
Centre Georges Pompidou

PAGE 156:
Several Circles, 1926
Einige Kreise
Oil on canvas, 140.3 x 140.7 cm
New York, The Solomon R. Guggenheim
Museum, Gift of Solomon R. Guggenheim, 1941

"If I have, e.g., in recent years so frequently and so enthusiastically made use of the circle, the reason (or the cause) is not the 'geometrical' form of the circle, or its geometrical characteristics, but rather my own extreme sensitivity to the inner force of the circle in all its countless variations. I love circles today in the same way that previously I loved, e.g., horses – perhaps even more, since I find in circles more inner possibilities, which is the reason why the circle has replaced the horse."
(Kandinsky to Will Grohmann, 1930)

the point, the line and the plane and their immanent energies. Klee also started from these elements in his *Pedagogical Sketchbook (Pädagogisches Skizzenbuch)*, published as Bauhaus book no. 2, but saw in everything a principle of movement, of growing and becoming. Despite their contrasting ideas, Klee and Kandinsky sometimes produced astonishingly similar pictures during their time together in Dessau (cf. pp. 158/159). When Klee left the Bauhaus in 1930 to go and teach at the Düsseldorf Academy of Art, Kandinsky wrote a farewell tribute to him which was published in *bauhaus* no. 3 (printed in lower case, as was usual for Bauhaus typography): "as an example of unswerving dedication to his work, we could all learn something from klee. and undoubtedly have learned... at the bauhaus, klee exuded a healthy, generative atmosphere – as a great artist and as a lucid, pure human being."

During his time at the Bauhaus, Kandinsky was also offered the opportunity to turn his ideas of a synthesis of the arts into reality in a stage production at Dessau's Friedrich Theatre. Although the Bauhaus had its own theatre workshop, Kandinsky's connections with it were few. Theatre at the Bauhaus was largely dominated by the figure of Oskar Schlemmer, who had begun his Bauhaus career as a student in the joinery workshop and in 1925 had taken over the theatre workshop. Schlemmer subscribed to the "elemental" approach practised at the Bauhaus, breaking down his theatre work into the basic elements of space, form, colour, sound, movement and light. Building upon these basic elements, Schlemmer de-

Paul Klee:
Senecio, 1922
Oil on gauze on card, 40.5 x 38 cm
Basle, Öffentliche Kunstsammlung Basel,
Kunstmuseum

Kandinsky and Klee photographed from the balcony, Dessau, 1930
Photograph
Paris, Musée National d'Art Moderne,
Centre Georges Pompidou

Klee and Kandinsky occasionally produced astonishingly similar pictures during their time together in Dessau. Whereas Kandinsky's paintings were abstract formations which allowed figurative associations, Klee's were abstracted forms harbouring poetic significance. Both men published their theories on art as part of the series of Bauhaus books; Klee's *Pedagogical Sketchbook* appeared in 1925 and Kandinsky's *Point and Line to Plane* in 1926.

PAGE 158:
Upward, 1929
Empor
Oil on card, 70 x 49 cm
Venice, The Peggy Guggenheim Collection

159

Paul Klee:
Gate in the Garden, 1926
Tor im Garten
Oil on card, 54.5 x 44 cm
Berne, Kunstmuseum Bern,
Prof. Max Huggler Foundation

Colourful Sticks, 1928
Bunte Stäbchen
Mixed media on card, 42.7 x 32.7 cm
New York, The Solomon R. Guggenheim
Museum, Gift of Solomon R. Guggenheim, 1938

Lily Klee:
Kandinsky and Klee Imitating the Goethe and
Schiller Monument in Weimar, 1929
Paris, Musée National d'Art Moderne,
Centre Georges Pompidou

"more than twenty years ago, i moved into the ainmillerstraße in munich, and soon learned that the young painter, paul klee, who had just made his successful debut at the galerie thannhauser, lived almost next door to me. we remained neighbours up until the outbreak of the war, and from this period dates the beginning of our friendship. we were blown apart by war. only eight years later did fate bring me to the bauhaus at weimar, and so we became – klee and i – neighbours for a second time: our studios at the bauhaus were situated almost side by side. soon followed another separation: the bauhaus flew from weimar with a rapidity that a zeppelin might have envied. to this flight klee and i owe our third and closest period of proximity: for more than five years we have been living right next to one another, our apartments separated only by a fireproof wall. but despite the wall, we can visit one another without leaving the building, by a short walk through the cellar... but our spiritual proximity would have existed even without access through the cellar."
(Kandinsky's tribute to Klee upon the latter's departure from the Bauhaus, 1931)

Lily Klee:
The Goethe and Schiller Monument in Weimar,
1929
Photograph
Paris, Musée National d'Art Moderne,
Centre Georges Pompidou

veloped the famous Bauhaus ballets which subsequently toured Germany and Switzerland in 1929. Kandinsky had often expressed his thoughts on theatre in Bauhaus publications, but had never become actively involved in practical stage work. That was to change in 1928, when the director of the Friedrich Theatre in Dessau invited him to design sets to accompany a staged performance of Modest Mussorgsky's *Pictures at an Exhibition*. The commission was a singular and highly attractive one for Kandinsky, since it involved transposing Mussorgsky's composition, itself inspired by sixteen pictures at an exhibition, back into visual media. Just as Mussorgsky's music offered an "abstract" reflection of the composer's innermost feelings and reactions upon viewing the pictures in question, Kandinsky's décor was composed of chiefly abstract forms. Kandinsky himself regularly stressed that the sets were "abstract" and that, as in Bauhaus theatre, the theatrical elements were intended to create a non-narrative performance. He did not allow this to constrict him, however, but now and again drew upon forms which were vaguely "representational", for example in *The Great Gate of Kiev* and *The Market Place at Limoges*. These were forms, as he said himself, that sprang to mind as he listened to the music.

In 1928 Walter Gropius resigned as director of the Bauhaus in order to devote himself to his architectural practice. His post was taken by the Swiss architect Hannes Meyer, who headed the Bauhaus until 1930. Under Hannes Meyer, greater emphasis was placed upon technical and functional projects. The "bogus-advertising-theatricalness of the previous Bauhaus", as Hannes Meyer termed it in a letter to Adolf Behne, was viewed as the private luxury of the Bauhaus painters. In view of the

Picture II, Gnomus
Bild II, Gnomus
Stage set for Mussorgsky's *Pictures at an Exhibition*, Friedrich Theatre, Dessau, 1928
Tempera, watercolour and ink on paper,
20.5 x 35.8 cm
Cologne, Theaterwissenschaftliche Sammlung
der Universität zu Köln

Picture XVI, The Great Gate of Kiev
Bild XVI, Das große Tor von Kiew
Stage set for Mussorgsky's *Pictures at an Exhibition*, Friedrich Theatre, Dessau, 1928
Tempera, watercolour and ink on paper,
21.2 x 27.3 cm
Cologne, Theaterwissenschaftliche Sammlung
der Universität zu Köln

For the stage set Kandinsky designed a décor of
abstract forms and complexes of forms and
colours that sprang to his mind as he listened to
Mussorgsky's music.

school's modest budget, this old aesthetic could no longer be afforded. The Bauhaus programme was now increasingly influenced by social concerns, and in particular the growing poverty and destitution currently spreading amongst broad sections of the population. Necessity, utility and low cost became the keywords; fashionableness was to be avoided.

Certain features of the works of Kandinsky's last years at the Dessau Bauhaus anticipate to his later Paris pictures. His forms grow smaller and more diverse, with large, strictly geometric forms appearing with increasing rarity. His formats, too, become smaller. Kandinsky's repertoire of forms during these later Dessau years consists of regular geometric forms, abstract symbols, shapes recalling the figurines in his Mussorgsky stage sets, and organic-seeming elements. Pictorial components are frequently presented stacked or in rows. Kandinsky's adoption of a two-dimensional, small-component pictorial structure may have been prompted by the increased focus upon architecture and technology which followed the arrival of Hannes Meyer. Kandinsky had already submitted examples of architecture and technology to abstract analysis in his *Point and Line to Plane*. A radio tower and a "technological forest" of pylons

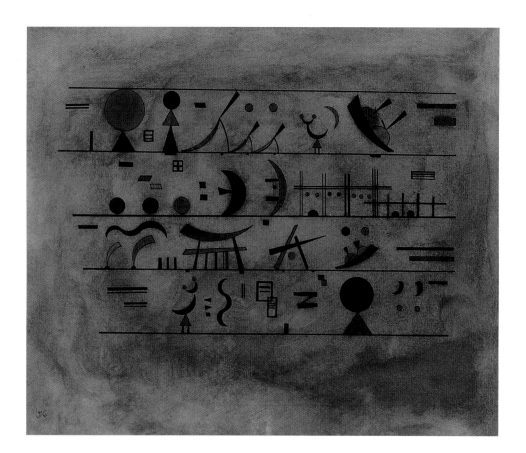

Rows of Signs, 1931
Zeichenreihen
Tempera and ink on paper, 41.7 x 50.3 cm
Basle, Öffentliche Kunstsammlung Basel,
Kupferstichkabinett

were thereby registered as a grid of lines and intersections, while he described the Eiffel Tower as "the most significant early attempt to create a particularly tall building out of lines". The end of the Twenties saw Kandinsky producing pictures in which small symbols are arranged in a certain order. In *Levels* (p. 165), forms accentuated with red float on a white frame, perhaps an ironic reference to the standardized "housing cells" designed at the Bauhaus and built with the help of industrial production methods. The forms in *Rows of Signs* (p. 164) are hieroglyphs, ciphers encoding a secret world. There is nevertheless room for humour in this play of forms, as seen in its boat shapes and bizarre antennae.

Kandinsky's pictorial formulations during this period are characterized by a remarkable diversity. The artist was constantly exploring new constellations of formal tensions, whether in a seemingly disordered distribution of figures floating freely in space, as in *Fixed Flight* (p. 166), or in a predominantly horizontal and vertical arrangement of small elements in which the character of the picture is determined by a deliberately-placed geometric form in a pale colour, such as *Decisive Pink* (p. 167). Kandinsky increasingly renounced the suggestive power of luminous primary colours, and embraced instead a flatter palette of mixed colours which anticipates the chromaticism of his Paris years.

The atmosphere at the Dessau Bauhaus at the start of the 1930s was increasingly political. A powerful Communist faction amongst the students sought to exert its influence over the school as a whole. Kandinsky and Klee were attacked for their "ivory-tower painting", and Kandinsky's classes were boycotted by Communist students. In a proclamation of July 1930, his preliminary theory course was strongly criticized for teaching subjective and individual abstract design. "If it is to be a true elementary

PAGE 165:
Levels, 1929
Etagen
Oil on card, 56.6 x 40.6 cm
New York, The Solomon R. Guggenheim
Museum

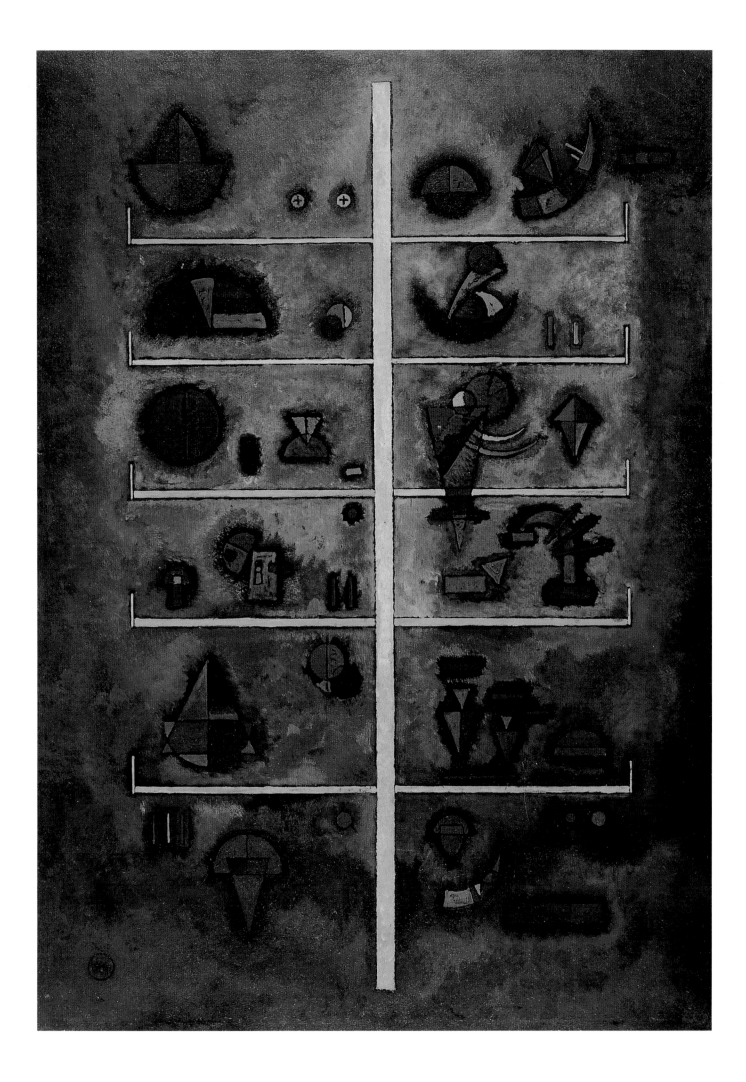

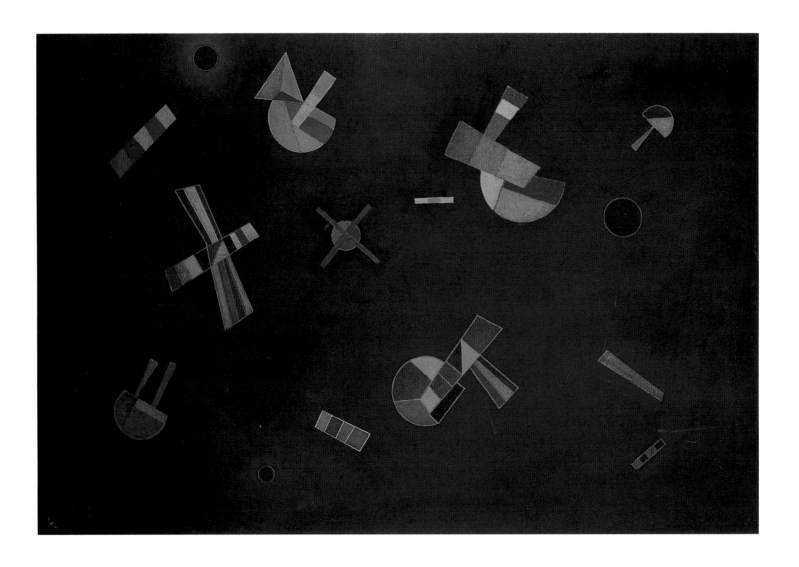

Fixed Flight, 1932
Fixierter Flug
Oil on panel, 49 x 70 cm
Paris, Collection M. and Mme. Maeght

The free distribution of small, component-like
forms within an undefined pictorial space antici-
pates elements of Kandinsky's later Paris works.

course for the Bauhaus," the students declared, "the primary task of the
Vorkurs should be to provide students with a historico-theoretical intro-
duction to the development of the social and material fundamentals and
of the intellectual cohesion which follows from these, and on this basis
develop the future tasks of the Bauhaus."

There were calls for the abolition of the *Vorkurs*, for classes by Albers
and Kandinsky to be made optional, and for the introduction of the "his-
torico-theoretical" teaching on a social and materialistic basis already
mentioned in the proclamation.

Such a development was fatal for the Bauhaus, whose contract with the
city of Dessau precluded it from all political activity. Hesse, Dessau's
mayor, demanded Hannes Meyer's resignation. Meyer was succeeded by
the architect Ludwig Mies van der Rohe, who took over as head of the
Bauhaus in summer 1930.

Meanwhile, Kandinsky prepared his theoretical course on artistic de-
sign for the last time. In Dessau, as in Weimar, he constantly sought to
broaden his teaching by including new materials and design examples.
He now incorporated scientific material from the fields of botany,
zoology, astrology and crystallography into his course.

In 1931 Kandinsky received one final opportunity to decorate an inter-
ior, when he was commissioned to execute three large-scale compositions,

made out of ceramic tiles, for the walls of a music room. This music room was to form part of the German Architecture Exhibition ("Bau-Ausstellung") in Berlin, where it appeared in the section entitled "The Modern Apartment", organized by Mies van der Rohe. In these ceramic designs Kandinsky took up the geometric forms and abstract structures of his late Dessau works. A room in which people gather to experience music, Kandinsky wrote in the catalogue to the exhibition, must have a special power. Painting, which serves as a kind of tuning fork, can affect people and "tune" them for such a musical experience. With the help of the ceramics company Villeroy and Boch, Kandinsky's music room was reconstructed in 1975 at Artcurial in Paris, where it can still be seen.

Political developments in Germany at the end of the 1920s once again posed an acute threat to the Bauhaus' existence. Boosted by the results of the Reichstag elections in September 1930, the National Socialists stepped up their campaign against the Bauhaus. The Dessau National Socialists demanded the school's immediate closure: "Foreign members of staff must be dismissed without notice, since it is incompatible with the responsibility that a good municipal government bears towards its cit-

Decisive Pink, 1932
Entscheidendes Rosa
Oil on canvas, 80.9 x 100 cm
New York, The Solomon R. Guggenheim Museum

Striking here is the even distribution and strictly vertical and horizontal alignment of the geometric forms.

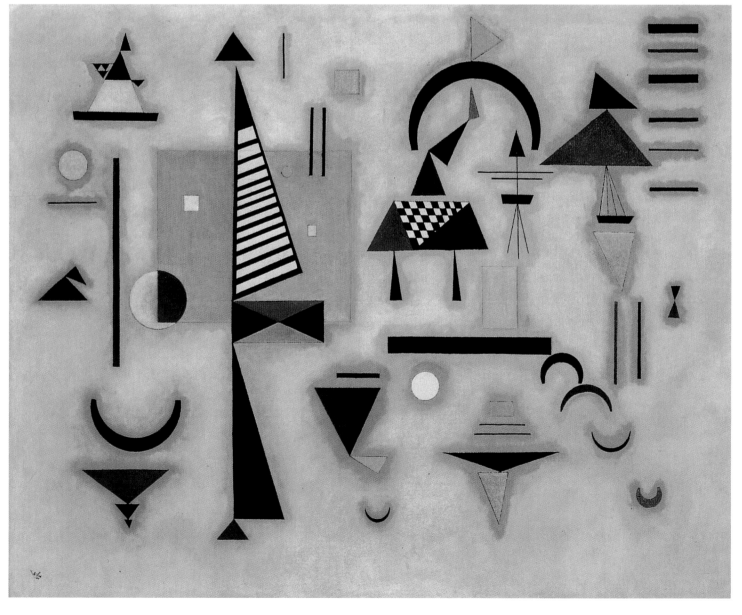

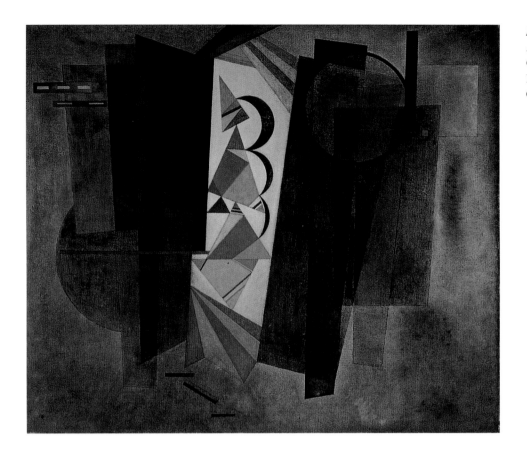

Development in Brown, 1933
Entwicklung in Braun
Oil on canvas, 101 x 120.5 cm
Paris, Musée National d'Art Moderne,
Centre Georges Pompidou

izens that our German comrades should go hungry while foreigners are richly remunerated out of the taxes paid by the destitute German people."

In a letter to the former Bauhaus student Werner Drewes, Kandinsky described the new situation and the effect it was having on the art market: "Collectors are buying little or nothing... The art dealers are going bust or cutting right back... Simultaneously, a rising ground swell of feeling on all sides is giving new courage to those who put the brakes on everything and hate anything new. In Weimar, the National Socialist ministry has removed all new pictures from the museum. Hitler's portrait hangs in the offices of the former Bauhaus. In Berlin, Schultze-Naumburg is officially criticizing all artists working in new directions. Our new title is: 'the Eastern Subhumans'. Etc. etc. along these lines..."

In September 1932 the Dessau Bauhaus was closed. Mies van der Rohe moved the school to Berlin, where it continued to operate – now along private lines – in a disused telephone factory in the suburb of Steglitz. In April 1933 the Berlin Bauhaus was searched for evidence of Communist sympathies; incriminating literature was found and the school was closed. Shortly afterwards the Gestapo demanded the dismissal of the architect Ludwig Hilberseimer and of Kandinsky himself. At the end of July, the Bauhaus faculty unanimously agreed to dissolve the Berlin Bauhaus.

For Kandinsky, the situation after Hitler's seizure of power became increasing precarious. He embodied everything that was undesirable in Hitler's Germany: he was a Russian, an abstract painter and a Bauhaus teacher. Although Kandinsky and his wife had been granted German citizenship in 1928, it rapidly became clear that they could not remain in Germany. After twelve years they were once more forced into exile.

These paintings arose during the summer of 1933, following the final closure of the Bauhaus. They were the last that Kandinsky executed before leaving Germany for France.

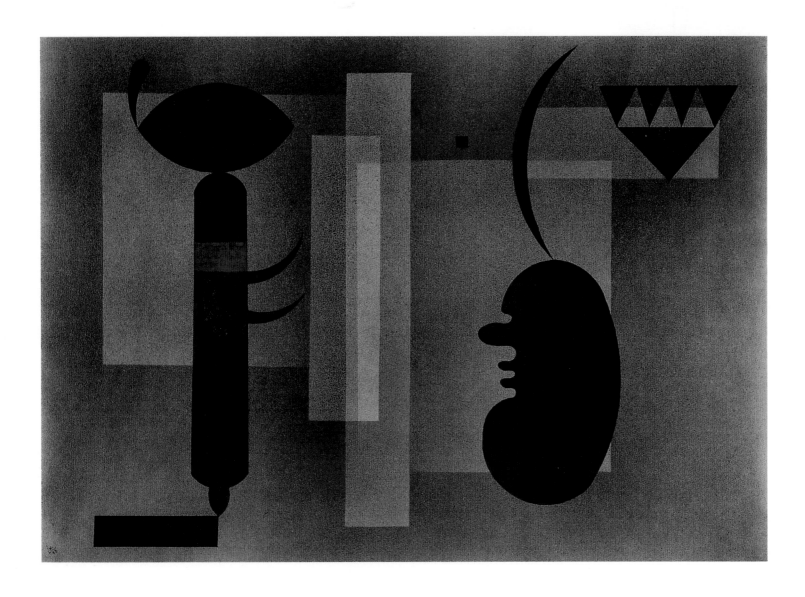

Gloomy Situation, 1933
Trübe Lage
Watercolour, gouache and pencil on paper,
47.3 x 66.8 cm
New York, The Solomon R. Guggenheim
Museum, The Hilla Rebay Collection, 1971

Paul Klee:
Mask of Fear, 1932
Maske der Furcht
Oil on burlap, 100.4 x 57.1 cm
New York, Collection The Museum of Modern
Art, Nelson A. Rockefeller Fund

Hugo Erfurth:
Portrait of Kandinsky, 1933

"I do not wish to be considered a 'Symbolist', a
'Romanticist' [or] a 'Constructivist'. I would be
content if the viewer were to experience the
inner life of the living forces employed, their re-
lationships, if proceeding from one picture to an-
other, he were to discover on each occasion a dif-
ferent pictorial content."
(Kandinsky, 1928)

Last years in Paris

"No one knows me in Paris," Kandinsky lamented to Hannes Neuner, one of his former Bauhaus pupils. The national pride of the French, who only knew their own painters, made it all the harder for a foreigner like Kandinsky to gain a foothold in the market. This difficulty was compounded by the strong competition which already existed in the city, which was home to more artists than anywhere else.

Indeed, Kandinsky had seriously misjudged the state of the French art scene when he moved to Neuilly-sur-Seine on the outskirts of Paris in 1933. Encouraged by the promising sales brought by two exhibitions in Parisian galleries in 1929 and 1930, while he was still at the Bauhaus, he now expected to be able to live from his painting. But abstract art was finding it hard to gain recognition in the Paris of the thirties. Cubism and Surrealism dominated the market, and Kandinsky's bold abstractions appeared foreign and incomprehensible both to artists and gallery-owners alike. His relations with his French colleagues remained correspondingly distanced. Contact with other foreign painters proved easier. Thus Kandinsky met Piet Mondrian, Marc Chagall, Joan Miró, Constantin Brancusi and Max Ernst. Even here, however, he developed no close personal friendships.

Just two avant-garde galleries in Paris were prepared to give Kandinsky their active support: the little Montparnasse gallery owned by Jeanne Bucher, a dedicated champion of unknown artists who organized a total of three exhibitions for Kandinsky, and the gallery run by Christian and Yvonne Zervos in the offices of the magazine *Cahiers d'Art*. Christian Zervos, the editor of *Cahiers d'Art*, had corresponded regularly with Kandinsky between 1927 and 1933; in 1930 he had reproduced pictures by Kandinsky in his magazine, accompanied by a detailed commentary by Will Grohmann, and had reported every exhibition of Kandinsky's work both in Germany and elsewhere. Zervos' unflagging efforts to publicize his work strengthened Kandinsky in his belief that, following the closure of the Bauhaus, he was sufficiently well known in Paris to be able to live from his art.

In 1931 *Cahiers d'Art* published an essay by Kandinsky on abstract art. Although Paris was no stranger to "abstract" painting – it had already seen the formation of groups of abstract artists such as Cercle et Carré (Circle and Square), whose members included Mondrian, Robert and Sonia Delaunay and Georges Vantongerloo – it was obviously felt that an

Egyptian, 1911
(from: *Blaue Reiter Almanac*, 1911)

PAGE 170:
Sky Blue, 1940
Bleu de ciel
Oil on canvas, 100 x 73
Paris, Musée National d'Art Moderne,
Centre Georges Pompidou

These cheerful figurations floating against an atmospheric, milky-blue ground are typical of Kandinsky's vocabulary of forms during his Paris years. Their similarity with forms invented by early cultures is astonishing. In his book *On the Spiritual in Art*, Kandinsky acknowledges that points of inner contact can exist between the art of the present and the past: "The similarity of the inner mood of an entire period can lead logically to the use of forms successfully employed to the same ends in an earlier period. Our sympathy, our understanding, our inner feeling for the primitives arose partly in this way. Just like us, those pure artists wanted to capture in their works the inner essence of things, which of itself brought about a rejection of the external, the accidental."

apology for abstract art was needed. For too long, Cubism had dominated artistic developments in France.

In his "Reflections on Abstract Art" which appeared in Zervos' magazine, Kandinsky is clearly aware that he is arguing for the defence. "'Abstract' painters are the accused," he begins. "They must prove that painting without an object is really painting and has the right to exist alongside the other kind." Other stylistic trends, such as Impressionism, Cubism and Expressionism, were also criticized at the outset as anarchic. "Our age is not an ideal one, but among the few important 'innovations', or among mankind's new qualities, one must know how to appreciate this growing ability to hear a sound in the midst of silence... A vertical associated with a horizontal produces an almost dramatic sound. The contact between the acute angle of a triangle and a circle has no less effect than that of God's finger touching Adam's in Michelangelo." And just as fingers are not only anatomy, but also pictorial means, so the circle and triangle are equally not merely geometry, but pictorial means. "In time it will be demonstrated for certain that 'abstract' art does not exclude an association with Nature, but that on the contrary, this liaison is greater and more intimate than in recent times."

Kandinsky continued to go to the defence of abstract art in more than a dozen essays written over the following years in Paris.

Despite the difficulties facing him, Kandinsky's eagerness to work was undiminished, and he devoted himself with renewed vigour to his painting. Having converted the spacious living room in his Neuilly apartment into a studio, he began concentrating on large-format canvases. The compositions from this period show him taking up elements from his Bauhaus period and organizing them into new arrangements, while simultaneously developing an ever more concentrated and sophisticated vocabulary of forms.

Striped, 1934
Rayé
Oil and sand on canvas, 81 x 100 cm
New York, The Solomon R. Guggenheim Museum

In Neuilly-sur-Seine Kandinsky developed his preference for a strict pictorial framework. Thus the figures which at first sight appear to be floating freely in space are in fact related in subtle ways to the strips into which the pictorial ground is divided.

After a long break, he now resumed the use of the title "Composition". This title was given only to the most carefully planned and executed of his works and denoted the highest level in his pictorial hierarchy. The majority of Kandinsky's *Compositions* were completed during his Murnau years; having produced just one at the Bauhaus, in 1923, he now painted the last two in Paris.

The most striking feature of *Composition IX* (p. 173) is the contrast between the strict diagonals of the ground and the part-geometric, part-biomorphic and bizarre forms which overlie them. Although Kandinsky had regularly employed diagonals as instruments of compositional tension since his Moscow days, the rigorous division of the pictorial plane into diagonal strips seen in *Composition IX* is unique in his œuvre. The directional impulse given by the diagonals is reinforced by their colours, which approximate on the left to the primaries yellow, blue and red, and on the right to the secondaries violet, orange and green. The forms floating above them appear to bear no relationship to the ground. In a preliminary drawing for *Composition IX* (p. 173 below), the dominant membrane-like form assumes a more pronounced diagonal orientation and seems to be escaping upwards. In the final oil painting, however, it has contracted into a heart shape which rests against the background with no indication of movement. The pastel forms fluttering around this black arch are suggestive of microscopically-enlarged organisms and appear to float past the viewer.

In 1939, after tough negotiations over the price, *Composition IX* was purchased by André Dézarrois, the director of the Jeu de Paume museum

Composition IX, 1936
Composition IX
Oil on canvas, 113.5 x 195 cm
Paris, Musée National d'Art Moderne,
Centre Georges Pompidou

At the heart of this picture lies the contrast between the formally rigorous ground, divided into vibrantly-coloured diagonal strips, and the bizarre, unrelated formations floating freely above it.

Untitled, 1936
Pen and pencil on paper, 32.5 x 50.6 cm
Paris, Musée National d'Art Moderne,
Centre Georges Pompidou

173

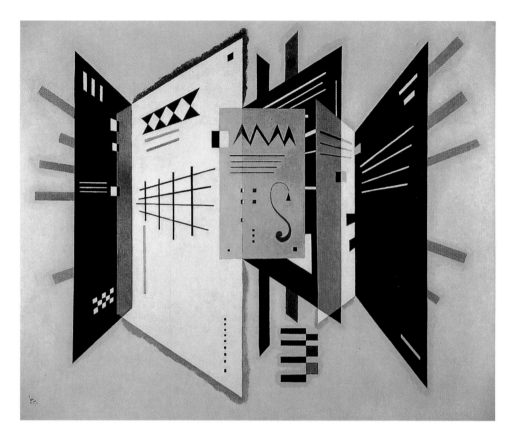

Points, 1935
Pointes
Mixed media, 81 x 100 cm
Long Beach (CA), Long Beach Museum of Art,
The Milton Wichner Collection

In this picture, dominated by geometric forms,
the layering of vertical trapezoids creates an an-
imated pictorial depth.

in Paris. It thereby became the first large abstract painting to enter the col-
lection of a French museum. The pictures of Kandinsky's Paris years re-
veal no obvious common denominator. After his "cold" period, as he
called his Bauhaus phase, he now desired "polyphony" and the combina-
tion of "fairytale" and "reality", as he wrote in an essay in *Cahiers d'Art*
in 1935. It was a desire for an inner unity, a "pictorial fairytale" which
can only be told via the "reality" of painting.

Meanwhile, his pictorial vocabulary grew more diverse. His works re-
vealed a striking trend towards natural forms, seemingly borrowed from
the realm of molecular biology. "Every genuine form of art emerges from
a living correlation of man to the real substance of the forms of nature,
the forms of art," wrote Macke in his essay on masks in the *Blaue Reiter
Almanac*. The biomorphic forms in *Sky Blue* (p. 170), a late work from
these Paris years, reflect Kandinsky's rich imagination and reveal his de-
light in inventing new, surreally bizarre pictorial elements. In the works
of his last creative years, Kandinsky allowed his forms, as in *Sky Blue*, to
float freely in space without anchoring them to the background, and
thereby suppressed the geometric element in favour of an atmospheric
pictorial space. In the years prior to this, however, he frequently tied his
compositions to a geometric framework which produced a formal tension
within itself (*Striped*, p. 172). In *Points* (p. 174), the geometric structure is
very much more complex and expressive. Here Kandinsky groups a num-
ber of vertical trapezoids to create an animated, confusing interplay of dif-
ferent depths in the pictorial plane. These razor-sharp quadrilaterals re-
lease waves of eccentric movement, which are countered by the calming,
concentric force of the rectangle positioned slightly above the centre of
the composition.

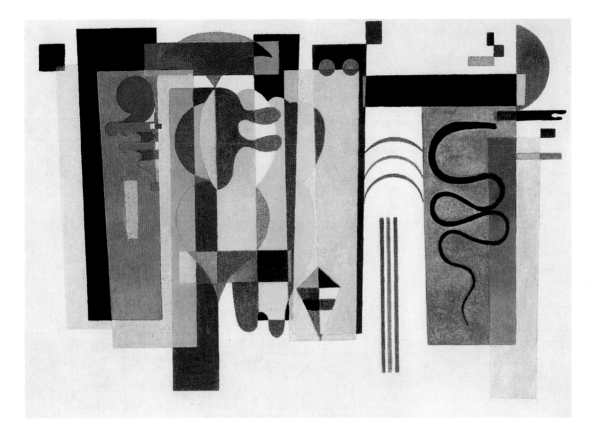

Two Green Points, 1935
Deux points verts
Mixed media, 114 x 162 cm
Paris, Musée National d'Art
Moderne, Centre Georges
Pompidou

Geometric formations from Kandinsky's Bauhaus period are here combined with the biomorphic elements typical of his Paris years. A new feature is the inclusion of sand mixed into the paint. Kandinsky was familiar with this technique from the Bauhaus and experimented with it in Paris between 1934 and 1936. It lends the canvas a sculptural, fresco-like quality.

Kandinsky had been in Paris for two years when he painted *Points*. He was still little known, however, and the effects were starting to tell. There were few buyers for the large-format compositions to which he had returned. French collectors who had earlier bought his small Dessau pictures now held back. At the same time, the political situation in Germany was placing increasing constraints on his contacts with German collector friends. Meanwhile, demand for art in general was stagnating. Kandinsky had no dealer to represent him in Paris, and no longer had the option, as in the past, of falling back on income from inherited property. In 1935 he was still hoping to be able to return to Germany. Like many others monitoring the situation from the outside, Kandinsky did not believe that Hitler could hold onto power for long. In order to smooth the passage for his return, he even asked his nephew, who was living in Berlin, to inform the relevant authorities that his current residence in France was motivated by purely artistic concerns and had no political grounds.

But it very soon became clear that any return to Germany was impossible. Unsurprisingly, the hostility towards the arts in Nazi Germany granted no special pardon to Kandinsky's work: in 1937, as part of a museum "cleansing" programme ordered by the state, all works by Kandinsky were removed from public collections. That same year, three of his oil paintings from 1910, 1916 and 1926 and two watercolours from the Bauhaus era (p. 179) were shown at the "Degenerate Art" ("Entartete Kunst" exhibition in Munich.

In August 1937, however, even as his earlier works were being branded "degenerate" in Germany, recent paintings from Kandinsky's Neuilly studio were on show for the first time in a Paris museum. Thanks to the efforts of gallery-owner Jeanne Bucher and the Polish painter Mar-

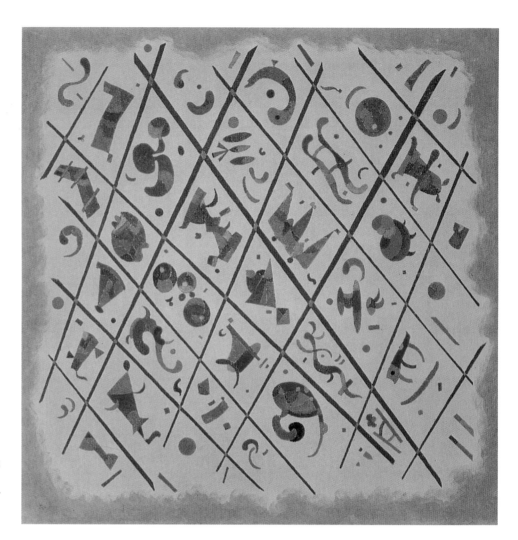

Division – Unity, 1934
Division – Unité
Mixed media on canvas, 70 x 70 cm
Tokyo, Museum of Modern Art

A relaxed complex of freely-invented formations
in which Kandinsky gives his imagination full
rein. The artist invents a range of cheerful pictor-
ial symbols as if compiling a sheet of design
samples.

coussis, thoroughly versed in the Parisian art scene, the Jeu de Paume mu-
seum agreed to stage the exhibition "Origines et Développement de l'Art
International Indépendant", tracing the development of modern art from
Impressionism through to abstraction. The response was highly favour-
able. For the first time, Kandinsky's pictures were seen by a large public.

Kandinsky was virtually only able to show paintings from the last de-
cade, however. The large and innovative œuvre of his Moscow and Bau-
haus years was scattered between the United States and Russia (which in
1930 had confiscated the paintings he had deposited in Moscow), while
many of his Munich works, and especially those of his Blaue Reiter
period, were still in the care of Gabriele Münter. As a consequence, much
of his work was not accessible to the public and in many cases had not
even been photographed. In the Paris exhibition of 1937, Kandinsky was
only able to include *Picture with a Black Arch* (p. 88) of 1912 from his
Munich period, and *On White II* (p. 139) of 1923 from his Bauhaus
period. It was clearly difficult for him to provide a true summary of his
life's work, and it is understandable that he should press Christian
Zervos, who in 1929 had published a monograph on Paul Klee, to do the
same for him.

For Kandinsky and his wife, both German citizens since 1928, the situ-
ation in Paris grew increasingly awkward towards the end of the 1930s.
When their German passports ran out and they had supply proof of their

Kandinsky in his studio in Neuilly-sur-Seine,
c. 1937, Photograph
Paris, Musée National d'Art Moderne,
Centre Georges Pompidou

Untitled, 1934
Chinese ink on paper, 33.1 x 22.8 cm
Paris, Musée National d'Art Moderne,
Centre Georges Pompidou

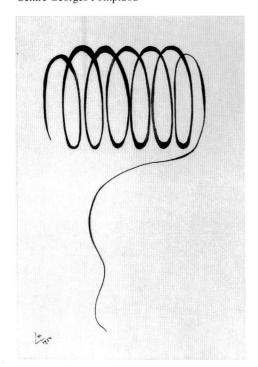

Thirty, 1937
Trente
Oil on canvas, 81 x 100 cm
Paris, Musée National d'Art Moderne,
Centre Georges Pompidou

Thirty irregular rectangular fields house thirty
different drawings. The strict alternation of black
and white not only provides a supporting com-
positional framework, but also enables Kandin-
sky to investigate the effect of black forms on
white and white forms on black.

177

View of the south wall of Room 3 in the
"Degenerate Art" exhibition, 1937
Photograph
Essen, Museum Folkwang

This view of Room 3 in the "Degenerate Art"
exhibition shows the Dada wall. Pictures by
Schwitters, Klee, Hausmann and Haizmann hang
on top of a crude version of Kandinsky's *The
Black Spot*, an abstract composition of 1921.

"Entartete Kunst"
On 19 July 1937, Adolf Ziegler, president of the
Imperial Ministry of Fine Arts, opened an exhibi-
tion in Munich entitled "Entartete Kunst" ("De-
generate Art"). The exhibition contained some
600 works of contemporary art, hung in chaotic
order and accompanied by defamatory slogans.
The works had all been removed from German
museums by the Nazis over the preceding weeks.
A 32-page catalogue published in conjunction
with the exhibition employed suggestive means
and an inflammatory style to decry modern art as
supposed evidence of a cultural decline in Ger-
many.

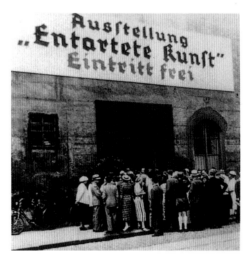

Entrance to the "Degenerate Art" exhibition,
Archaeological Institute, Munich, 1937
Photograph
Munich, Süddeutscher Verlag

Visitors queued to see the "Degenerate Art"
exhibition not just on the opening day: more
than two million people attended the show,
which ran from July to November 1937 in Mun-
ich and subsequently toured all the major cities
of Germany.

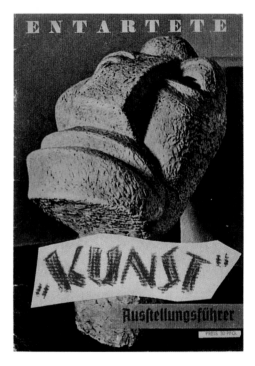

Front cover of the "Degenerate Art" exhibition
catalogue, 1937
Cover illustration: Otto Freundlich, *The New
Man*, 1912

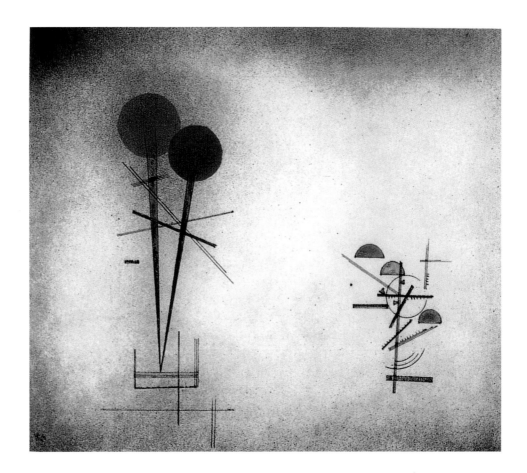

Two Complexes, 1928
Zwei Komplexe
Watercolour, ink and pencil on paper,
39.2 x 45.6 cm
New York, private collection

Conclusion, 1924
Abschluß
Watercolour on paper, 33.5 x 48.4 cm
Private collection

57 of Kandinsky's works in German museums
were impounded by the National Socialists. Four-
teen were subsequently shown at the "Degener-
ate Art" exhibition – including these two water-
colours from Kandinsky's Bauhaus period,
which were removed from the City Museum of
Arts and Crafts in Halle.

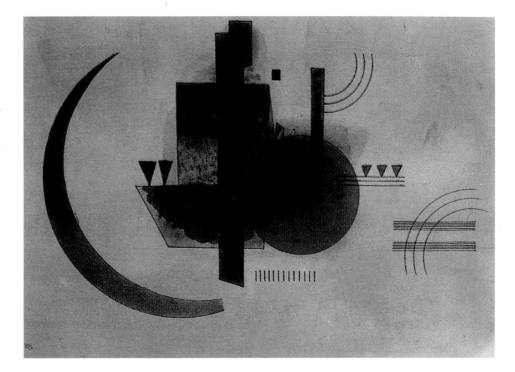

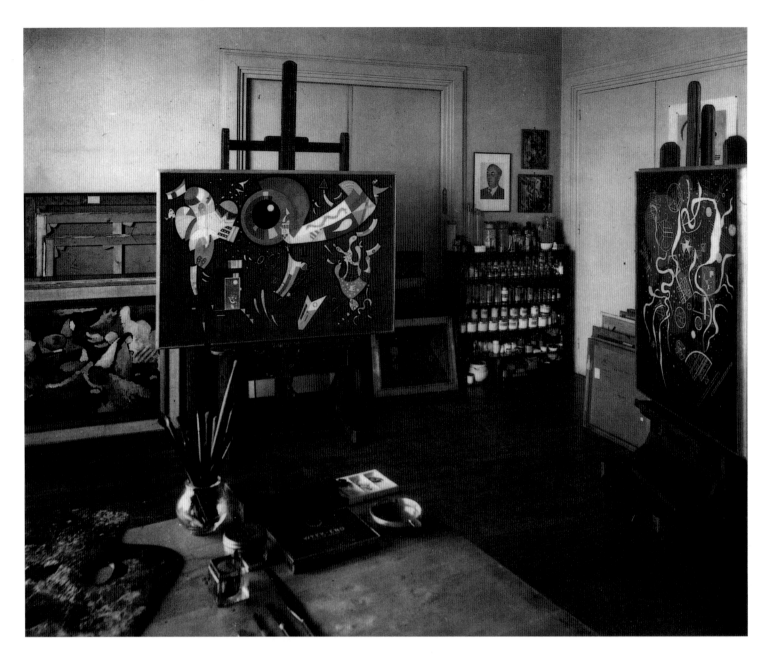

Kandinsky's studio
Photograph
Paris, Musée National d'Art Moderne,
Centre Georges Pompidou

Kandinsky's studio in Neuilly-sur-Seine. On the
easel on the left: *Around the Circle* of 1940; on
the right: *Movement I* of 1935.

The apartment block in Neuilly-sur-Seine in
which Wassily and Nina Kandinsky lived from
1933. Kandinsky died here on 13 December
1944.
Photograph
Paris, Musée National d'Art Moderne,
Centre Georges Pompidou

Kandinsky in his studio in Neuilly-sur-Seine
Photograph
Paris, Musée National d'Art Moderne,
Centre Georges Pompidou

View of the river Seine from Kandinsky's
apartment
Photograph
Paris, Musée National d'Art Moderne,
Centre Georges Pompidou

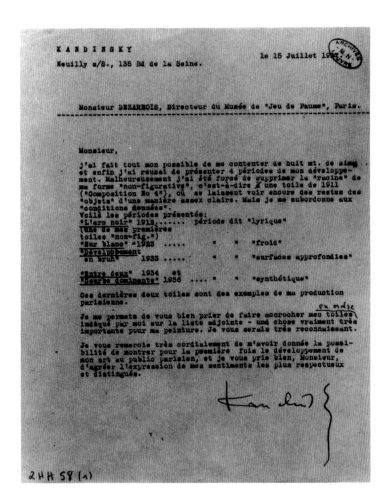

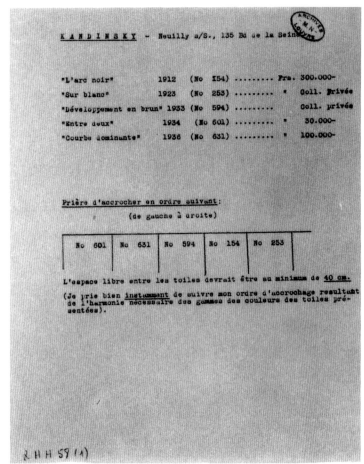

Letter to Monsieur André Dézarrois, director of the Jeu de Paume museum in Paris, dated 15.7.1937:

"Monsieur,
I have done my best to content myself with 8 metres, and I have finally succeeded in presenting 4 periods of my development. Unfortunately, I was forced to leave out the 'roots' of my 'non-figurative' form, in other words a work of 1911 (*Composition IV*), where traces of 'objects' can still be seen fairly clearly. But I shall submit to the 'given conditions'.
Here are the periods presented:
Black Arch 1912: 'lyrical'
(one of my first 'non-figurative' canvases)
On White 1923: 'cold'
Development in Brown 1933: 'deepened surfaces'
Between Two 1934 and
Dominant Curve 1936: 'synthetic'

These last two canvases are examples of my work in Paris.
I beg to request that the pictures be hung in the order indicated on the attached list – this is very important for my painting. I would be most grateful.
I thank you most warmly for granting me this opportunity to show the development of my art to the Parisian public for the first time.
Yours sincerely,
Kandinsky"

"Aryan" identity in order to get them renewed, they decided to apply for French citizenship. This was granted in 1939. In the summer of 1940 they spent three months in the Pyrenees, where they learned of Paul Klee's death. Following the occupation of Paris by German troops, they returned to Neuilly. Good friends invited them to emigrate to America, but Kandinsky, now 75 and settled in his Parisian surroundings, decided to remain in France. He continued to paint in Neuilly, more or less undisturbed by political events.

Over the previous years, Kandinsky's efforts to achieve variety of form within a fixed disposition had given rise to pictures organized into regular and irregular fields containing figures. In *Division – Unity* (p. 176), freely-invented forms are housed within a loose diamond grid. Grid and net structures had already appeared as early as 1922 in *Small Worlds* (pp. 130, 131) and continued to surface in later years (*Thirty*, p. 177). In the case of *Division – Unity*, the grid is open on all four sides, suggesting a linear structure loosely laid against the pictorial ground and resembling a single component selected from a sheet of form samples. The arabesque-like formations within the grid imply that they can be varied or added to at will, as if Kandinsky was concerned less with the individuality of his creations than with the possibilities of form and colour they offer. In *Thirty* (p. 177), a collection of forms is housed within a chessboard grid of black and white fields. The forms themselves are a mixture of geometric and organic configurations and free lines, in places reminiscent of Chinese characters. They are abstract, cipher-like figurations such as those found in ever new varia-

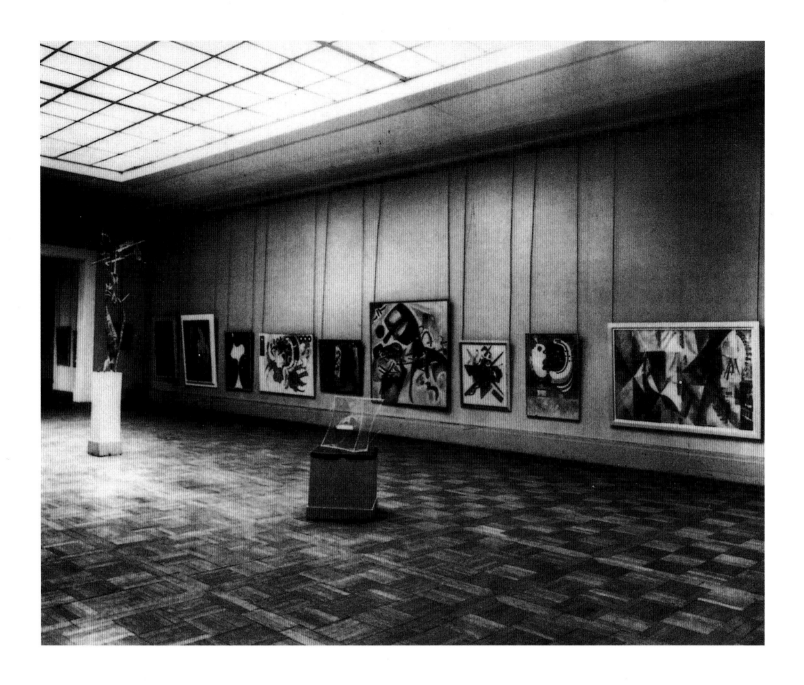

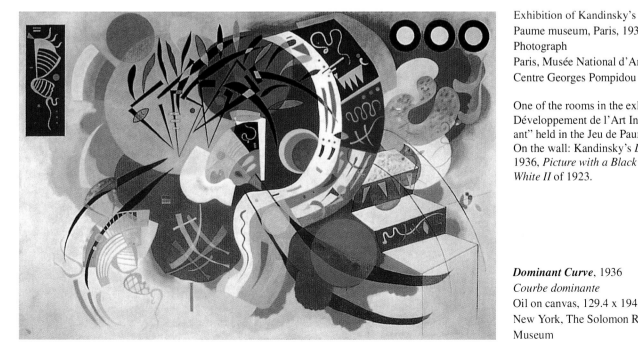

Exhibition of Kandinsky's pictures in the Jeu de Paume museum, Paris, 1937
Photograph
Paris, Musée National d'Art Moderne, Centre Georges Pompidou

One of the rooms in the exhibition "Origines et Développement de l'Art International Indépendant" held in the Jeu de Paume, Paris, 1937. On the wall: Kandinsky's *Dominant Curve* of 1936, *Picture with a Black Arch* of 1912, and *On White II* of 1923.

Dominant Curve, 1936
Courbe dominante
Oil on canvas, 129.4 x 194.2 cm
New York, The Solomon R. Guggenheim Museum

tions in Kandinsky's sketches (p. 177 above), here being tested out as pictorial elements. The invention of a rich formal vocabulary is not Kandinsky's sole concern, however; he is equally interested in the negative-positive effects: how do black forms appear on white, and vice versa? In 1930 he painted *White on Black*, a geometric composition in which white rectangles are arranged in a concentric rhythm on a black background. *Thirty* is a more complex picture, but also more schematic. It seems as if the artist, well aware that an uncontrolled handling of pictorial elements can lead to arbitrariness, wanted to avoid this danger by weaving his forms into a structural framework.

In 1939 Kandinsky painted his tenth and last great *Composition* (p. 186). Here a bubblelike and a trapezoidal form are set against a dark ground, while small forms float around them. The two main figures seem to have broken out of their geometric existence and to have transformed themselves into organic formations, which are moving upwards and away from each other. Some of the small forms are arranged in convex waves, emphasizing the upward movement of the trapezoidal form. By contrast, a similar but concave wave in the lower half acts as a stay. The left-hand, bubblelike form is pushed outwards and away from the trapezoidal form by its accompanying smaller forms. The rows of small ciphers contained within it are suggestive of characters and cite the hieroglyphic formations from the earlier *Rows of Signs* of 1931 (p. 164).

Despite the diversity of its forms, *Composition X* is an example of unity and harmony and represents one of the most magnificent works of Kandinsky's Paris years. The composition is balanced, and both cool and warm colours assume equal luminosity against the dark ground. The free-floating forms evoke the image of cosmic constellations which are subject to inner laws of harmony.

In *Around the Circle* (p. 187), painted one year later, fantastical forms float in "musical" movements around the red circle of the title. Here, too, the dark ground makes the colours stand out all the more strongly, with the glowing red circle, reinforced by pink, striking the dominant note. "Red, as one imagines it," wrote Kandinsky in *On the Spiritual in Art*, "is a limitless, characteristically warm colour, with the inner effect of a highly lively, living, turbulent colour, yet which lacks the rather light-minded character of yellow, dissipating itself in every direction, but rather reveals, for all its energy and intensity, a powerful note of immense, almost purposeful strength. In this burning, glowing character, which is principally within itself and very little directed toward the external, we find, so to speak, a kind of masculine maturity..."

Kandinsky's pictures of these years give no hint of external events, of the war and the German Occupation. Daily life was seriously affected: fuel and food were both in short supply; it was almost impossible to transfer money; deliveries of mail were rare; and there were no magazines at all. Materials for painting were equally difficult to procure. Despite this, Kandinsky tried to live life as normal. He continued to attend the few exhibitions that were held in Paris. In 1942, an exhibition of his own works was staged by the courageous gallery-owner Jeanne Bucher under the difficult conditions of the Occupation. In summer 1942 he painted his last large-format picture, after which he restricted himself to small formats on

***Untitled**, 1934*
Pencil on paper, 19.1 x 14.1 cm
Paris, Musée National d'Art Moderne,
Centre Georges Pompidou

"Our age is not an ideal one, but among the few important 'innovations', or among mankind's new qualities, one must know how to appreciate this growing ability to hear a sound in the midst of silence... Nowadays, in painting a point sometimes expresses more than a human face."
(Kandinsky in *Reflections on Abstract Art*, 1931)

PAGE 185:
***Tender Ascent**, 1934*
Montée tendre
Oil on canvas, 80.4 x 80.7 cm
New York, The Solomon R. Guggenheim
Museum

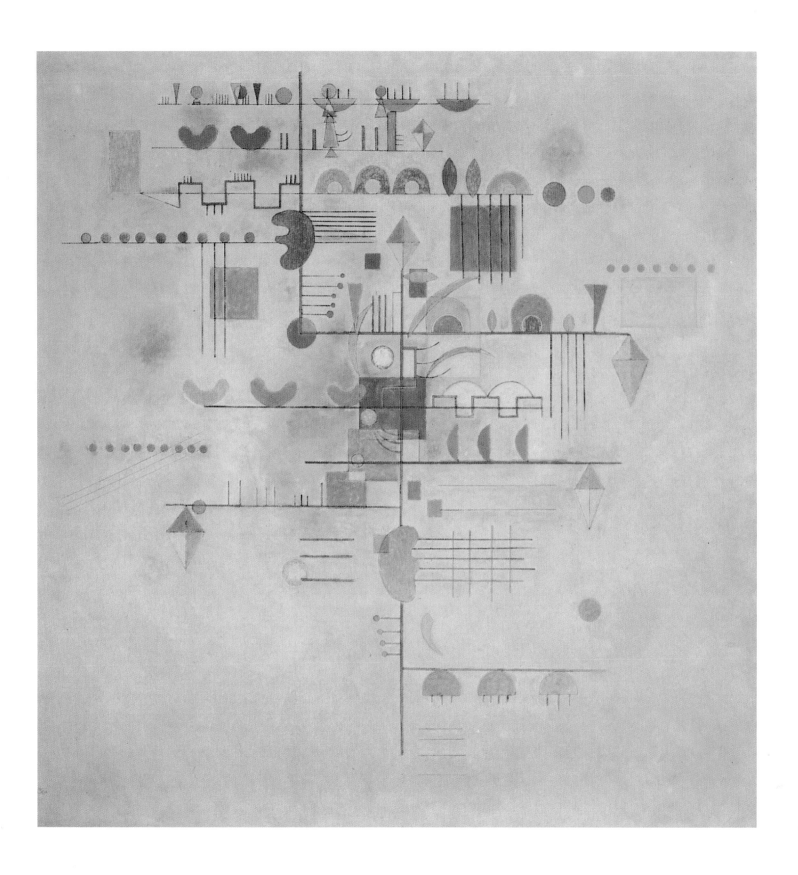

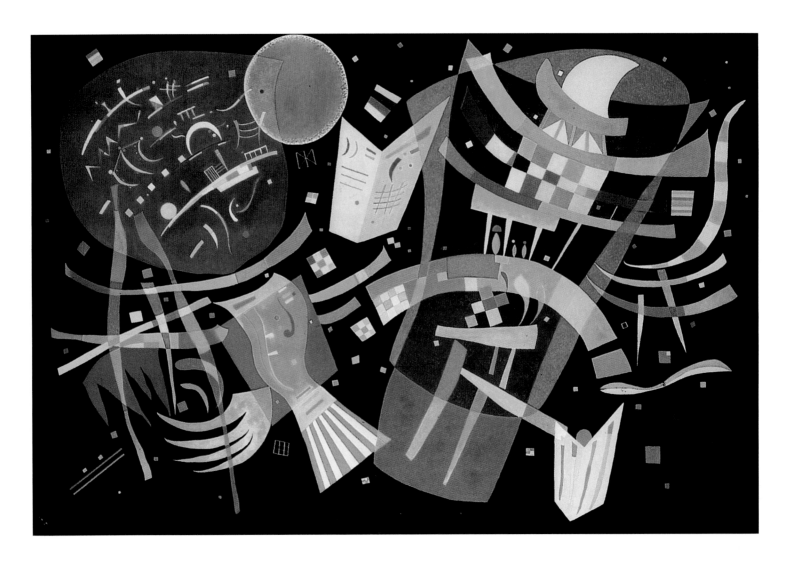

Composition X, 1939
Komposition X
Oil on canvas, 130 x 195 cm
Düsseldorf, Kunstsammlung Nordrhein-Westfalen

Kandinsky's last great composition before the outbreak of the Second World War
bears no hint of the impending catastrophe. With its perfect balance of colour and
form, *Composition X* is one of the superlative achievements of Kandinsky's Paris
years.

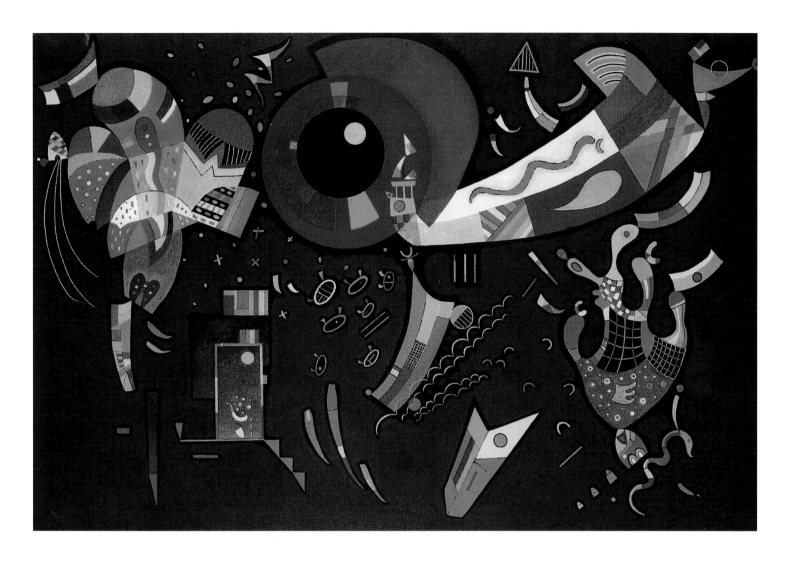

Around the Circle, 1940
Autour du cercle
Oil and enamel on canvas, 97 x 146 cm
New York, The Solomon R. Guggenheim Museum

"Each true painting is poetry. For poetry is not made solely by use of words, but also
by colours, organized and composed; consequently, painting is a pictorial poetic
creation… The source of both languages is the same; they share the same root:
intuition – soul."
(Kandinsky, statement published in *Journal des Poètes*, 1938)

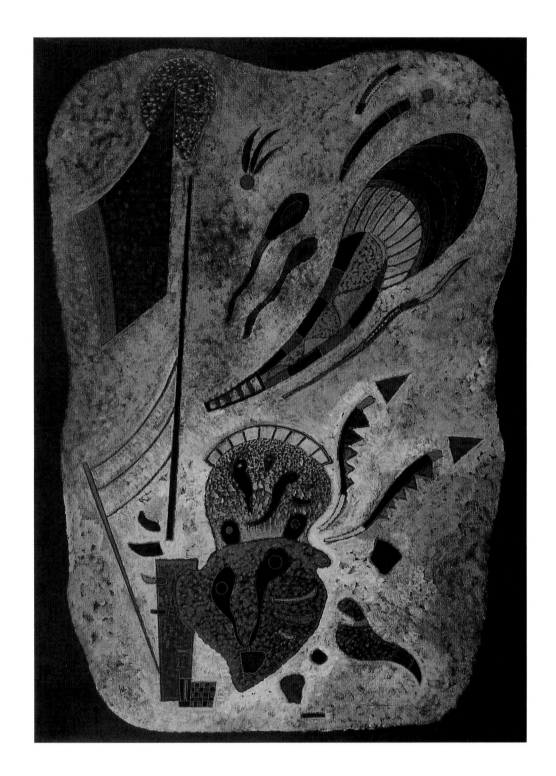

Twilight, 1943
Crépuscule
Oil on card, 57.6 x 41.8 cm
New York, The Solomon R. Guggenheim Museum

Flying and ascending are recurrent themes in the works of Kandinsky's Paris years.
Forms float upwards against an undefined background, their exquisite colours
modulated like enamels. Kandinsky's powers of invention showed no signs of
diminishing with age. He continued to discover new forms in the treasurehouse of his
imagination.

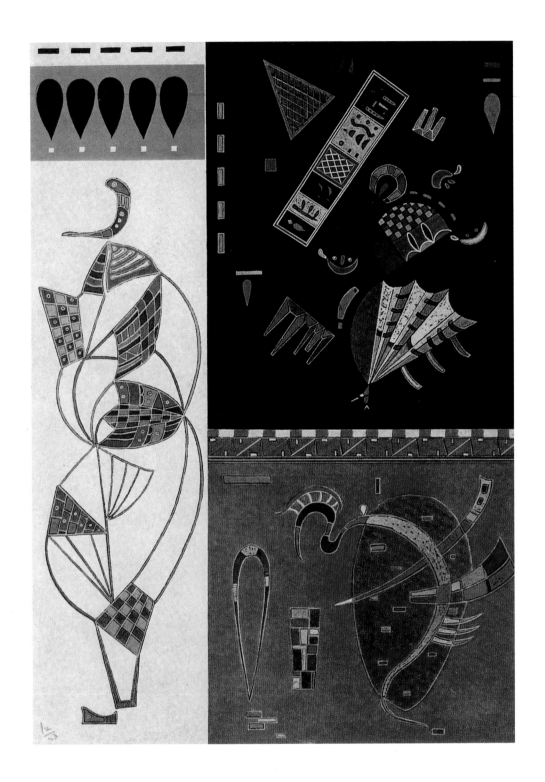

Division – Unity, 1943
Division – Unité
Mixed media, 58 x 42 cm
London, private collection

Once more Kandinsky divides his composition into fields or compartments, which he
fills with free, partly ornamental and partly zoomorphic formations. Will Grohmann
described these as "primal stages of growth, from which almost anything
could develop".

cardboard and wood, in which he developed an exotic cosmos of playful figurations.

Kandinsky continued to paint every day up to the end of July 1944. The last picture he was to record in his list of completed works was *Tempered Elan* (p. 191), which he finished in March. By then he was already suffering from arteriosclerosis and his strength was slowly fading. Kandinsky died on 13 December 1944 at the age of 78.

Kandinsky's artistic legacy can be summed up in the following words, taken from an article which he himself wrote for a Swedish magazine in 1937:

"I ask you to understand that my painting does not try to reveal 'secrets' to you, that I (as many people think) have not found a 'special language' that has to be 'learned' and without which my painting cannot be read. This should not be made more complicated than it really is. My 'se-

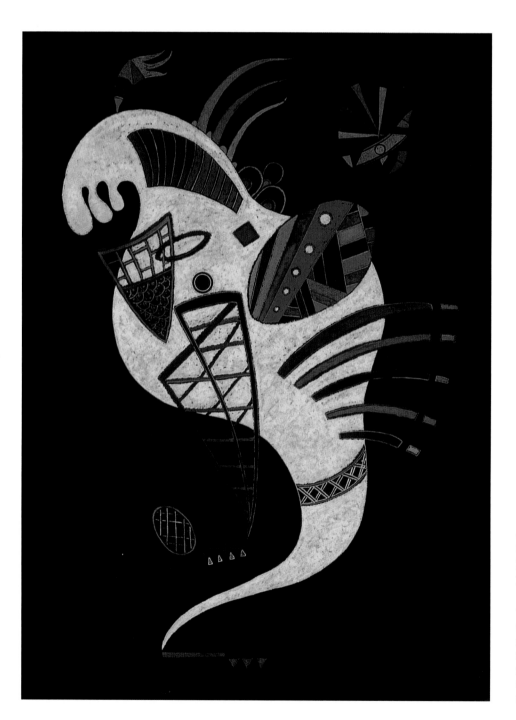

White Figure, 1943
Figure blanche
Oil on card, 58 x 42 cm
New York, The Solomon R. Guggenheim Museum, Gift of Solomon R. Guggenheim, 1947

"Scientific research has also allowed the artist to uncover a new reality. Aquatic plants, infinitesimal animals, a drop of water with its microbes magnified a thousand times – these are becoming new pictorial possibilities and are permitting a development in the decorative arts."
(Fernand Léger)

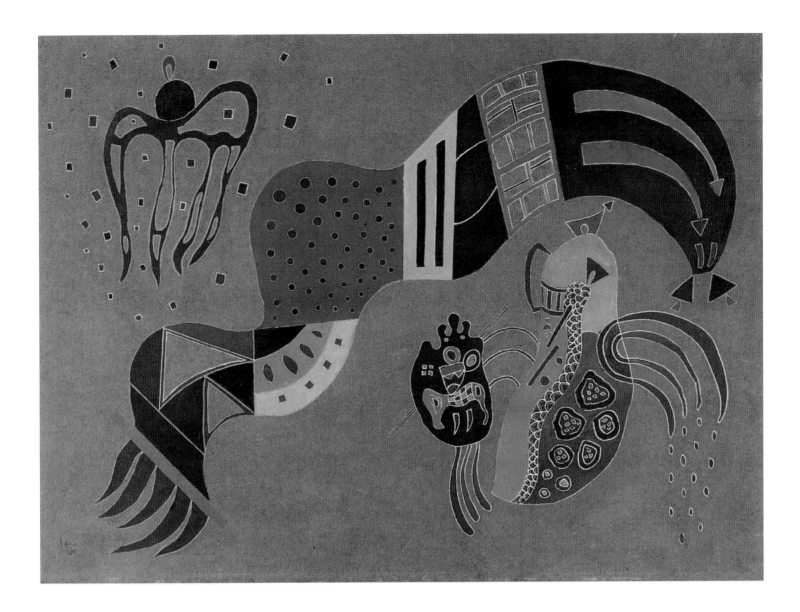

cret' consists solely of the fact that over the years I have obtained that fortunate skill (have maybe fought for it unconsciously) to liberate myself (and with that my painting) from 'destructive secondary sounds', so that each form comes alive – acquires sounds and consequently expression, too. Simultaneously, I have experienced the bliss of hearing the weakest language. And so I have fortunately been able to extract, with complete freedom and without restraint, whatever form from the endlessly great 'treasure of form' that I need for a particular moment (work of art). Here, I do not need to worry about the 'content', but solely about the right form. And the correctly extracted form expresses its thanks by providing the content all by itself... The content of painting is painting. Nothing has to be deciphered. The content, filled with happiness, speaks to that person to whom each form is alive, i.e., has content."

Tempered Elan, 1944
Elan tempéré
Oil on card, 42 x 58 cm
Paris, Musée National d'Art Moderne,
Centre Georges Pompidou

"Every spiritual epoch expresses its particular content in a form that corresponds exactly to that content. In this way, every epoch assumes its true 'physiognomy', full of expressive power, and thus 'yesterday' is transformed into 'today' in every spiritual realm. But apart from this, art possesses another capacity, unique to itself, that of sensing 'tomorrow' in 'today' – a creative and prophetic force."
(Kandinsky, "Every Spiritual Epoch", *10 Origin*, 1942)

Wassily Kandinsky 1866–1944:
Life and work

Wassily Kandinsky aged six, 1872

Kandinsky as a student in Moscow, c. 1888

thropology to undertake a research expedition to the province of Vologda. Writes essays on peasant law and on pagan relics in tribal religion. The powerful folk art of northern Russia makes a profound impression on him. Visits the Hermitage in St. Petersburg and sees his first pictures by Rembrandt. Trip to Paris.

1892 Concludes his studies and passes his law exams. Marries his cousin, Anya Chimikian.

1893 Becomes an assistant at Moscow University. Writes his doctoral thesis on "The Legality of Labourers' Wages". Is appointed an attaché at the Moscow University faculty of law.

1895 Artistic director of an art printing works in Moscow.

1896 At an exhibition of French art in Moscow, is overwhelmed by one of Monet's *Haystacks* series. Declines the post of lecturer at the University of Dorpat. Decides to pursue a career as an artist and moves to Munich.

1897 Studies at Anton Ažbè's private art school for two years. Meets the painters Alexei von Jawlensky and Marianne von Werefkin. Visits the exhibition by the Munich Secession, and sees Jugendstil at its peak.

1898 Applies unsuccessfully to join Franz von Stuck's class at the Academy. Continues to paint independently.

1900 Re-applies to Franz von Stuck and is accepted. Fellow students include Paul Klee. Shows his work in an exhibition by the Moscow Artists' Association in Moscow. Meets the members of the literary cabaret "Die Elf Scharfrichter".

1901 Together with Rolf Niczky, Waldemar Hecker, Gustav Freytag and Wilhelm

Hüsgen, founds the Phalanx artists' exhibiting society, of which he is elected president. The first Phalanx exhibition is held in August. The Phalanx School of Painting opens in the winter under Kandinsky's directorship. Trip to Rothenburg ob der Tauber; trip to Odessa. His first essay on art, *A Critique of Critics (Kritika kritikov)*, appears in the Moscow newspaper *Novosti dnia*.

1902 Meets Gabriele Münter through the Phalanx School of Painting, where she is a student. Second Phalanx exhibition. Spends part of the summer in Kochel with his painting class. Third Phalanx exhibition includes works by Lovis Corinth and Wilhelm Trübner.
Exhibits in the Berlin Secession for the first time. First black-and-white and colour woodcuts. Produces numerous oil studies and tempera paintings over the next five years.

1866 Kandinsky is born on 4 December into an upper middle-class family in Moscow. His father is a tea merchant from Siberia; his mother, Lydia Tikheeva, is a Muscovite.

1869 Travels to Italy with his parents.

1871 The family move to Odessa. Kandinsky's parents divorce. His aunt takes over the task of bringing him up. He takes lessons in drawing and music.

1876 Attends the humanities grammar school in Odessa until 1885. Annual trips to Moscow with his father.

1886 Begins studying law and economics at the University of Moscow.

1889 Sponsored by the Imperial Society for Natural Sciences, Ethnography and An-

Students at the Phalanx School of Painting (centre: Gabriele Münter; front right: Kandinsky)

1903 The seventh Phalanx exhibition features works by Claude Monet. Following the closure of the Phalanx School of Painting, Kandinsky is invited by Peter Behrens to teach a class on decorative painting at the Düsseldorf School of Arts and Crafts; he declines. Travels to Vienna, Venice, Odessa and Moscow. Publishes *Poems without Words* in Moscow.

1904 Ninth Phalanx exhibition, with works by Alfred Kubin; Kandinsky shows colour drawings and woodcuts. 15 of his works are included in the Moscow Artists' Association exhibition. Works on a theory of colour.
Separates from his wife Anya in September and travels with Gabriele Münter to Holland, Berlin, Odessa, Paris and Tunis. Exhibits in the Paris Salon d'Automne for the first time (and from now on annually until 1910). The twelfth and last Phalanx exhibition is held in Munich in December. The association subsequently disbands.

1905 Travels back to Germany from Tunis via Italy. Further trips to Dresden, Odessa and Rapallo. Exhibits at the Salon des Indépendants in Paris and with the Moscow Artists' Association. Becomes a member of the Deutscher Künstlerbund (German Artists' Federation).

1906 Travels with Gabriele Münter via Genoa and Milan to Paris. Lives in Sèvres, near Paris, from 28 June to 9 June of the following year. Takes part in numerous exhibi-

tions, including the Salon d'Automne in Paris, the Secession in Berlin and with the artists of Die Brücke in Dresden.

1907 Exhibits 109 works in the Musée du Peuple in Angers. Trip to Switzerland. Lives in Berlin with Münter from September to April of the following year.

Wassily and Nina Kandinsky in Moscow, c. 1917

1908 Exhibits in the Salon des Indépendants in Paris from March until May. In mid-August, first stay in Murnau with Münter, Jawlensky and Werefkin. In September, moves into an apartment with Münter at 36, Ainmillerstraße, not far from Paul Klee.

1909 The Neue Künstlervereinigung München is founded on 22 January. Kandinsky is elected president. Gabriele Münter buys a house in Murnau. From now until the outbreak of World War I, Kandinsky makes regular trips to Murnau. Paints Murnau landscapes. His *Xylographs* are published in Paris. Exhibits in the Salon des Indépendants.
The first Neue Künstlervereinigung exhibition is held from 1 to 15 December at the "Moderne Galerie Thannhauser" in Munich. First paintings behind glass, inspired by Bavarian folk art. First "Improvisations".

1910 Lengthy stay in Murnau. Exhibits with the Sonderbund westdeutscher Künstler (Special Federation of West-German Artists) in Düsseldorf. Second exhibition by the Neue Künstlervereinigung. Meets Franz Marc, who writes a glowing review of the Neue Künstlervereinigung exhibition. Meets August Macke. Spends October to December in Russia (Moscow, St. Petersburg and Odessa). Exhibits 52 works in the International Salon in Odessa. Takes part in the Jack of Diamonds exhibition organized

by Larianov. Paints his first three "Compositions". Works on his theoretical treatise *On the Spiritual in Art*.

1911 Greatly excited by a concert of music by the Viennese composer Arnold Schoenberg, which he attends in Munich; start of correspondence between the two artists. Steps down as president of the Neue Künstlervereinigung. Collaborates with Marc and others on the publication of *The Struggle for Art*, a reply to the pamphlet *Protest of German Artists against the Importation of French Art* issued by Carl Vinnen. Together with Marc, first plans for the *Blaue Reiter Almanac*.
Kandinsky obtains a divorce from his wife Anya.
Kandinsky's *Composition V* is rejected by the Neue Künstlervereinigung jury; Kandinsky, Marc, Münter and Kubin resign. The first exhibition by the "Editors of Der Blaue Reiter" takes place in Thannhauser's gallery in Munich alongside the third exhibition by the Neue Künstlervereinigung.
Kandinsky's essay *On the Spiritual in Art* (*Über das Geistige in der Kunst*) is published by the Munich-based Piper Verlag.

1912 The second Blaue Reiter exhibition, which includes graphic works, takes place in February in Hans Goltz's gallery in Munich. Kandinsky has his first one-man show in Herwarth Walden's Sturm gallery in Berlin. Exhibits with the Moderner Bund (Modern Alliance) in Zurich. Exhibition in Rotterdam in November.
On the Spiritual in Art goes into its second and third editions.
Takes part in numerous other exhibitions. Trip to Odessa and Moscow from mid-October to mid-December, during which he participates in the Knave of Diamonds exhibition in Moscow as well as in "Contemporary Painting" in Yekaterinodar and other exhibitions.

1913 Exhibits in the Armory Show in New York. Arthur Jerome Eddy, one of the first American collectors of Kandinsky's works, visits the artist.
Participates in the First German Autumn Salon in the Sturm gallery in Berlin. His *Reminiscences* (*Rückblicke*) are published in an album by the Sturm Verlag.
Piper publishes the prose-poems *Sounds* (*Klänge*).
Kandinsky finishes *Composition VI* and *Composition VII*, his last two compositions before the war.

1914 One-man show in Thannhauser's gallery in Munich and in the "Kreis für Kunst" in Cologne. Paints four large wall panels for the villa of Edwin A. Campbell in New York.
War breaks out on 1 August. On 3 August, Kandinsky and Münter flee to Switzerland. Lengthy stay in Goldach on Lake Constance. Kandinsky works on *Point and Line to Plane* and writes *Violet Curtain*, a composition for theatre. In November, travels on without Münter via Zurich to Russia. Settles in Moscow.

1915/16 Spends December to March 1916 in Stockholm. Meets Gabriele Münter for the last time at an exhibition at Gummeson's gallery in Stockholm.

1917 On 11 February, marries Nina Andreevsky, daughter of a general. Honeymoon in Finland. Birth of a son, Vsevdod, who dies in 1920.

1918 Politico-cultural work in Moscow as a member of the Fine Arts Department of the People's Commissariat of Enlightenment. Professorship at the Higher State Artistic and Technical Workshops. A new edition of his autobiographical *Reminiscences* is published in Russian.

1919 Appointed director of the Museum for Pictorial Culture in Moscow. Takes over as chairman of the pan-Russian commission for museum acquisitions; between now and 1921 he organizes the equipping and opening of 22 new museums in the Russian provinces.
Together with Kasimir Malevich and El Lissitzky, takes part in the First State Exhibition in Moscow.

1920 Co-founder of the Institute of Artistic Culture (INKhUK). Appointed professor of aesthetics at Moscow University. Shows 54 works in the XIX. Exhibition of the Pan-Russian Central Exhibition Committee in Moscow. Increasing conflict with Rodchenko. Leaves the Workshops for Monumental Painting.

1921 Leaves the Institute of Artistic Culture. Appointed to build up the Department of Psychology at the newly-founded Academy of Aesthetics, of which he is made vice-director. Runs the reproduction workshop. In December, Kandinsky and his wife leave Russia for Berlin.

1922 Spends six months in Berlin, during which time he takes part in numerous exhibitions. Takes up his post at the Weimar Bauhaus in June. Publication of *Small Worlds*, a portfolio of graphic works. Assisted by his Bauhaus students, completes a series of wall paintings for the Unjuried Art Show in Berlin.
Takes part in the First Exhibition of Russian Art in the van Diemen Gallery in Berlin.

Poster designed by Herbert Bayer for the exhibition marking Kandinsky's 60th birthday, Dessau, 1926

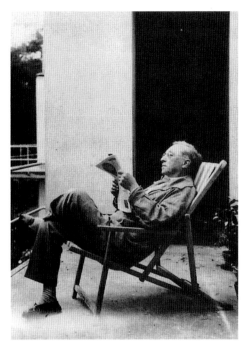

Nina and Wassily Kandinsky at the Bauhaus, 1926

Poster advertising a lecture by Kandinsky, 1928

Kandinsky on his balcony in Dessau, 1932

1923 First one-man show in New York with the Société Anonyme, of which he is made honorary president.

1924 Kandinsky, Klee, Feininger and Jawlensky found Die Blaue Vier (The Blue Four); the group exhibits in the US. At the end of December, the Weimar Bauhaus is dissolved.

1925 In April the Bauhaus moves to Dessau. Kandinsky follows in June. Brunswick businessman Otto Ralfs founds the Kandinsky Society.

1926 The Kandinskys move into one of the Bauhaus Masters' houses built by Gropius; the Klees live next door.
Point and Line to Plane (*Punkt und Linie zu Fläche*), Kandinsky's second major theoretical work, is published in Munich.
Numerous one-man shows in German and other European cities to mark his 60th birthday.
The first number of the *bauhaus* journal is dedicated to Kandinsky.

1927 Runs a free painting class at the Bauhaus. Summer holiday with the Schoenbergs on Lake Wörther in Austria.

1928 Wassily and Nina Kandinsky are granted German citizenship.
Commissioned to design stage sets for a performance of Mussorgsky's *Pictures at an Exhibition* in the Friedrich Theatre in Dessau.

1929 First one-man show of watercolours and drawings in the Zak gallery in Paris.
Trip to Belgium. Visits James Ensor in Ostende. Holiday with the Klees in Hendaye-Plage.

1930 Makes contact and exhibits with

the Paris group Cercle et Carré. Trip to Italy. Schultze-Naumburg removes works by Kandinsky, Klee and Schlemmer from the museum in Weimar.

1931 Designs ceramic-tile murals for a music room in the German Architure Exhibition in Berlin. Trip to Egypt, Turkey,

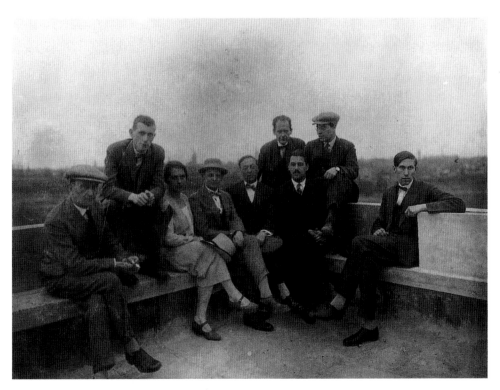

The Bauhaus Masters on the roof of the studio block, Dessau, c. 1927 (from left: Albers, Breuer, Stölzl, Schlemmer, Kandinsky, Gropius, Bayer, Moholy-Nagy, Scheper)

Greece and Italy. First articles for the French magazine *Cahiers d'Art*.

1932 The Dessau Bauhaus is closed by the National Socialists. The school moves to Berlin, where it re-opens as a private institute housed in a former telephone factory.
Kandinsky moves to Berlin in December.

1933 The Bauhaus closes down in July. In autumn Kandinsky travels to Paris, and in December settles permanently with his wife in an apartment at 135, Boulevard de la Seine in Neuilly-sur-Seine, a suburb of Paris. He will remain there until his death.

1934 Joint exhibition with the Abstraction-Création group. Exhibition in the *Cahiers d'Art* editorial offices. Meets Constantin Brancusi, Robert and Sonia Delaunay, Fernand Léger, Joan Miró, Piet Mondrian and Albert Magnelli. Renews friendship with Jean Arp. Spends the summer in Normandy.

1935 Turns down an invitation to become artist in residence at Black Mountain College in North Carolina.
Exhibitions in the *Cahiers d'Art* offices in Paris and at I. B. Neumann's gallery in New York.
Summer holiday on the French Riviera.

1936 Takes part in the exhibitions "Abstract and Concrete" in London and "Cubism and Abstract Art" in New York. Holiday in Italy. In December, first exhibition in Jeanne Bucher's gallery in Paris.

1937 One-man show at Karl Nierendorf's gallery in New York. Seizure of his works in German museums. 14 of his pictures are shown in the "Degenerate Art" (Entartete Kunst) exhibition in Munich.
Takes part in the exhibition "Origins and Development of International Independent Art" (Origines et Développement de l'Art International Indépendant) in the Jeu de Paume museum in Paris.

1938 Takes part in the "Abstract Art" exhibition at the Stedelijk Museum in Amsterdam. Four poems and woodcuts are published in the magazine *transition*.
His essay on *Concrete Art* appears in the first issue of *XXe Siècle*.

1939 *Composition IX* is purchased by the French state. Kandinsky and his wife are granted French citizenship.
Completes his last *Composition*.

1940 Following the invasion of German troops, spends two months in the Pyrenees.

1941 Invited to emigrate to America, but declines.

Ernst Kallai:
***The Artist**, 1930
Caricature of Kandinsky

1942 Paints his last large canvas, *Tensions délicates*. From now on he restricts himself to smaller formats on cardboard. One-man show in Jeanne Bucher's gallery in Paris.

1943 Holiday in Rochefort-en-Yvelines.

1944 Last exhibitions with Jeanne Bucher and in the Galerie L'Esquisse in Paris.
Falls ill in March, but continues to work until July.
Dies of cerebrovascular disease on 13 December in Neuilly-sur-Seine, at the age of 78.

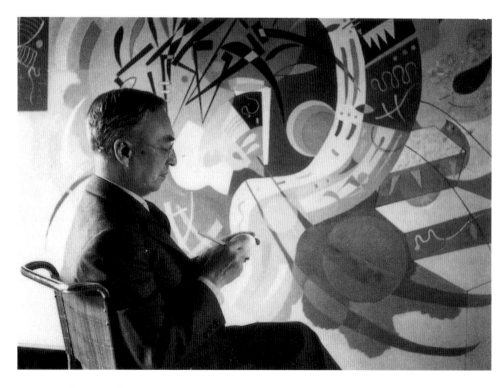

Kandinsky in his studio in Neuilly-sur-Seine, 1939
Photograph
Paris, Musée National d'Art Moderne, Centre Georges Pompidou

Major exhibitions

1901
Phalanx, Munich.
1902
Phalanx, Munich. Sezession, Berlin.
1903
Phalanx, Munich. Sezession, Berlin. Odessa.
1904
Phalanx, Munich. Salon d'Automne, Paris.
St. Petersburg.
1905
Salon d'Automne, Paris. Deutscher Künstler-
bund, Berlin.
1906
Sezession, Berlin. Salon d'Automne, Paris.
Deutscher Künstlerbund, Weimar.
1907
Salon d'Automne, Paris. Die Brücke, Dresden.
Salon des Indépendants, Paris. Musée du Peuple,
Angers.
1908
Sezession, Berlin. Salon d'Automne, Paris.
Salon des Indépendants, Paris.
1909
Salon d'Automne, Paris. Salon des Indépend-
ants, Paris. Neue Künstlervereinigung, Galerie
Thannhauser, Munich.
1910
Salon d'Automne, Paris. Neue Künstlervereini-
gung, Galerie Thannhauser, Munich.
1911
Sezession, Berlin. Salon des Indépendants, Paris.
Der blaue Reiter, Galerie Thannhauser, Munich.
1912
Salon des Indépendants, Paris. Der blaue Reiter,
Galerie Thannhauser, Munich. Der Sturm, Ber-
lin. Galerie Hans Goltz, Munich.
1913
Armory Show, New York. 1. deutscher
Herbstsalon, Berlin. Galerie Bock u. Sohn,
Hamburg.
1914
Galerie Thannhauser, Munich.
1916
Gummeson Gallery, Stockholm.
1921
Galerie Nierendorf, Cologne.
1922
Galerie Guldendahl, Berlin. Gummeson Gallery,
Stockholm.
1923
Kestner-Gesellschaft, Hanover.
1926
Galerie Nierendorf, Berlin. Galerie Arnold,
Dresden. Kunstverein Dessau.
1927
Galerie Goltz, Munich. Museums in Mannheim,
Amsterdam, The Hague, Zurich.
1928
Frankfurter Kunstverein. L'Epoque, Brussels.
Fides, Dresden. Möller, Berlin. Neuerische
Halle, Nuremberg.
1929
Zak, Paris. Le Centaure, Brussels. Museums in
Halle, Breslau, Kiel.

1931
Flechtheim, Berlin.
1932
Möller, Berlin. Museum Essen.
1934
Galleria del Milione, Milan. Cahiers d'Art,
Paris.
1935
Cahiers d'Art, Paris. New Art Circle, New York.
1936
Jeanne Bucher, Paris. Germanic Museum,
Harvard.
1937
Kandinsky and contemporary French masters,
Kunsthalle Bern. Origines et Développement de
l'Art International Indépendant, Paris. Nieren-
dorf Gallery, New York.
1938
Three Masters of the Bauhaus, Kandinsky, Klee
and Feininger, Nierendorf Gallery, New York.
Guggenheim Jeune Gallery, London.
1939
Jeanne Bucher, Paris. Nierendorf Gallery, New
York.
1942
Jeanne Bucher, Paris. Nierendorf Gallery, New
York.
1944
Nierendorf Gallery, New York. Galerie
L'Esquisse, Paris.
1945
Galerie Eaux Vives, Zurich.
1946
Braque, Kandinsky, Picasso, Kunsthaus Zürich.
1947
Gouaches, Aquarelles, Dessins, Drouin, Paris.
Stedelijk Museum, Amsterdam.
1948
Kunsthalle Basle. Stangl, Munich. Sidney Janis
Gallery, New York.
1949
Sidney Janis Gallery, New York. Drouin, Paris.
1950
De Beaune, Paris. Nebelung, Düsseldorf. Gimpel
Fils, London.
1951
Galleria del Naviglio, Milan. Maeght, Paris.
1952
Institute of Contemporary Art, Boston.
1953
Knoedler, New York. Museum of Art, San
Francisco. Walker Art Center, Minneapolis.
Museum of Art, Cleveland. Lowe Gallery,
Miami. Rosengart, Lucerne. Moeller, Cologne.
Maeght, Paris. Retrospective: Munich, Berlin,
Hamburg, Nuremberg, Stuttgart, Ulm, Wies-
baden, Mannheim.
1954
Haus der Kunst, Munich. Tapestries, Denise
René, Paris. Berggrün, Paris.
1955
Kunsthalle Bern. Période dramatique 1910 –
1920, Maeght, Paris.

1956
Kandinsky Murals, Museum of Modern Art,
New York.
1957
Chalette, New York. Kleemann, New York. Tate
Gallery, London. Statens Museum, Copenhagen.
Maeght, Paris. 44 œuvres du Musée Guggen-
heim, Palais des Beaux-Arts, Brussels. Musée
d'Art Moderne, Paris.
1958
100 works by Kandinsky, Wallraf-Richartz-
Museum, Cologne.
1959
Aquarelles et Gouaches, Musée des Beaux-Arts,
Nantes. Klee-Kandinsky, une Confrontation,
Berggrün, Paris.
1960
Œuvres de 1921–27, Maeght, Paris.
1961
New Gallery, New York. Flinker, Paris.
1962
Guggenheim Museum, New York.
1963
Musée National d'Art Moderne, Paris. Gemeente
Museum, The Hague. Kunsthalle Basle. Dessins,
Galerie Claude Bernard, Paris.
1965
Moderna Museet, Stockholm.
1966
Das druckgraphische Werk. Zum 100. Geburts-
tag, Lenbachhaus, Munich.
1969
Kandinsky Watercolours, The Museum of Modern
Art, New York.
1971
Aquarelle und Gouachen, Kunstmuseum
Berne.
1972
Aquarelle und Zeichnungen, Galerie Beyeler,
Basle. Aquarelles et Dessins, Galerie Berggrün,
Paris. Kandinsky: Peintures, Dessins, Gravures,
Éditions, Galerie Karl Flinker, Paris.
1976
Haus der Kunst, Munich.
1979
Kandinsky: Trente Peintures des Musées Sovié-
tiques, Musée National d'Art Moderne, Paris.
1983
Kandinsky: Russian and Bauhaus Years 1915–
1933, Guggenheim Museum, New York.
1984
Kandinsky: Russische Zeit und Bauhausjahre
1915–1933, Kunsthaus Zürich, Berlin. Musée
National d'Art Moderne, Paris.
1985
Kandinsky in Paris, 1934–1944, Guggenheim
Museum, New York.
1989
Kandinsky. Die erste sowjetische Retrospektive,
Schirn Kunsthalle, Frankfurt.
1992
Kandinsky, Kleine Freuden, Kunstsammlung
Nordrhein-Westfalen, Düsseldorf.

Bibliography

Kandinsky's own writings:

Über das Geistige in der Kunst. Insbesondere in der Malerei, Munich 1912. Translated as "On the Spiritual in Art" in: *Kandinsky. Complete Writings on Art 1901–1942*. Edited and translated by Kenneth C. Lindsay and Peter Vergo, London 1982.

Der Blaue Reiter. Edited by Wassily Kandinsky and Franz Marc. Munich 1912. Translated as: *The Blaue Reiter Almanac*, edited by Wassily Kandinsky and Franz Marc. Documentary edition by Klaus Lankheit, London 1974

Rückblicke. In: *Kandinsky, 1901–13, Der Sturm*, Berlin 1913. Translated as "Reminiscences" in: Lindsay and Vergo (eds), op. cit.

Essays über Kunst und Künstler. Edited by Max Bill, Stuttgart 1955. Translated as "Essays on Art and Artists" in: Lindsay and Vergo (eds), op. cit.

Punkt und Linie zu Fläche. Beitrag zur Analyse der malerischen Elemente. Bauhausbücher 9, Munich 1926. Translated as "Point and Line to Plane. A Contribution to the Analysis of Pictorial Elements" in: Lindsay and Vergo (eds), op. cit.

Arnold Schoenberg, Wassily Kandinsky. *Letters, Pictures and Documents.* Edited by Jelena Hahl-Koch and translated by John C. Crawford. London 1984

Wassily Kandinsky, Franz Marc. *Briefwechsel.* Edited by Klaus Lankheit, Piper Verlag, Munich 1983.

Vassily Kandinsky. *Correspondances avec Zervos et Kojève.* Textes présentés, établis et annotés par Christian Dérouet. Les Cahiers du Musée National d'Art Moderne, Centre Georges Pompidou, Paris 1992

Catalogues raisonnés:

Hans K. Roethel, Jean K. Benjamin: *Kandinsky, Catalogue Raisonné of the Oil-Paintings*, Vol. 1, 1900–1915. Sotheby Publications, London 1982

Hans K. Roethel, Jean K. Benjamin: *Kandinsky, Werkverzeichnis der Ölgemälde*, Zweiter Band, 1916–1944. Verlag C.H. Beck, Munich 1984

Hans K. Roethel: *Kandinsky, Das graphische Werk.* DuMont Schauberg, Cologne 1970

Selected exhibition catalogues:

Kandinsky, Gemälde und Aquarelle. Wallraf-Richartz Museum, Cologne 1958

Wassily Kandinsky 1866–1944. Haus der Kunst, Munich 1977

Klee und Kandinsky, Erinnerungen an eine Künstlerfreundschaft anläßlich Klees 100. Geburtstag. Staatsgalerie Stuttgart, Stuttgart 1979

Wassily Kandinsky, Drei Hauptwerke aus drei Jahrzehnten. Kunstsammlung Nordrhein-Westfalen, Düsseldorf 1981

Kandinsky und München, Begegnungen und Wandlungen 1896–1914. Edited by Armin Zweite, Städtische Galerie im Lenbachhaus, Prestel Verlag, Munich 1982

Kandinsky, Russische Zeit und Bauhausjahre 1915 – 1933. Bauhaus-Archiv, Museum für Gestaltung, Berlin 1984

Vom Klang der Bilder. Die Musik in der Kunst des 20. Jahrhunderts. Prestel Verlag, Munich 1985

Kandinsky, Œuvres de Vassily Kandinsky (1866–1944). Catalogue établi par Christian Dérouet et Jessica Boissel, Collections du Musée National d'Art Moderne, Paris 1985

Wassily Kandinsky. Die erste sowjetische Retrospektive, Gemälde, Zeichnungen und Graphik aus sowjetischen und westlichen Museen. Schirn Kunsthalle, Frankfurt 1989

Stationen der Moderne. Die bedeutenden Kunstausstellungen des 20. Jahrhunderts in Deutschland, Berlinische Galerie im Martin Gropius-Bau, Berlin 1989

"Entartete Kunst". Das Schicksal der Avantgarde im Nazi-Deutschland. Edited by Stephanie Barron, Los Angeles and Berlin 1991

Kandinsky, Kleine Freuden, Aquarelle und Zeichnungen. Edited and with essays by Vivian Endicott Barnett and Armin Zweite, Kunstsammlung Nordrhein-Westfalen, Düsseldorf, Prestel Verlag, Munich 1992

Selected works on Kandinsky:

Aust, Günter: Kandinsky, Berlin 1960

Bill, Max (ed.): Wassily Kandinsky, Boston 1951

Düchting, Hajo: Wassily Kandinsky 1866–1944, A Revolution in Painting, Benedikt Taschen Verlag, Cologne 1993

Eichner, Johannes: Kandinsky und Gabriele Münter. Von Ursprüngen moderner Kunst, Verlag F. Bruckmann, Munich 1957

Gollek, Rosel: Der Blaue Reiter im Lenbachhaus, Prestel Verlag, Munich 1988

Grohmann, Will: Wassily Kandinsky. Life and Work. Thames and Hudson, London 1959

Hanfstaengl, Erika (ed.): Wassily Kandinsky, Aquarelle und Zeichnungen im Lenbachhaus München, Prestel Verlag, Munich 1974 and 1981

Hüneke, Andreas (ed.): Der Blaue Reiter. Dokumente einer geistigen Bewegung, Reclam Verlag Leipzig, Leipzig 1989

Kandinsky, Nina: Kandinsky und ich, Kindler Verlag, Munich 1976

Lassaigne, Jacques: Kandinsky, Cleveland 1964

Overy, Paul: Kandinsky, The Language of the Eye, Elek, London 1969

Poling, Clark V.: Kandinsky-Unterricht am Bauhaus, Farbenseminar und analytisches Zeichnen, Weingarten/Berlin 1982

Riedl, Peter Anselm: Wassily Kandinsky, Rowohlts Monographien, Reinbek bei Hamburg 1983

Weiss, Peg: Kandinsky in Munich, Princeton 1985

Hommage à Wassily Kandinsky, XXième Siècle, Paris 1974

Wassily Kandinsky, XXième Siècle, No. 27, Paris 1966

Other works consulted:

Droste, Magdalena: bauhaus 1919–1933, Benedikt Taschen Verlag, Cologne 1993

Hess, Walter: Dokumente zum Verständnis der modernen Malerei, Rowohlt, Hamburg 1986

Paul Klee: Diaries 1898–1918. Edited and with an introduction by Felix Klee, Peter Owen, London 1965

Die Zwanziger Jahre. Manifeste und Dokumente deutscher Künstler. Edited and annotated by Uwe M. Schneede, DuMont Schauberg, Cologne 1979

Wünsche, Konrad: Bauhaus. Versuche, das Leben zu ordnen, Verlag Klaus Wagenbach, Berlin 1989

bauhaus berlin, Eine Dokumentation. Compiled by the Bauhaus-Archiv Berlin, Weingarten/Berlin 1985

The publishers wish to thank the museums, archives and photographers for their permission to reproduce the illustrations and for their support and encouragement in the preparation of this book. We are particularly grateful to the Städtische Galerie im Lenbachhaus, Munich, the Musée National d'Art Moderne, Paris, and the Solomon R. Guggenheim Museum, New York. In addition to the collections and institutes named in the captions, the following acknowledgements are also due:
Archiv für Kunst und Geschichte, Berlin: 20, 48, 76, 178;
Artothek, Peissenberg: 58;
Bauhaus-Archiv, Berlin: 195;
H. Bayer, Berlin: 149;
Erik Bohr, Berlin: 132;
Martin Bühler, Berlin: 159, 164;
Photograph courtesy of The Art Institute of Chicago, Chicago: 103;
David Heald, copyright The Solomon R. Guggenheim Foundation, New York: 35, 37, 82, 99, 102, 121, 138, 154, 156, 160, 165, 167, 169, 172, 183, 188, 190;
Photograph, © 1991 The Solomon R. Guggenheim Foundation, New York: 158;
Bildarchiv Hansmann, Munich: 12, 28;
Lepkowski, Berlin: 144, 146;
Musée National d'Art Moderne, Centre Georges Pompidou, Paris: 196;
Museum Folkwang, Essen: 178;
Photograph, © 1993, The Museum of Modern Art, New York: 112, 113, 168;
Schneider, Berlin: 140;
Elke Walford, Hamburg: 47